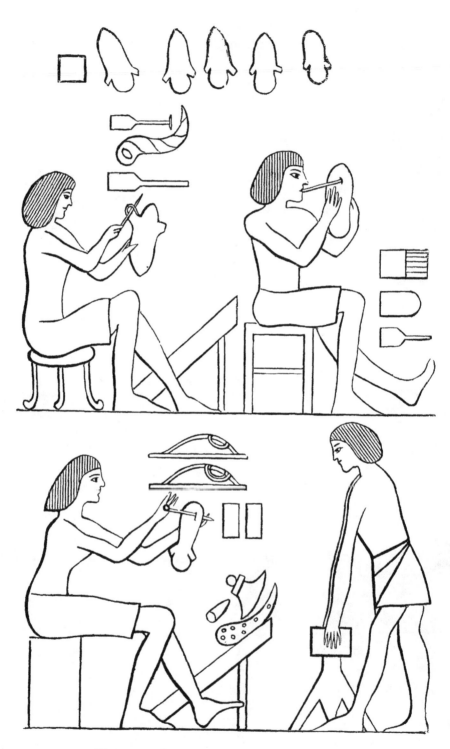

EGYPTIAN SANDAL-MAKING, ABOUT B.C. 1500.

THE ART OF
BOOT AND SHOEMAKING

A Practical Handbook

INCLUDING

MEASUREMENT, LAST-FITTING, CUTTING-OUT, CLOSING, AND MAKING

WITH A DESCRIPTION OF THE MOST APPROVED MACHINERY
EMPLOYED

By JOHN BEDFORD LENO

LATE EDITOR OF " THE BOOT AND SHOEMAKER "

With Numerous Illustrations

Martino Publishing
Mansfield Centre, CT
2010

Martino Publishing
P.O. Box 373,
Mansfield Centre, CT 06250 USA

www.martinopublishing.com

ISBN 1-57898-972-8

Cover design by T. Matarazzo

Printed in the United States of America On 100% Acid-Free Paper

THE ART OF
BOOT AND SHOEMAKING

A Practical Handbook

INCLUDING

MEASUREMENT, LAST-FITTING, CUTTING-OUT,
CLOSING, AND MAKING

WITH A DESCRIPTION OF THE MOST APPROVED MACHINERY
EMPLOYED

By JOHN BEDFORD LENO

LATE EDITOR OF "THE BOOT AND SHOEMAKER"

With Numerous Illustrations

Capio Lumen

W. FOULSHAM & Co.,
Publishers,
4, PILGRIM STREET,
LONDON, E.C.

PRINTED BY
WILLIAM CLOWES AND SONS, LIMITED,
LONDON AND BECCLES.

PREFACE.

DESPITE the extreme antiquity of the art of which the Author has here treated, it was not till the commencement of the present century that the first known attempt to treat of Boot and Shoemaking from a practical standpoint was made by Mr. Rees. This treatise was followed by the works of O'Sullivan and Devlin, that of the latter forming a portion of the series of practical works issued under the superintendence of the late Mr. Charles Knight.

The art of Boot and Shoemaking may be said to have undergone a complete revolution during the past fifty years, and it is consequently impossible that works written so long since as those mentioned could satisfy the requirements of the present day.

The introduction and successful application of machinery, the increased division of labour, the improved methods and instruments adopted and employed by modern craftsmen, and the use of new materials, are sufficient, besides other considerations, to justify and necessitate the production of a modern treatise on the subject.

Notwithstanding the acknowledged success that has

attended the employment of machinery, hand-making still retains a leading position in the Boot and Shoe-making industry; and although the number of men now employed is not equal to those formerly engaged in hand-work, the status of those remaining has in no sense declined. The best class of Boots and Shoes are those made by hand for our leading "bespoke" masters; and it is, moreover, from the ranks of this department of the trade that the most competent machine workers are con-tinuously recruited; therefore it is that, in the present work, the author has devoted so large a portion of the space at his command to hand-production, in which it may safely be said that the true art of the Shoemaker lies.

The author will not conclude these prefatory remarks without tendering his sincere thanks to Mr. Tyrrell for his valuable assistance.

CONTENTS.

———◆———

CHAPTER I.

HISTORICAL.

CHAPTER X.

BOOT AND SHOEMAKING: MEN'S WORK.

CHAPTER XI.

BOOT AND SHOEMAKING: WOMEN'S WORK.

CHAPTER XII.

LEGGINGS AND GAITERS.

CHAPTER XIII.

MENDING.

CHAPTER XIV.

FURRING.

CHAPTER XV.

BOWS, ROSETTES, &c.

CHAPTER XVI.

BOOT AND SHOE ARMOUR: TIPS, PLATES, NAILS, &c.

CHAPTER XVII.

KIT-CUTTING.

CHAPTER XVIII.

SHARPENING KNIVES, AWLS, &c.

CHAPTER XIX.

SPECIAL OPERATIONS.

CHAPTER XX.

BOOT AND SHOE MACHINES.

CHAPTER XXI.

LEATHER CUTTING, SPLITTING, AND ROLLING MACHINES.

CHAPTER XXVI.

USEFUL RECEIPTS FOR SHOEMAKERS, &c.

BOOT AND SHOEMAKING.

CHAPTER I.

HISTORICAL.

A succinct History of Boots and Shoes.—The Difficulty of tracing the Origin of Foot-gear.—The Materials used by the Egyptians in the Manufacture of Sandals, &c.—Baudoin's Treatise "De Solea Veterum." —Tychius, of Bœotia, declared by Pliny to have been the first Shoe-wearer.—Plautus and Seneca on Shoes of Gold.—The Streets of Old Rome crowded with Shoemakers' Stalls, and an Edict issued for their Removal.—Foot-gear used by the Greeks and Romans to distinguish Rank and Position.—Evelyn's Visit to Venice.—Choppines.—Boots and Shoes as Instruments of Torture.—Saints Crispin and Crispinian. —Our Frontispiece.—The Kit of the Ancients.—Foot-gear of the Ancient Britons.—The Irish, Scotch, and Hebridian Brogues.— Fashion controlled by Deformity.—Sumptuary Laws applied to Boots and Shoes.—Saxon Foot-gear.—Did Cardinal Wolsey wear Shoes of Gold?—Curled Toes.—Shoes and Prayer.—Shoemakers in Religious Houses.—The Shoes of Chaucer's Absolon. —The Cordwainers' Company of the City.—Pisnettes and Pantoffles.—The Choppine in England.—Slouched Boots.—Boots of the Cavaliers and Puritans.— Buckles and Brilliants.—Heels and Toes.—Clogs.

IT would be almost as difficult to decide the period when foot-clothing was first worn by man as to fix the date of his existence. All that we know in regard to the reform is that in some of the most ancient records we possess allusions to foot-coverings occur. These tell us that sandals, shoes, &c., were made, and worn by the Egyptians and the inhabitants of other eastern countries, from the leaves of the papyrus, and raw hides, over three thousand years ago ; but whether foot-clothing was first made from vegetable or animal substances must ever remain a matter of conjecture. The earliest efforts of foot-clothiers were, in all probability, confined to protecting the soles of

the wearers of their productions, and consisted of sole-guards and their fastening appliances. For these, linen, rushes, broom, flax, wood, bark of trees, hides of animals, and even metals were employed. Many references to foot-gear will be found in the Old Testament.

Baudoin, a shoemaker, has written a learned treatise, "De Solea Veterum," in which the origin, material, and form of the earliest foot-gear are inquired into; and as an argument in favour of the custom of protecting the feet, he declares that if God had intended man to go bare-footed, he would not have given him the skins of animals! Pliny makes the extraordinary assertion that Tychius, of Bœotia, first wore shoes; but he has not only failed to supply us with the grounds upon which he based his conclusion, but the date of the so-called first wearer's existence. From the Greek and Roman classics we learn that boot, shoe, and sandal-making was practised as an art at a very early period, and, moreover, that differently fashioned foot-gear was prescribed by legal enactments to be worn for the easy distinguishment of both rank and profession. Plautus, in his "Bacchides," introduces us to a rich man who wore shoes with soles of gold; and Seneca records that Julius Cæsar wore shoes formed of the same precious metal. In Domitian's reign, we read, the streets of Rome were so crowded with shoemakers and their stalls as to necessitate the passing of an edict for their removal. In Rome, the shoes worn by the patrician order were made to reach higher up the leg than those worn by the plebeians; while the boots of the common people were fashioned of wood, and slaves are known to have gone barefooted. It is impossible, with the space at our command, to even name the immense variety of boots, shoes, and sandals worn by the different classes of Greeks and Romans; not only were classes distinguished by their foot-gear, but even the divisions of classes. Every grade of military and civil life was known by the mode in which the foot was clothed, and the sock and buskin, which still mark two distinct classes of actors, are a bequeathment from this singular and ancient custom.

Writing of Ascension Week in Venice, Evelyn tells us how at its great fair he saw noblemen stalking with their ladies on choppines. "'Tis ridiculous," he writes, "to see how these ladies crawle in and out of their gondolas by reason of their choppines, and what dwarfs they appear when they are taken down from their wooden scaffolds." On a strange gentleman being asked how he liked the ladies of Venice, he replied that they were "*mezzo carno, mezzo ligno* (half flesh, half wood), and he would have none of them." It is possible that the Romans first set the example of using boots and shoes as instruments of torture and degradation. The Romans used a shoe of iron, as the early Christians knew to their cost. The instrument known as "the boot" is described as being made of a slip of parchment. This was placed on the leg wet, and by its steady yet violent contraction caused intolerable pain to its wearer. A boot into which wedges were driven is known to have been employed for a like end.

The brothers Crispin and Crispinian, two shoemakers of Rome, on adopting the Christian faith were expelled the city. History informs us they wandered into France, preaching and working by turns in the several towns through which they passed till they arrived at Soissons, where they suffered martyrdom on October 25, 308. These brothers, in accordance with an old-world Catholic custom, became the patron saints of shoemakers, and on each succeeding anniversary of their martyrdom it is still a practice in many countries for shoemakers to pay tribute to their memories. With regard to the mode in which this was done in England, an old rhymster wrote—

"On the 25th October
Seldom a souter's sober."

By way of frontispiece, with the view of showing the earliest mode in which men plied the trade of sandal-making, we present our readers with copies of two paintings traced by Rosselini. These are supposed to date from the time of Pharaoh, or about fifteen hundred years before the time of Christ. The low stool upon which one of the workers is seated bears a remarkable

resemblance to those we have seen shoemakers use. Only a few of the tools pictured bear the slightest resemblance to those composing the kit of a modern craftsman.

In the succeeding pages we will confine ourselves, therefore, to the productions of our own shores. It may be remarked that the more striking features of English boots have been at different dates common to nearly all western nations, and that shoe-wearers have been more indebted to the French than to any other people for the diversity of patterns and forms of boots and shoes we are about to describe.

However rude and uncivilised the earliest inhabitants of Great Britain and Ireland may have been, it is almost impossible to conceive a time when at least a portion of them were unimpressed with the necessity of clothing their feet. The ever-recurring injuries from contact with the earth's varying surface could not have failed to have impressed upon them the necessity of some primitive form of foot-armour. "The shoes worn by the Belgic Britons," says Meyrick, "were made of raw cowhide." Such shoes are known to have been worn by the Irish down to the time of Edward III., and by the Scotch, with certain variations, to a much later date. "The brogue," writes Mrs. S. C. Hall, in her " Ireland," "was made of untanned hide; but for the last century at least it has been made of tanned leather. The leather of the upper is much stronger than that used in the strongest shoes, being made of cowhide dressed for the purpose, and it never has an inside lining like the ordinary shoe; the sole leather is generally of an inferior description. The process of making the brogue is different from that of shoemaking, and the tools used in the work bear little analogy. . . . The regular brogue was of two sorts, the single and the double pump, the former consisting of the sole and upper only; the latter had a welt sewed between the sole and upper leather. In the process of making the regular brogue there was neither hemp, wax, nor bristles used by the workman, the sewing all being performed by a thong made of horsehide prepared for the purpose. . . .

The brogue is worn larger than the foot, the space being filled in with a sap of hay. The Irish brogue-makers pride themselves on the antiquity of their trade, and boast over shoemakers, whom they consider a spurious graft on their noble art." Still more interesting is the account given by Hugh Miller of the shoes even yet worn at Eigg, one of the Hebridian Islands. He describes them as being of a deep madder colour, soles, welts, and uppers, and resembling in form the yawl of *The Betsy*. He tells us they were sewn by thongs, and altogether the production of Eigg, from the skin out of which they were cut, the lime that had prepared it for the tan and root by which the tanning had been accomplished, down to the last on which they had been moulded. He moreover describes how one of the islanders made him a pair of these shoes, the way in which the roots for the liquor (*Tormentilla erecta*) were collected, and the homely tanning of the skin. It may be mentioned that shoes have been dug up in England that do not materially differ from the above. These are formed from a single piece of untanned leather, slit in several places to allow of a thong being passed through, that, when drawn tight, fastened the shoe to the foot like a purse. The discovery of these early formed shoes proves that it is a mistake to credit Mr. Nicholson, who lived in the early portion of the present century, with the introduction of "rights and lefts."

It would be wearisome to attempt to describe the many forms that boots and shoes have been made to assume since the displacement of the brogue. One thing may be noted, however, with regard to subsequent productions, namely, that the comfort of the wearer has not always been the chief thing cared for. There has been a constant skipping from one extremity of form to another, regardless of the fact that no great change was ever known to take place in the feet the shoes were intended to protect and comfort. Charles VII. of France wore coats with long tails to hide his legs, that were the reverse of shapely. Henry Plantagenet, Duke of Anjou, to hide a large and unsightly excrescence on one of his feet, wore shoes with excessively

long points. Henry VIII. is said, though there is
pretty good proof that extremely broad boots were worn
before his time, to have occasioned the introduction of
shoes of disproportionate breadth in order to obtain ease
and comfort for feet that were misshapen. In all the
instances quoted, the unsightly and ridiculous forms became
fashionable, so fashionable and so outrageous that sumptu-
ary laws had to be passed to restrict their use, or rather
proportions. Fines and other punishments were imposed
for wearing boots with toes over two inches in length, and
at another period for wearing shoes with toes above six
inches in breadth. It would appear that our Saxon fore-
runners, partially at least, adopted the Greek and Roman
custom of wearing boots and shoes to distinguish their
rank or station : and from a similar custom that prevailed
in France we are told is derived the proverb, "Etre sur
grand pied dans le monde." The chief characteristic of
Saxon foot-gear is a long, pointed toe, and the slashing of
the upper. The shoes worn in the eleventh, twelfth, and
thirteenth centuries, and, indeed, both before and after,
were cut from leather, silk, velvet, satin, and every de-
scription of then-existing woven fabric, and ornamenta-
tion and extravagance were at different periods carried to
absurd lengths. The great Cardinal Wolsey is said to
have worn shoes of gold. We know that he was guilty
of many extravagances, but we can scarcely credit this,
although we admit there is a possibility of his having done
so. The probability is that gold embroidery or leather
stamped in gold is what the author intended to convey.
It is related that a courtier named Robert, in the third
Edward's time, wore the toes of his boots so long that he
had to stuff them with tow and curl them up like a ram's
horn, from which they obtained the name of *cornadu.*
We are again, however, reminded of the old and well-
worn proverb, "There is nothing new under the sun," by
a quotation that tells us that the same thing was prac-
tised as early as the time of Rufus, and that they were,
previous to Edward's time, worn in Cracow. Hume, in
his History of England, keenly remarks in his notice of

the declamations of the clergy against this absurd fashion, "The ecclesiastics took exception to this ornament, which they said was an attempt to belie the Scriptures. . . . But such are the strange contradictions of human nature, though the clergy of that time could overthrow thrones, and had the authority to send above a million of men on *their* errand, they could not prevail against those long-pointed toes." The legal enactments referred to put them down for a time, but they sprang into existence once more, and in allusion thereto a writer of the period observes, "A fashion we have lately taken up is to wear our forked shoes almost as long again as our feet, not a little to the hindrance of the action of the foot, and not only so, but they prove an impediment to reverential devotion, for our boots and shoes are so mounted that we can hardly kneel in God's house."

Shoemaking was practised in monastic institutions, excepting those belonging to monks denominated "bare-footed," from a very early date, and the existence of the practice appears to have given offence to Richard, the first Abbot of St. Alban's Abbey, who complained of the monks and canons associating with shoemakers and tanners. In the description of Absolon, the parish clerk, Chaucer tells us "the upper leathers of his shoes were carved to resemble the windows of St. Paul's Cathedral," which goes a long way to prove they were of monkish origin.

Trade organisations are known to have existed among shoemakers from a very early period. The Cordwainers' Company of the City of London was first incorporated by letters patent granted by Henry IV., its title being at that time "The Cordwainers' and Cobblers' Company." The incorporation of this body was again recognised in the fifteenth century by Act of Parliament, the provisions of which gave its members power to restrain the making of boots and shoes "after a preposterous fashion," under a penalty of twenty shillings, and to put a stop to Sunday and holy day trading by similar mulcts and fines, or in lieu thereof, imprisonment.

In Edward VI.'s reign, and long after, courtiers

wore high boots with very long tops that could be pulled over the knee and half up the thigh when wanted. These boots fitted the leg like a stocking, and closely resembled the buskin. The chivalrous Earl of Surrey is pictured by Holbein as wearing boots of this order. They are slashed across, as was the fashion with the Anglo-Saxons. These slashings are said to have been employed at the time of their revival to " advertise " the rich silk stocking then coming into fashion. Shoes with two straps and latchets, cut similar to those worn some fifty years back, came into vogue at the time of Elizabeth, as did pumps ; and a writer of the period possibly alludes to the latter under the name of "pisnettes." "Men," says the same writer (Stubbs) "have corked shoes, pisnettes, and fine pantoffles, which bare them up two inches or more from the ground." Some of these, he tells us, were made of white leather, some of black, and some of red ; some of black velvet, some of white, and some of green. They are, moreover, said to have been carved, cut, and stitched all over with silk, and laid on with gold and silver. From attacks on the ladies at this period we learn that they indulged in similar extravagances. The choppine was introduced into this country in the sixteenth century, but it never reached the absurd proportions that it did in Venice and Rome. Shakspeare, in a salutation to a lady, writes, " What, my young mistress, by'r lady, your ladyship is nearer heaven than when I saw you last by the altitude of a choppine." Many of the shoes of this period closely resemble the shoes now worn, and the modern fashion of ornamenting shoes with bows, &c., over the instep is evidently a copy of the fashion then in vogue. There is this difference to be noted : such ornaments are now confined to the foot-gear of ladies, whereas at the period referred to they were common to both ladies' and gentlemen's shoes.

Shoes of buff leather, with slashes in their uppers, were very much worn in the reign of the first James, when high boots again came into fashion. These were clumsily formed, and were allowed to slouch down over the calves and ankles of their wearers, like untied stockings. It was

probably from these boots that wrinkled legs took their rise. About this time a lady is said to have admired "the good wrinkles of a gallant's boots." These high slouching boots were worn by pedestrians as well as by riders. Apart from the gold-lace and silver-thread with which "shoe-ties" were edged at this period, the shoes worn did not entail a great expense to the wearers. Dramatists of the same reign and of that of Charles I. make frequent mention of corked shoes. In a play called *Willy Beguiled*, a girl has to say, "I came trip, trip, trip, over the Market Hill, holding up my petticoats to the calves of my legs, to show my fine coloured stockings, and how trimly I could foot it in a new pair of corked shoes I had bought." The boots of the Cromwellian era were mostly made of buff Spanish leather. They were plain to ugliness and were armed with a square piece of leather in front to keep the pressure of the stirrup from the instep. During the existence of the Commonwealth, and for some time after, the tops of the boots were of enormous width. The shoes of the reign of Charles II. and James II. were distinguished by high heels and longish toes, tapering towards their points, but cut square at the ends, the uppers of which not only covered the insteps but extended some distance over the shins of their wearers. Shoes of Spanish leather, laced with gold, were also commonly worn. Those of the men of fashion had squarer or less pointed toes, with huge flaps ornamented with diminutive buckles, the heels being somewhat higher and covered with coloured leather. We are told that buckles were first used in the reign of William III. ; but, if so, how comes it that the brass of Robert Attelath, at Lymm, who died in 1376, is pictured with shoes with buckles? It is only fair to state that some incline to the belief that the buckles worn prior to William III. were only used as ornaments. The costliness of many of the buckles so worn is placed beyond doubt from the fact that they were often fashioned of the most precious metals, and studded with brilliants. William himself wore high jack-boots, scarcely differing in form from, and having the same belongings by way of instep-guards, as those of

his predecessor. They were cut as ugly as can possibly be imagined.

Ladies' shoes had high heels. It was quite common to bridge the arch with a leathern clog. The high-cut quarter shoe continued to be worn by men during the reigns of George I. and II. Red was the fashionable colour for their heels, and they were adorned with buckles of large dimensions. The shoes worn by ladies were much handsomer than those worn by their immediate predecessors, the ugly square toes having given way to toes less broad and more sightly. The clog worn was also an improvement, the heel of it being sunk to receive the heel of the shoe. The uppers, cut from silks and satins, were richly embroidered. The heels of these shoes were of wood covered with silk, satin, and fancy leather. As time advanced shoe quarters were cut lower, and the heel brought more forward. In 1790 the shoes worn by ladies were cut exceedingly short in the vamp and of necessity low in the quarters. As for heel, they had scarcely any. Buckled shoes lasted down to the commencement of the present century, or rather they were revived at that period. They were speedily succeeded by shoes fastened with strings. The bucklemakers, who were almost ruined by the change, petitioned the then Prince of Wales to leave off wearing shoe strings in favour of buckles, but his readiness to oblige the petitioners did not materially serve them. In the reign of George III. close-fitting top boots, the legs of which were cut from grained leather, were very commonly worn. The upper portion was cut more to resemble the form of the leg, and it was furnished with a turn-over, or a top as it was afterwards called. High boots so cut were found to be difficult to get on and off, and in the process of time the height of leg was lowered. In many of these lowered boots, the turn-over reached down to the ankle. It was during this reign that the Hessian came into fashion, perhaps the handsomest boot ever worn. This boot was a German importation ; but boots similarly cut are known to have been worn in Bohemia as early as 1700. This was followed by the Wellington.

In the reign of George IV. ladies wore boots laced up the front. Side lacing revived in that of the succeeding monarch, and the " Adelaide " boot took its name from William's consort. Sandalled slippers were also concurrently worn, and remained in fashion till the early portion of the reign of Victoria. Ribbon for shoe strings was commonly employed at this period. The cut of the quarters of shoes has since undergone many changes, and military-heeled boots have become quite common for ladies' wear. There was an interval when the high heel was superseded by the low, but recently, as our readers know full well, the high heel has once more asserted itself. The Blucher, which came into fashion in the early portion of the present century, continued in great favour down to a very recent date, and even yet is not entirely displaced. The introduction of elastic within the memory of readers of moderate age did much to discountenance the Blucher boot and indeed many others. Boots with springs in them are known to have their disadvantages ; but from the fact that they are self-fastening, they are certain to remain popular.

With regard to more modern boots and shoes, we prefer to leave them to those who may succeed us. We are, moreover, justified in making this omission from the fact that there is little if any necessity to cumber our pages with matters with which even the least observant cannot fail to be acquainted.

CHAPTER II.

THE ANATOMY OF THE FOOT.

The Value of a Knowledge of Anatomy to Shoemakers.—Sir Charles Bell
on the Structure of the Human Foot.—Its Bones and Muscles.—How
its Actions are controlled.—Its chief Characteristics.—Its Economy.
—The Task of the Shoemaker.—The Pioneering Big Toe and Mode
of Protecting it from Injury.—Overlying Toes.—Faults of Construc-
tion and their evil Influences.

SHOEMAKERS as a rule, it must be confessed, know little
of the foot's anatomy. At a time like the present, when
the value of technical education is so generally recognised,
it is singular that no satisfactory effort is being made to
relieve them of this disadvantage. Naturally it may be
thought that this would have been the first thing taught
in the art and mystery of boot and shoemaking, for how
is it possible that a maker of these necessary articles, void
of such knowledge, can properly furnish the foot? To
design a house the architect must be able to realise the
habits and wants of those it is intended to shelter; it is
equally necessary that those whose duty it is to afford
shelter and protection to the human foot should com-
prehend its mechanism and the composition of its various
parts. This very necessary information is not difficult of
attainment, that is, so much of it as is necessary for the
guidance of the shoemaker.

In speaking of the human foot, Sir Charles Bell says,
" There is nothing more beautiful than its structure, nor,
perhaps, any demonstration which would lead a well-
educated person to desire to know more of anatomy. It
has in its structure all the fine appliances you see in a
building. In the first place, there is an arch in which-

ever way you regard the foot; looking down upon it we perceive several bones coming round the astragalus, and forming an entire circle of surfaces in the contact. If we look at the profile of the foot an arch is still manifest, of which the posterior part is formed by the heel, and the anterior by the ball of the great toe, and in the front we find in that direction a transverse arch ; so that instead of standing, as might be imagined, on a solid bone, we stand upon an arch composed of a series of bones, which are united by the most curious provision for the elasticity of the foot; hence, if we jump from a height direct upon the heel, a severe shock is felt; not so if we alight upon the ball of the great toe, for there an elasticity is found in the whole foot, and the weight of the body is thrown upon this arch, and the shock is avoided." Thus, it will be perceived, this arch is not solid like that of a bridge, and that had it been so it would have been unworthy of the praise that has been so generally bestowed upon it.

It is evident that whether standing or walking the more evenly the pressure on these parts is distributed, the less the strain on the foot or any part thereof will be. To this evenness of pressure it is the shoemaker's duty to contribute. Whatever tendency there may be in the foot to wander into or retain a false position, it is his duty to correct.

The first thing that strikes a person on attempting a critical examination of the human foot is its large proportion of bone. On pressing its top surface and that of its inner side, the amount of flesh will be found to be very small indeed ; the same may be said of the inner and outer ankle, and at the extreme back part this scarcity of flesh-covering is still more remarkable. The most fleshy portions of the foot are its outer side, the base of the heel, and the ball of the big toe. The reason for this generous disposition of flesh in these parts is easily comprehended. The underneath portions cover those parts of the foot that would otherwise have to meet the ground, and, acting as pads, lessen the concussion. The distribution of so much flesh proportionately on the outer side of the foot shows that it is intended as a shield against danger.

The foot reaches to the two leg bones to which it is articulated by the astragalus. The joint is of the tenon and mortise order, and by it four movements are provided for: flexion, extension, inward and outward rotation. By the first the toes are raised, by the second they are pointed, by the third the movement for turning the sole so that its outer side is brought in contact with the earth is effected, and by the fourth the reverse movement that brings the inside of the sole to a like position is accomplished. Of these movements it may be said that the first two are free, and the last restricted. Speaking of the movements of the foot generally it is known that but few, very few, are effected by means of a single muscle. The muscles of the foot act in nearly all cases in combination, and so complex are their actions, that our greatest surgeons do not profess themselves able to describe the whole satisfactorily.

Shoemakers would do well to observe how wisely Nature has positioned the burthen of the body on the arch of the foot, on the structure of which Sir Charles Bell has spoken in such raptures, and to note the reasons that may be said to have dictated the selection of that position. The solid hinder flank over which the burthen rests possesses the required stability, and, moreover, so positioned, the weight, with scarce an effort, can be readily thrown on the foremost part of the arch.

The principal agent for the flexibility and security of the foot in front is the medio-tarsal joint, which runs across the breadth of the foot immediately before that part which carries the burthen, and lies between the astragalus and the os calcis at the back, and the scaphoid and cuboid before. It is by means of the action of this joint that, when the ground is uneven, the uprightness of the body is maintained, and it is chiefly by it that the toes are turned to meet the sole of the foot. The outside of the foot possesses two joints, between the calcis and cuboid, and the cuboid and metatarsus, and the inside four, namely, between the calcis astragalus, scaphoid, internal cuneiform, and metatarsus.

The inner portion of the medio-tarsal joint is of the ball-and-socket order, and the other more of the mortise character. These bones are kept in their places by ligaments, muscles, and tendons, one or more muscles being attached to each of the bones of the foot, the astragalus excepted, while tendons of great strength pass through appointed grooves in the bones and cross each other on the sole of the foot. The foot depends for its efficiency on muscular force and the equitable balance of power among the muscles themselves. It is worthy of mention that every tendon, with the exception of the tendon Achilles, passing from the leg to the foot, is inserted in

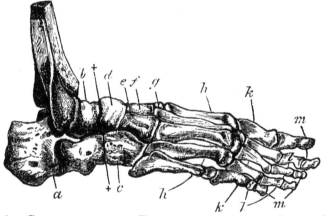

Fig. 1.—Skeleton of the Foot, seen from the Outer Side.

a, Os calcis; *b*, astragalus; ** The medio-tarsal joint, running right across the foot, and separating into an anterior and posterior portion; *s*, the cuboid; *d*, the scaphoid, or navicular; *e*, outer cuneiform; *f*, middle cuneiform; *g*, a small bit of the inner cuneiform; *hh*, metatarsal bones; *kk*, first phalanges; *l*, second phalanges; *m*, unequal phalanges.

front of the medio-tarsal joint, and all muscular contraction, saving that appertaining to the raising of the heel and the extension of the ankle, primarily acts on the anterior portion and medio-tarsal articulation, and secondarily on the back part and ankle joint.

It will be seen from the foregoing account of the anatomical structure of the foot that it is divided into three parts, the toes, the waist and instep, and the heel

and ankle. The bones of the foot proper (exclusive of those belonging to the toes) are twelve in number, that is the number contained from the joining. In their natural position fluid and gristle keep the majority, if not the whole, slightly asunder, forming a kind of buffer between every interstice. The bones are denominated the passive organs of locomotion, and the muscles that move them are termed active. The muscles are planned mechanically to act upon the bones and to pull them, at the will of their owner, into any direction that he may desire. These movements can be thus effected as readily as a seaman can operate upon the spars, &c., of the vessel that he is engaged to navigate.

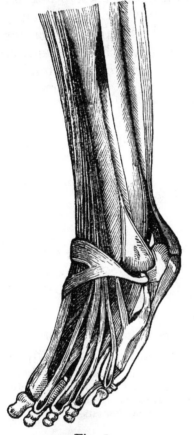

Fig. 2.

The diagram (Fig. 1), with the separate names of the bones attached, is fully sufficient explanation of the Latin names used. By reference thereto, the different parts alluded to will be easily distinguished.

It is not necessary, for the purposes for which this work is intended, to enter into a description of the entirety of the muscles and tendons of the foot, nor to endeavour to portray the whole of their various actions. By means of the engraving (Fig. 2) the disposition of the various muscles, &c., will be better understood, far better than by any verbal puzzle that might be presented.

The careful reader will have learnt what are the chief characteristics of the foot—its spring and elasticity; and that these result from its wondrous mechanism and mar-

vellous fitness of the arrangement of its tendons, muscles, and integuments. *It is the shoemaker's duty to provide for each and all fair play, free action.* It is true that the economy of the foot is so perfect that it possesses wonderful powers of resistance and adaptability ; but it is not meant that these should be unnecessarily trespassed upon or unduly strained, and despite the wonderful efforts of Nature to guard the foot from evil consequences *it is the shoemaker's duty to afford it additional security.*

Of all portions of the foot the pioneering big toe is the most liable to be struck and the most susceptible of injury The tendency of the foot in walking is to travel towards the toe of the boot, in a word to creep or press into, rather than shun danger. This tendency, it is almost unnecessary to say, must be either counteracted or provided for. The first can be partially accomplished by attention to the spring of the waist, the fit of the upper and the preparation of the sole, and the second by allowing an efficient length of sole beyond the termination of the toe when not in action. Not too much, but enough ; so that in the event of the toe of the boot or shoe striking forcibly against any hard substance the most prominent toe of the foot, and of necessity the remainder, will remain untouched. Had these matters been always attended to, enlargements of big toe joints would have been less common, and it may be added, of rare occurrence.

A mere glance at the two illustrations provided will suffice to show that pointed toe boots are an abomination, false in theory, false practically, and destructive, not only of the ease and comfort of those that wear them, but, sooner or later, of their walking powers.

In the natural foot when off duty, its toes touch each other gently ; when called on to assist locomotion or bear their share of the superincumbent weight, they spread out though not to any great extent, it is true. This being their natural action, no sensible maker of boots and shoes would attempt to restrain it, or allow it to be restrained. Still, from a want of knowledge of the foot's anatomical structure, the stupid mandates of all-powerful fashion, the

folly of maker and wearer, or from one cause or many, it has been restrained, and as a necessary consequence, few feet widen to the extent that is required. What chance is there of the toes of a vast number of feet spreading when instead of remaining side by side as Nature intended they should lie, they have been so crushed and crowded together that they literally overlie each other? Again, it may be said that the grand lesson taught by Anatomy is the danger of allowing undue pressure to interfere with the foot's action, or rather multiplicity of actions. It gives us a favourable impression of providing boots and shoes with box or puff toes which allow the toes their free action and indicates with emphasis, that to join the vamp to the upper immediately over the big toe joint is an act of stupidity and danger. As already stated, it warns us against narrow-toed boots, and more forcibly still, against absurdly high heels, that cannot do otherwise than disturb the nicely adjusted balance that Nature intended for the easy and graceful carriage of the body and its accompanying members.

It is, moreover, a fault to construct a boot with too thick a waist. If this lesson in anatomy teaches anything more forcibly than another, it is that shank-pieces should be sparingly employed, in order that the play of the arch of the foot should in no way be restricted. The awkward gait of the agricultural labourer is clearly traceable to stiff-waisted boots.

The cause of a sole twisting before being worn will be found, it is believed, in an imperfect settling of the leather by the rolling machine or hammering during the process, or in the boot or shoe being taken off the last before sufficiently dry.

CHAPTER III.

THE FOOT:—ITS AILMENTS, AND THEIR REMEDIES.

The Shoemaker and Fashion.—Corns.—The Hard Corn.—The Soft Corn.—The Black Corn.—The Blood Corn.—The Bunion.—Callosities.—Sweating Feet.

The Shoemaker and Fashion.—It would be a tough matter to decide whether the bootmaker or the boot-wearer is responsible for the large amount of foot torture that has had to be borne. As in most instances where the blame is pretty evenly dividable each party asserts himself innocent. The wearer is forgetful of the determination of his youthful days to have his boots made small, too small, and in strict conformity to the ruling fashion; and the shoemaker stubbornly denies that he was ever instrumental in injuring the foot of a customer. It would be a sheer waste of space to pursue this matter much farther, inasmuch as it is impossible to apportion the blame fairly. In our introductory remarks we have shown that it is not always a shoemaker who introduces a fashion. Had the master craftsman who served the eighth Harry refused to conform to the desires of his royal master, he would undoubtedly have lost the court patronage, and possibly his head. It may be safely said with regard to the introduction and continuance of a fashion, the deciding power rests with the wearer, or rather the bulk of wearers, and it would be as reasonable to blame a printer for the production of a work conceived and written in bad taste, as a shoemaker for conforming to an absurd and injurious demand

upon the part of the general public. Customers seldom seek advice from shoemakers until their feet are ruined, and in the majority of instances that we have known where it has been tendered without being asked for, it has met with anything but a kindly reception. Still, as hinted, the shoemaker has been far from blameless. Even with regard to fashion, he has always held a power to modify its evil influences, a power which he has not always chosen to exercise. For the proper disposition of seams, the selection of material, accuracy of fit, the shoemaker must be held mainly, if not solely, responsible, despite of all that has been or may be said in his behalf.

In this chapter it is purposed to touch briefly on corns, bunions, and other callosities, known to result from the unequally disposed pressure of ill-fitting boots and shoes, and other removable evils.

Corns.—It is frequently asserted that there are such things as hereditary corns. This is in all probability a mistake, arising from the members of families having transmitted to them skins more liable to corns than those of others. M. Le Forest, a royal chiropodist of France, declared corns to be the result of a thick and viscid humour in the pores of the skin, which on being unduly pressed upon assumes the form of a callous substance. Plateus, another eminent authority, asserts that corns are produced by the lymph or alimentary fluid, designed for the use of the skin, being detained in the pores and rendered hard by constant pressure. Lavaugion says they arise from the laceration of the nervous filaments of the mucous net or plexus of the skin, letting the lymph escape, when, resting under the epidermis, it coagulates, and through its inspissation, forms the substance of corns. All who have given attention to the subject declare that corns are mainly due to pressure and friction.

The Hard Corn is formed by friction rather than by pressure. The process has been thus described: "The hard corn is produced by the constant collision of a tight or small shoe against the projection point of some prominent bony surface, as on the last joints of third, fourth,

and little toe. The action is kept up, a sense of pain is experienced, which produces inflammation ; rest decreases this inflammation, leaving an induration behind it. Renewed action, from the preceding causes, reproduces the same effects, inflammation again ensues, which in its turn is equally decreased either by rest or a temporary removal of the cause, leaving behind a second or accumulated degree of induration. This continued action and reaction bring on a callosity rising above the surface of the skin, which increases from its basis in proportion to the excess or diminution of the exciting cause. Once formed pressure alone will suffice to sustain it." An ordinary hard corn of recent formation may be removed by scraping up the callous skin around its border and prying out carefully with a knife, taking care that the under skin is not cut through. A hard corn of long standing will succumb to the continued application of an ointment formed of marsh mallows. Occasional bathing in warm water and scraping with a blunt knife will materially assist the remedy prescribed. In the event of the above failing, try the following: Bathe the foot in warm water, shave the corn somewhat close, and then touch it with nitric or nitro-muriatic acid. When the corn is fully ripe, a membrane separates it from the true skin, so that it can be taken off without injuring its surface.

The Soft Corn is chiefly the result of pressure. If those troubled with them are of sedentary habits, a considerable time will be found to elapse before their surfaces become callous. "These corns," writes an excellent author, " are soft and spongy elevations on the parts acted upon (subjected to pressure), and the surface of the skin by no means loses its sensibility, as is the case with hard corns." They are also produced by "lazy toes," that is, toes that have been thrust out of their natural position, and override each other. Soft corns are mostly found on the inner side of the smaller toes. Those so located are called concealed corns. Soft corns on the surface of joints will by mechanical action become hard. Concealed corns

are remarkably painful and sensitive, even when free from
pressure or friction. It is doubtful if any treatment save
burning will suffice to cure a soft corn, though bathing
and the application of marsh mallow ointment may be
tried. Only a small quantity of acid should be employed,
and as soon as the under skin becomes influenced, the
desired effect is accomplished, for when it heals, the corn
is gone. Something soft should be put between the toes
to separate them, and prevent unnecessary irritation during
the process.

The Black Corn owes the appearance from which its
separate distinction and name are derived to a clot of
coagulated blood settled at its root. This is possibly the
result of the rupture of a small blood vessel. Either of
the hard-corn remedies will assist a cure.

The Blood Corn is known to be excessively painful. It
is said to result from an ordinary corn forcibly displacing
the blood vessels surrounding it, and causing them to rest
upon its surface. Its treatment and cure are exceedingly
difficult, and in the event of bathing and relief from
friction and pressure not sufficing to effect a cure, appli-
cation had better be made to a properly certificated
surgeon.

The Bunion will, as a rule, be found situated on the
big toe joint. The chief cause of its formation is known
to be the wearing of boots or shoes of insufficient length.
The foot meeting with resistance in front and behind, is
robbed of its natural action, the result being that the big
toe joint is forced upwards, and subjected to continuous
and unnatural friction and pressure. The wearing of
narrow-toed boots that prevent the outward expansion of
the toes may be safely taken as a secondary cause. A
bunion is rather an inflammatory swelling than a corn.
The treatment to be most commended is warm footbaths
and poultices, when the part is tender and irritable, and
frequent cold baths at other times. Caustic should only
be applied when the bunion is surmounted with a corn-
like substance. In instances where appearances go to
prove that the bunion has been caused from the toe

being pressed inwards, a wadding of wool placed between the big and adjoining toe will prove advantageous.

Callosities on the heel and instep are not as a rule particularly troublesome, and are easily cured by being relieved from pressure and friction.

The use of punctured plasters and cushions is advisable, where relief is not to be otherwise obtained.

Toe-nails, if not properly attended to, are a continuous source of trouble and pain. A good authority on nails and their treatment says: "On learning that a nail has a tendency to pierce the quick, efforts should at once be made to counteract it. This can best be done by bathing the foot in warm water, and gradually raising up that part of the nail, and introducing a piece of lint under it, which will cause the nail to extend itself in a different direction. Before inserting the lint it will be found advisable to scrape the nail longitudinally nearly down to the quick." The nail of the big toe is more liable to grow into the quick than those of the smaller ones. This arises from the pressure it is often called upon to sustain. The thin membrane called by anatomists "the semi-lunar fold," from its resemblance to a half-moon, acts as a regulator to the nail's growth. This fold should be carefully guarded, inasmuch as its slightest injury has a fatal influence on the nail's perfect growth. Nails should always be cut square and never shorter than the toes. To cut them out at the corners is a mistake. When the nails are pared, their regulators should be first detached from the nails with a blunt pointed instrument.

Sweating Feet.—The following cure for abnormal sweating of the feet is highly recommended:

Pulverised tannin sprinkled inside the boots or shoes, will in three days prevent tender feet from perspiring or blistering. Tannin thus applied rapidly strengthens and hardens the skin, softened by the simultaneous action of moisture and heat; perspiration being thus reduced to the proper degree, without its healthy action being in the slightest way interfered with, the exhalations as a matter of course cease to be offensive. The cessation of

disagreeable odours is explained by the fact that the products of the ammoniacal decomposition of the skin are immediately combined with the tannin so carried off. Boot uppers should always possess sufficient porosity to allow the perspiration an easy escapement. In case of waterproof boots and others known to be defective in the above respect, being worn, it is as well on their removal to bathe the feet. With many, this is a necessity. An occasional washing out of the boots themselves may also be advisable. To prevent perspiration entirely is dangerous, inasmuch as skin diseases will often follow.

CHAPTER I V

MEASUREMENT.

Variation in Form and Character of Feet.—The Necessity of Careful Measurement.—What a Measurer Requires.—The Elongation of the Foot under Pressure.—Points of Measurement.—How to Measure for Short and Long Work.—Directions for taking the Heel Measure.—Ankle Measure and where to take it.—Leg Measure.—Allowances.—Fitting.—An American writer's notion of Measurement.—Description of Size Stick.

Lord Toppington—Hark thee, Shoemaker! these shoes ain't ugly, but they don't fit me.
Shoemaker—My Lord, methinks they fit you very well.
Lord Toppington—They hurt me just below the instep.
Shoemaker—(feeling his foot). My Lord, they don't hurt you there.
Lord Toppington—I tell thee, they pinch me execrably.
Shoemaker—My Lord, if they pinch you, I'll be bound to be hanged, that's all.
Lord Toppington—Why, wilt thou undertake to persuade me I cannot feel!
Shoemaker—Your Lordship may please to feel when you think fit. I think I understand my trade.
Lord Toppington—Now by all that's great and powerful, thou art an incomprehensible coxcomb, but thou makest good shoes, and so I'll bear with thee.
Shoemaker—My Lord, I have worked for half the people of quality in town these twenty years, and 'twere very hard I should not know when a shoe hurts, and when it don't.—*From Vanburgh's comedy of* "THE RELAPSE."

Variation in Form and Character of Feet.—Despite of all that has been said and written regarding measurement, little if any improvement has been made on the old method. That misfits are frequent, is undeniable, but in the majority of instances these do not reflect upon the principle of measurement. A want of proper care upon the part of the measurer, or a proper understanding between measurer, last-fitter, and maker, is more often than not the cause of misfits. There is nothing in the shoemaking business that requires a fuller mastery of the entire trade than measurement, and yet it is by no means uncommon to see mere novices set to perform this necessarily difficult operation. Were all feet formed alike,

measurement and fit would be comparatively easy and persons with little knowledge of bootmaking could easily be taught to convey to the last-fitter and maker all the particulars requisite for securing a perfect fit and ease and comfort to the boot-wearer. It is, however, as difficult to find two pairs of feet alike as two faces. Feet differ not only in size and proportion, but in their powers to resist and conform themselves to pressure.

The Necessity of Careful Measurement.—When the measurer, the last-fitter, and the maker, are separate and distinct persons, the foremost should be able to give not only the separate measurements, but to instruct the two latter in all that is requisite to be known of the feet measured. These three persons must be trained to thoroughly understand each other. For instance, it is not sufficient for the measurer to say the measure was taken across this or that joint, as feet that compare in length do not compare with regard to the location of their joints; and in case they did compare, the difficulty would not be destroyed, inasmuch as the joints of the last may be differently positioned. Again, with regard to insteps, their prominences are not always in the same positions, nor do lasts conform in these particulars.

What a Measurer Requires.—No person in a position to be called upon to take a foot's measurements should be unprovided with a note-book. That many men possess powerful and well-trained memories is indisputable, but we hold, despite the wonderfully retentive powers they possess, that the single safe mode is to pencil down the various measurements taken, if only in order to refer to in case of doubt. This book should be used for recording measurements, and for noting peculiarities which claim attention. Here is a sample of such entries as we would advise.

DATE———

"T. Smith, Brownlow Villas, Kew. Pair of oil-grained, leg-laced shooting boots, stout calf goloshes and toe-cap, bellows tongues and hooks, wide welts, two rows of nails in soles. Length of foot 6's, joints 8¾, first instep 9,

second ditto 9⅜, heel 12⅝, ankle 8¾. The feet very hollow in the waist, the insteps prominent. Wanted by Date————."

The above is sufficient for an example, the particular items of which it consists can be multiplied at the pleasure of the measurer, or person taking the order.

By aid of the accompanying diagram (Fig. 3) the following instructions will present few difficulties.

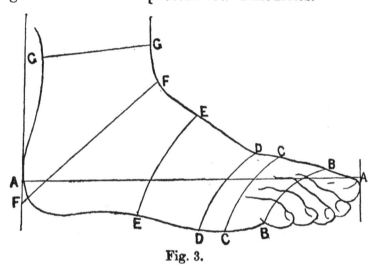

Fig. 3.

The measurer must provide himself also with a size-stick, several slips of cartridge paper of about ¾ of an inch in breadth, a sheet of foolscap, and a full-length broad marking pencil. Then the length of the foot from A to A is taken by means of the stick while the customer is seated. This done, let the foot be placed on the sheet of foolscap paper, so as to cause it to bear its fair share of the weight of its owner. Then draw with the pencil a line round the foot, the pencil being kept perfectly upright.

The Elongation of the Foot under Pressure.—The increased length of the foot when thus subjected to pressure must be carefully noted, as this knowledge is needed to determine the amount of allowance. The giving of the arch when the foot is pressed upon elongates the foot a full size.

Points of Measurement.—The points of measurement
that follow should be marked precisely on the paper on
which the outline has been drawn. It is also advisable to
accompany the outline with any remarks that are likely to
prove of value to the fitter up or maker.

How to Measure for Short and Long Work.—By
means of a strip of cartridge paper first take the

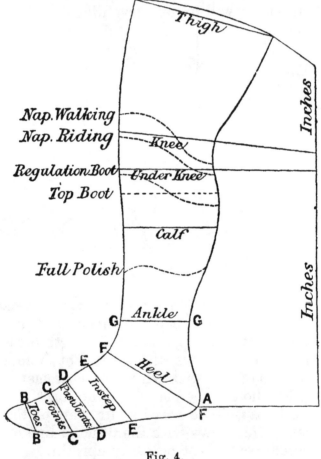

Fig. 4.

measurement over the root of toes, B B; then over joints
C C; then past joints D D; then at instep E E; then at heel
F F; and finally at ankle G G, marking the measure with a
slight yet perceptible tear for each separate measurement.
These measurements will be ample for a boot that is

intended to reach no higher than the ankle. It may be stated that the measurement over root of toes is generally dispensed with, inasmuch as all that is required is supplied by the rude outline referred to above. It is worthy of remark that the ankle measure as usually understood is not the true ankle measure. In some shops it is customary to take the true ankle measure in addition. In measuring for full Polish the measurement must be taken as shown, and for Wellingtons it is necessary to take the calf measure. For top boots a measurement above the calf. For regulation and Napoleons measure in addition as in Fig. 4. The length of leg and top required must be accurately noted.

Directions for taking the Heel Measure.—The heel measure is taken round the extreme point of the back and bottom of the foot, the measure slip being brought round the front on the top of instep at the point marked F. In measuring the heel, be careful not to bring the measure upon the leg.

Ankle Measure and where to take it.—The slovenly way in which the ankle measure is often taken has a great tendency to produce misfits. The ankle measure should be taken just above the bones in the smallest part of the leg.

The Leg Measure.—The leg measure must be taken at the precise height of leg ordered, as a change will seriously affect the circumference measurement. It is usual to take the several measurements moderately tight, and instruct the last-fitter to allow a quarter of an inch under in joint and instep and full up at heel. A roughly sketched side view of foot will serve the last-fitter materially. It need not do more than indicate the foot's peculiarities. The measurer should not be in too great a hurry to complete his task. Customers are favourably impressed with those who appear to take great pains to obtain a perfect measurement.

Allowances.—For a patent leather boot, which is not elastic, the measure of the last should be smaller than for a calf boot, which is more yielding, and can therefore be

lasted tighter to the last with the pincers; the calf boot also retains more contracting reserve than does patent leather, the fact being that the pincers take more stretch out of upper leather than the foot does. The more elastic the leather, the more liable the pincers to encroach on the holding capacity of the boot and comfort of the foot.

Fitting.—One of the results of the factory system is that average well-proportioned feet can be fitted in almost every shop, and for them the dealer is seldom called on to take the measure, as he is generally provided with ready-made shoes, leaving only the disproportioned feet to require measuring. From the fact that a few measures are taken in the ordinary retail shoe shops, experts are generally not employed, and the measures, when required, have to be taken by the clerks, who have, in too many instances, little special qualification.

An American writer's notion of Measurement.— An American writing upon Measurement and Last-fitting says:—

"To be well acquainted with the art of fitting human foot-coverings, a thorough knowledge of the natural laws that govern the human foot in its average formation, growth, and motion, is needed, and then an application of a rule that shall give exact results in at least the average of cases, with strict rules for following those cases that depart one way or another from the average. To illustrate —we want the measure of a certain foot. It is not needed that every toe and portion of the foot shall be measured, although scarce any two points of measurement are alike; so we usually take measurements across the toes, the ball, the waist (which is between ball and instep), the instep, heel, ankle and leg. The measure taken at the toe is a certain distance from some other point; say to either toe or heel; so of instep measure; so, too, in taking measure of the leg, its measure varies according to the variation of point of measurement, and, to be correct, we must indicate how far up the measure is taken to have any exact value in the measurement, the truest rule being to take all

measures at certain fixed distances from the heel, these distances being regulated by the length of the foot.

" These or similar formulæ being completed, we are sure of having the exact measure at corresponding points, but correct measures do not insure an exact fit.

" The form must also coincide with that of the foot and leg, as it will be in its natural position when standing erect with the boot or shoe on ; but just here it must be borne in mind that the height of the heel determines what angle the leg sustains to the foot. Starting on the theory that in a boot without any heel on, the leg is on right angle with the foot, the leg of the pattern must be so cut for such a boot, and must be thrown back from this line according to the height of the heel, inch for inch, or fraction for fraction in proportion ; this will give the general direction of the pattern above the last. Of course the upper has to be to its form, and that of the leg is in some measure guided by the measurement, but not fully."

Description of Size Stick.—The following explanation of the size-stick (Fig. 5) will be found useful to those who have not perfectly mastered it. The first part of the size-stick is quite plain, because the smallest size of boots or shoes made is five inches long, and to get this length, the sliding upright has to be pushed forward to the first line of the size-stick. This is called the first size ; but babies' shoes mostly run from 2 to 5 sizes. It must be understood (see lines) that every third part of an inch is one size, and the sixth part of an inch is half a size ;

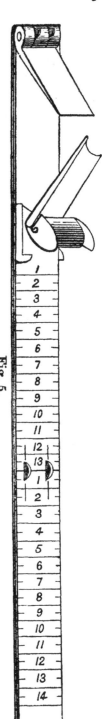

Fig. 5.

the next set of sizes are termed sixes to nines, and the next tens to thirteens; these are called children's. After the thirteenth size, the next third part of an inch is marked No. 1, No. 2, No. 3, and so on again. The first four sizes are termed ones to fours, and form the set of sizes to which youths' or misses' boots or shoes are cut. The first seven sizes, in this second numbering of the size-stick, are termed women's sizes, and, from the fifth size to the fourteenth are called men's sizes; so that babies' shoes run from five inches to six inches, and-two eighths; children's six to nines, from six inches five-eighths, to seven inches five-eighths; girls' tens to thirteens, from eight inches to nine inches; youths' ones to fours, from nine inches and three-eighths, to ten inches two-eighths and a half; women's ones to sevens, from nine inches and three-eighths, to eleven inches and two-eighths, and men's fives to fourteens run from ten inches and five-eighths, to thirteen inches and six-eighths. These six different sets of sizes are known in the trade by figures, as follows: 2 to 5, 6 to 9, 10 to 13, 1 to 4, 1 to 7, 5 to 12.

CHAPTER V.

LASTS.

The Antiquity of Lasts.—The last is a piece of wood
or iron shaped to resemble the foot, and is used as a
model in the formation of the boot or shoe. Its use has
been traced back to a very early period. Those who made
sandals did not require a last, as this form of foot-clothing
did not envelop the foot.

The Objects for which Lasts are employed.—When,
however, boots and shoes were formed to cover the toes, the
last became a necessity, it being found that if the boot or
shoe materially differed in its form to that of the foot, it
was extremely liable to be trodden out of all shape and
form, or to escape from the foot of the wearer. Moreover,
to secure the proper arching and rounding of the sole, the
moulding of the quarter and vamp to the shape of the foot,
and the bringing together of every part of the upper in
relation to the sole, the employment of an imitation of the
form of the foot, or a last, was imperative.

Last-making as a distinct Trade.—In ancient times
the foot-clothier was a tanner, currier, boot and shoemaker,
pattern-cutter, designer and last-maker. It may be here
mentioned that the models thus made were inevitably

characterized by the crudest workmanship, and that it was
not till last-making became a distinct and separate branch
of industry that any great improvement was initiated in
their mode of manufacture. Still, as we have remarked
elsewhere, there are disadvantages as well as advantages
arising from the sundering of the last-maker from the last-
user.

The Invention of Broken Lasts.—Messrs. Leclair and
Sakouski, of Paris, are credited with having made several
great improvements in the shape of lasts, and the latter
with inventing what are known in the trade as broken
lasts.

Misfits often the Result of Lasts improperly formed.
—Despite of what has been said regarding the improved
form lasts have been made to assume since their manu-
facture became a separate industry, many of the lasts
supplied to boot and shoemakers are totally unfit for use,
and the time spent in fitting them renders them dear at
any price. A man may cut and plan to perfection, but in
the event of the last being unfitted to its purpose, there is
always a chance of a misfit. There is no recognised
standard among last-makers, and they differ to such an
extent that it is practically impossible that all can be
correct.

**The Necessity of leaving them sufficiently Full at the
Joints.**—Some lasts are overloaded with stuff where
it is not wanted, others are deficient of timber where its
presence is essential, and there are yet more so ill-shaped
and radically wrong in form, that the maker might as well
attempt to fit up a bundle of firesticks. It may be safely
said that, as a rule, lasts are not left sufficiently full at the
joints and insteps.

Good and indifferent Last-makers.—Here and there a
last-maker may be found who thoroughly knows his
business; but the majority have fixed and stupid notions
regarding the form lasts should bear, from which there is
no stirring them.

The Purchase of Cheap Lasts an Act of Folly.—A good
last-maker is worth his weight in gold; to quote an old

proverb, because, like gold, he is difficult to discover. Shoe-makers are largely to blame in this matter. In too many in-stances they have been led away by cheapness and give their custom to incompetent last-makers, and moreover they have failed to decide among themselves their best form and character. Shoemakers would do well to ponder over the remarks we have ventured upon, and insist that the faults hinted at shall be corrected. Few masters are blind to the defects of the lasts usually supplied, and there is little if any excuse for their want of determination to insist upon a change.

Crippled Feet and Lasts made to fit them.—The best advice that can be given to a boot or shoe-wearer who has peculiarly or ill-formed feet, is that he should not trust to the fitting up of the ordinary lasts supplied to the maker; but go to the trifling expense of having a pair modelled to his feet. Let him take back these lasts into his own possession after each using, in order that they may be in no sense tampered with by the maker who may be induced to make them do double or treble duty. Thus provided, he will be able to point out to the maker the slight changes that may from time to time be necessary through any alteration that may take place in the form or character of his feet. Of course this in no wise does away with the necessity of the shoemaker's remeasure-ment. The fittings made from time to time to fit these changes he (the wearer) should insist on being left on the last, and the shoemaker should take great care that they do not get displaced or lost. In the event of the wearer having any peculiar notions of his own regarding the fitting of his boots, this plan will insure them being abided by.

Thin and Thick Stockings and their Influence on Fit. —It should be needless to point out to the wearer that a change in the thickness of the hose worn is often fatal to the proper fitting of a boot or shoe.

Right and Left Foot Variations.—It is seldom that two feet belonging to the same person are precisely alike; on the other hand, lasts ordinarily supplied by the last-maker

are made to resemble or conform to each other as nearly as possible. This alone should be sufficient to satisfy wearers of the genuineness of the advice given above.

Joints, Corns, Bunions, and Tender Insteps can only be satisfactorily and with certainty provided for in the way recommended.

The Tyranny Fashion exercises on Bootmakers and Boot-wearers.—It must be admitted that there is always a tendency upon the part of most bootmakers to conform to existing fashions, which may or may not be commendable. A wearer who possesses his own lasts, is preserved from the injuries that may follow this inclination of the maker; an inclination that is after all only natural on his part, inasmuch as nothing will so soon rob a master boot-maker of his custom as a confirmed belief upon the part of the great body of the public that the cut of his boots is old-fashioned.

CHAPTER VI.

FITTING UP THE LAST.

The Importance of Fitting the Last properly.—It follows as a necessary consequence that however correctly the measure of a foot may have been taken, failure is sure to result if the fitting up of the last is improperly performed.

The Last a Model of the Foot.—A perfectly fitted up last should be a fair rude counterpart of the foot of which it is supposed to be a model, and for the clothing of which it is intended to act as a guide.

The Measured and Unmeasured Portions of the Foot.—The measured portions must when fitted be exact (saving allowances that will be alluded to elsewhere) and the unmeasured portions so near that they will not affect the general result. To this end, with the view of saving as much time and labour as possible, lasts that approximate as closely as possible to the measurements should in all instances be selected.

Points to be considered in the Selection of Lasts.—In the selection particular attention should be paid to the arch of the waist. Be cautious not to choose a last with a higher arch than the foot, as, in case of this precaution being neglected, the shoe that is modelled from it, despite of every

effort to last it properly, is bound to set loose in the
quarters. In the selection and fitting up of the last, the
type or character of the foot must be carefully considered.

Diagrams of Feet.—Feet, hands, and every part and
member of the human form differ, but these differences,
however, admit of classification. For instance, in the feet

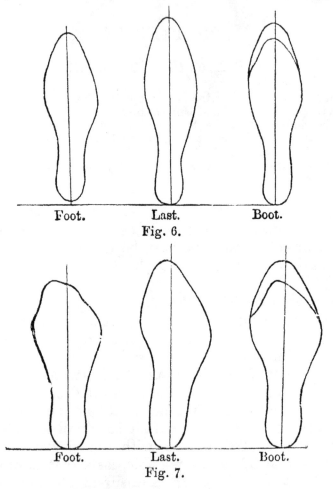

Foot.	Last.	Boot.

Fig. 6.

Foot.	Last.	Boot.

Fig. 7.

there are those that are quite flat under the instep and also
under the toes, while there are others that are hollow at these
parts. A flat bottom last should be selected for the former
and a last with a full amount of spring in it for the latter.
The pattern at the toes must be pitched to meet either of
these differences. With regard to the two feet pictured,

the first (Fig. 6) is intended to represent as nearly as possible the naturally formed foot, and the second (Fig. 7) a foot the shape of which has been changed by the wearing of ill-fitting boots. The second diagrams in line are intended to exhibit the shape of lasts that should be chosen to fit these two types of feet, and the third in line combine views of the feet and their coverings.

The vertical lines in the feet and last diagrams are intended to show the longitudinal bearing. The boot diagrams show, moreover, the proper mode of providing for the natural spread of the toes when the foot is under pressure; although the terminal points of the toes of the boots are made to assume totally different forms. The over-length of the last as compared with the foot must not be alike in all instances. That divergence is to be judged by the form and nature of the foot measured, and the material and kind of boot to be made.

Allowances for Giving and Non-giving Uppers.—When a close fit is ordered, and the upper is cut from thick and unyielding leather, or a button piece is intended, the last must be full up to measure, but from one-eighth to a quarter of an inch may be allowed if the upper is lighter and no button piece is intended. Two sizes is the minimum allowance, and that is usually given for long-quartered shoes and slippers; were a greater allowance made for foot-gear of this class, the hold upon the foot would be so slight that the shoe would be bound to slip at the heel before it had been worn any length of time. Three sizes should be allowed over for ankle boots, inasmuch as in all such boots the foot has a tendency to press forward. The thinner and straighter the foot the greater its liability to press forward, especially if the instep be low. Persons with feet of this type should be recommended to wear boots or shoes with low heels, which should be made to fit tight round the instep. High heels facilitate the forward movement of the foot, which tightness at the instep measure will prevent. A high instep materially lessens the chance of the foot forcing itself forward, and the allowance in length need not be so great in boots for

feet possessing this advantage. A foot conforming to the shape of that represented in the second diagram is, to a given extent, prevented by its departures from the straight lines at the inside and outside joints from moving forward, and does not require so great an allowance over its actual length as others. The proper allowance for women's may be safely put down at three sizes over the foot's measurement, though it would be wrong to make this a hard and fast line. Less allowance is required for a flat foot than for one that is well arched. The point of the heel of the last indicated by a star, if worn by hammering, is bound to put the measurement out if not seen to and provided for. E G will remain the

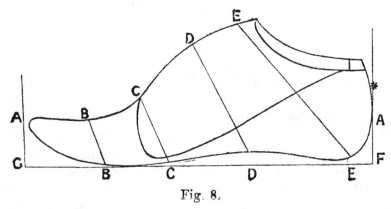

Fig. 8.

same, but the last will be perceptibly shorter. Beware of leaving too much on at the heel of the last, for nothing is more conducive to the discomfort of the wearer. Fig. 8 gives the points at which the last measurements are taken, which must conform in position to those taken from the foot, or a misfit will be sure to follow.

Treading Over and how Prevented.—A boot that is constantly worn keeps its form more or less perfectly in proportion to the perfection of its fit, or according to the correctness of the shape of the last on which it was made. The last may give such a shape to the boot as almost to compel the foot to tread over at one side. If full upon its inner side, with a general inclination that way, the boot will be so formed as to give that inclination

to the foot. But if thin and hollowed out on that side, while straight and full on the other, the tendency of the boot is all the other way. A foot which treads over of itself, is properly to be corrected by a last adapted to it on this principle, as well as by other means as may be practicable; but to attempt to force it into treading squarely by a stiff sole is to take a method which is radically wrong.

Last Diagram and Positions of Measurement.-- The length is measured from A to A, the toes from B to B, the joints over C and C, the instep over D and D, and the heel over E on instep, and E at the bottom of heel, as shown in Fig. 8. The last when done with should be numbered and entered before being stored away, due care being observed with regard to its having its joints, instep, and other fittings firmly fixed, in order that neither may be lost.

How to increase the Height of Instep.—When a man's last is not high enough on the instep, lift the block as

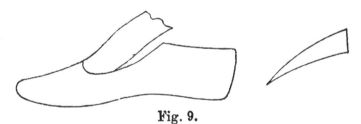

Fig. 9.

in Fig. 9, and insert beneath the wedge-shaped piece as pictured.

The woman's last differs, as will be seen in Fig. 10, and the height of the instep is raised by means of an *instep leather.* Leather insteps of all sizes and heights are sold at most leather cutters' shops. The following diagrams show the form of a woman's last and instep leather. The modern woman's last is provided with a block, as those used for men's. This does away with the necessity of using instep leathers. Still, as instep leathers are not entirely dispensed with, we have thought fit to describe the old method of raising the instep. If the heel

of the last is found too small for the measure, peg one or
more strips of leather round it equal to the difference.
If too small at the joint peg leather on top of the last
equal to difference. This leather, whether consisting of

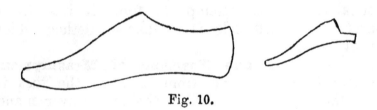

Fig. 10.

one or more pieces, should be skived away at the edges.
To increase the length of last, peg a piece of leather at
the toe, or round its heel.

In a boot that is to have a military heel the distance
between E and F must be slightly longer than in a boot
with a lower heel, the seat shorter, waist longer, and,
regulated by the height of heel, the spring from A to G
increased. For an ordinary walking boot of an 8 size
the spring from A to G should measure 1 inch, and the
back part E to F be regulated to height of heel. A man's
foot at c will usually be found to be flatter than a woman's,
which does away with the necessity of increasing the dis-
tance from E to F. The flatter foot does not change the
position of the upper, like that which ranges higher at this
point. Swellings, whether caused by bunions or otherwise,
must, of course, be properly provided for. This is effected
by fixing similar protuberances on the last. When the
joints are discovered to be wider than the instep, insert
pieces of leather previous to lasting. These must be left
loose, unpegged, in order that they may be easily with-
drawn, as if fixed it would be difficult if not impossible
to remove the last. The bed for the protruding under
part of the big toe is formed by leather fashioned for the
purpose and pegged on to the bottom of last.

Alden's Last Fitting Measures.—Alden's Last Fitting
Measures are well spoken of by those who employ them,
and are said to override many of the difficulties that occur

in this branch of the trade. From a letter written by the inventor, we give the following extract :—

"The size-stick appears very simple, as no matter the width or girth of a last, the length is the same, and a size-stick will measure any kind of last for the length, but for a perfect scale for width and girth, it is a separate measure for each fitting. As a different proportion in dividing from one size to another is necessary, a size-stick does not state in inches or parts of an inch of each size, it is simply marked, and the accompanying figures signify the length and size of that mark. My measures are made on the same principle; for instance, take any fitting measure (they are all arranged by one rule) say men's 2 fitting, the men's 8 is marked at $9\frac{1}{4}$ instep, $8\frac{5}{8}$ joints, $3\frac{1}{4}$ tread, 2 17-32 heel; this is generally acknowledged to be correct for an 8 ; then to make a child's, boy's 6 correspond, it must be $5\frac{3}{4}$ instep, 5 7-16 joints, 2 inch tread, $1\frac{5}{8}$ heel; the two-length last (almost the two extremes of the measure) is equally divided for all the other sizes, that is, from child's 6 to man's 8 they must certainly all be correct, each and every size the division to go up to 12. The women's measures are arranged by the same rule ; the woman's 5 and child's 4 are accurately marked and divided for other sizes.

" If a boot manufacturer requires to send to a last-maker for a set of lasts, say 2 fitting or 3 fitting, or in other instances 3 fitting girth and 5 fitting width of sole, by having recourse to this newly invented system the last-fitter would know exactly what to send, and so graded down in sizes as to suit the most correctly graduated patterns."

CHAPTER VII.

CHOICE AND PURCHASE OF MATERIALS.

Sole Leather. — Upper Leather. — Patent. — Cordovan. — Morocco. — Linen.—Elastics.—Machine Shoe Threads.

To dwell upon the advantages of knowing how to choose and buy, would be an unnecessary waste of both time and space. To be able to select and purchase advantageously the various materials of which boots and shoes are formed, necessitates on the part of the buyer the possession of a complete knowledge of his present and immediate future wants, and a deep insight into the nature and character of the things purchased. He who goes to market with his mind half made up, that is, undecided with regard to what he is going for, is sure to be led astray. Salesmen are selected for their capacity to force sales, that is, the power to induce or compel customers to buy not only what they do, but what they do not want, and their easiest-captured victims are those who venture to go to market without having first resolved what they are going for.

Sole Leather.—The first thing is to be able to distinguish its various kinds and qualities, and the second to know whether the prices asked are high, fair, or low. The rule for the former will be given elsewhere, the knowledge required can only be perfected by experience, while, inasmuch as the prices of leather are subject to great and continuous changes, the latter can only come from a careful study of the markets. The knowledge thus obtained will, however, avail little, if the power to gauge quality is wanting. It has been said that nothing varies in quality more than sole leather, that no two piles of it are alike, that each

separate tannage differs from others in plumpness, grain, fleshing and general get up. The true principle is to buy only leather that is merchantly dry. The cheapest leather that is bought is that which will cut most economically for the work for which it is intended. In all weights of two piles, differing in price, the highest may cut much the cheaper. Look out for damages, whether resulting from branding, cuts, neglect while in a green state, sun burn on the flesh side, water, over-sweating in piles, holds of vessels or cellars ; and if, despite these disadvantages, you decide to deal in such leather, be prepared to estimate the reduction that should attend your purchase.

Select hides that have an agreeable smell, a healthy hue, and are moderately clean. Avoid those that are coarse on the offal, and remember that unusually heavy necks are a pretty sure index to poor loins. Firmness in the flank, lightness in the neck, levelness in the shoulder, and substance in the butt are the characteristics of a good hide. In selecting shoulders for welting, see that they are neither too open nor too horny, inasmuch as it is difficult to get a firm edge from the former, and the latter is liable to break in sewing. In choosing insole or bellies, see that they are of sufficient width to provide for a man or woman's insole being cut crosswise. Careless of repetition, bear in mind that the three chief points for a purchaser to remember are, adequate rounding, judged by firmness of the edge, thinness of shoulder and good tannage. There is only one method of judging tannage that we know of, and that is by cutting through the prime of the butt. If when cut it is found to be even in colour throughout, the tannage may be safely taken to be good ; but if the cut edge is found to possess a dark or green shade in its centre it may be safely assumed that the leather has not been properly tanned, and will discredit its user.

Upper Leather.— Calf skins are usually purchased in bundles, consisting of a dozen skins, or singly. The skins forming these bundles are as nigh uniformity in weight as possible, and in selecting a bundle for a special class of work, it is customary to take one as an indicator of the

whole. We do not advise this, it is better that the pur-
chaser should run them over and satisfy himself by in-
spection. Waxed calf if good will be found to feel mellow,
supple, and plump, and when slightly pulled by the hand,
it will be firm, giving slightly when greater force is applied.
It should have a good grain, and the flesh side be firm and
flexible, soft and silky, and although there be plenty of
dubbin in it, it should admit of handling without trans-
mitting it. If folded and creased, little of crease or fold
mark should be visible. The skins selected should be well
rounded and flayed, and these important facts should be
kept in view that a beast in feeding always commences to
lay on fat at the rump and flank, and that it may safely be
taken, as a rule of guidance, if a skin is plump at the rump
and along the back the same quality will pervade the
whole, and that the reverse holds good in all skins of in-
ferior quality.

Calf skins should be very closely and critically examined.
Every user is desirous that the skins he selects shall be
well finished; but a high finish is oftentimes the result
of an excessive employment of vitriol in the earlier stages
of manufacture, which is known to render the leather
exceedingly liable to crack or break with a limited amount
of wear, while the gum and blacking are known to be
at least occasionally employed to smother up defects. It
needs a lynx eye to see, through the dressing, the defects
in a skin.

Patent.—In selecting patent leather see that it is close
in the grain, pliable though firm, has no stretch in it, and
that the patent bends with the grain, in other words, is not
brittle.

Cordovan.—Choose that which has a fine clear surface,
close grain, handles firm, but is not too rigid; the small
close wrinkled ridges on the black sides when the hand is
passed over should feel smooth and silky. It should be
equal in colour, when folded exhibit no ridges, and be free
from veins and flaws.

Morocco.—In the slipper trade morocco leather is
largely employed. The name arose from its being pre-

pared primarily by the Arabs in Morocco. The best moroccos are now manufactured in Paris. They are prepared in a vast variety of colours. Some of those, obtained by the employment of blue vitriol and other injurious chemicals, should be avoided. Blue moroccos should only be selected when specially ordered.

Linen.—In selecting linen and other woven fabrics for linings, care should be taken to avoid those that have been what is technically called "loaded." The practice of sizing was originally introduced with the view of giving a face or taking appearance to the material, but, as time advanced, it was discovered that it might be advantageously employed to increase the substance and profit derived from the sale of the material. As explained elsewhere, the dressing has a tendency to diminish rather than increase the strength of the fabric. Whether the dressing be composed of mineral or vegetable matter, it is certain, sooner or later, under climatic influence and damp, to lose its consistency. Whenever this occurs, its damaging influence may be easily detected. The character of the texture must also be taken as a test. Avoid purchasing that which is loose and open.

Elastics.—Stocking-net and honey-comb elastics are dearer than Terry, and are usually reserved for the better class of boots and shoes. Of the three named the last is the strongest, but it has the disadvantage of taking up and retaining dust, fluff, &c., and is not to be compared with stocking-net and honeycomb in appearance. Stocking-net should possess a soft silky look and brilliancy of colour. Before purchasing, its elasticity should be tested. If on being stretched and let free, it should be found to move sluggishly back into its normal condition, it should without hesitation be rejected. In selecting Terry see that it is closely woven, of a perfectly jet colour, and has a full amount of elasticity or spring in it. Great care should be exercised to keep all kinds of elastic free from air and damp, as both are known to exercise an injurious influence over their colour and elastic properties. Examine the india-rubber threads, and remember that the durability of the

web is proportioned to their stoutness. If at all in doubt about the condition of the elastic offered, stretch it to its utmost tension, and by smelling you will be able to satisfy yourself whether decomposition has or has not affected it. Heavily dyed webs should in all instances be thrown aside. The object of dyeing webs so heavily is to increase their weight. Inasmuch as the dye does not add to the strength of the web, a superfluity is bound to be injurious. To tell the truth, the excessive use of dye on elastics, like that of size on calicoes, is employed for no other purpose than to cheat its purchasers. While directing the attention of readers to elastics, we avail ourselves of the opportunity of impressing upon them the necessity of keeping all articles containing rubber away from oleaginous matters. India rubber is sure to go bad if it is touched with oil or grease. It is partly for this reason that in properly conducted establishments such great care is taken in the storage of elastics.

Machine Shoe Threads.—In the test to which machine threads are subjected in the testing machines, the record gives only the pulling or sustaining capacity. In the use of thread other considerations come into notice, the measure of strength and durability. To illustrate:

Thread is rated by the testing machine as follows:—

4-cord	3	will lift 37	pounds.
5	3	45	,,
6	3	55	,,
7	3	65	,,
5	10	70	,,

This is the highest test known to the trade. The above figures would seem to indicate that 5-cord 10 had a decided advantage over 7-cord 3; but as the 7-cord 3 can be run with a smaller needle than 5-cord 10, more stitches to an inch can be taken, and in working we find that a needle sufficiently large to run 7-cord 3 will consume in 9 stitches as much thread as the larger needle required for 5-cord 10 does in 8 stitches. Barbour's hand thread is spun through a patent evener, thus saving time and needles,

a most important consideration to the operator and also to the manufacturer.

In waxing 7-cord 3 has a more decided gain, in this, that in the circumference of the thread there are 7 openings for wax, against 5 in the 5-cord 10, which enables a more complete interior waxing, adds to the strength of the thread, and also makes it more adhesive to the leather, as the nearer the thread comes to filling the hole the better the work.

The chief points to be sought after are smoothness, evenness, and freedom from knots, even though these may be under the surface.

CHAPTER VIII.

CUTTING OUT,

Economical Adjustment of Patterns.—Lining Cutting, &c.—Trimming Cutting, &c.—Clicking, &c.—Allowances.—Cutting and Fitting up of Bottom Stuff, &c.

Economical Adjustment of Patterns.—All that we can hope to do with the space at our command is to give our readers a broad theoretical view of the art of cutting out. As many pages as this volume contains, and one hundred diagrams to boot, would not suffice for a full and detailed explanation of the cutter's art. Still it is hoped, by careful condensation and a judicious selection of pregnant examples, to enable the reader to grasp its leading canons, or, in other words, to place in his possession the key to the art of cutting. By the aid of a few well-devised diagrams, we are in the hopes of being able to dispense with long and wordy explanations. These diagrams, while failing to portray the endless varieties of facings, &c., will fully illustrate the method or methods adopted to insure economy by preventing waste. Take, for instance, that in which the mode of cutting side springs is shown, or that of cutting vamps, and the entire principle that governs the art, so far as economy is concerned, has been revealed. No matter the shape or the nature or purpose of the part required, the principle of economical adjustment or placing does not materially vary—it consists in covering or using up as much of the material as possible, with strict regard to fitness or adaptability. In bespoke cutting, where big

prices are asked for and obtained, economic cutting becomes a matter of secondary importance. In that department of the trade, fitness and excellence are the chief things to be considered. Taking a skin, the bespoke clicker critically scans it, not to resolve how he is to make the most out of it, but to learn whether it is of sufficient excellence for his purposes, and if so, he proceeds to cut his parts after a fashion that the manufacturer would stand aghast at. The foregoing remark is intended to refer to the best bespoke work only.

Lining Cutting, &c.—In the bespoke trade the linings for a pair of boots are cut at a single operation, the material being laid four thick on the board. In factories eight folds or two pairs are usually cut at a single operation. If the material is alike on both sides, it matters not how it is laid on the board; but otherwise, it must be folded so that the linings when cut and placed will have the best side to the feet of the wearer. Zinc patterns are undoubtedly the best; but they have the disadvantage of being costly compared with those cut from cardboard and paper. No matter of what they are fashioned, they should be carefully examined by the cutter before he attempts to use them. In some shops, the parts left for turning in are left on the patterns, with holes at proper distances from the edges for pricking the turn in; in other establishments the pattern is cut exact to the fitting, and the cutter has to prick close to the edge. Experience has decided that there is only one way of cutting linings economically, and that is to work to a uniform system, or to range them in as direct a line as possible. To do away with the necessity of repetition, it is as well to inform readers that the same rule holds good with reference to the cutting of almost every part of a boot or shoe, and that even in leather, when flaws and other damages occur continually, it has been proved to be more economical to proceed as though they had no existence rather than to get out of range, in order to avoid them. The stuff used for linings being uniform throughout, there is not the shadow of an excuse for making any such departure. See that the material is laid perfectly

E

smooth on the board, to which it must be made firm by using a weight or otherwise. The most economical prin-

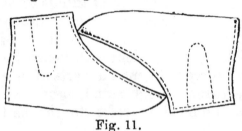

Fig. 11.

ciple is shown in the accompanying diagram (Fig. 11).

The dotted lines show the turning in. The allowance made is equal to a size. Cut and prick true to the pattern, as nothing produces more discomfort than a ruffled lining, which is almost sure to follow a want of accuracy in this respect. Remember that the strength of the material is in its length, and cut so that this will come across the foot. Linings are chiefly adopted to strengthen the uppers; hence it is not customary to employ them in men's work, if the leather is known to be sound and good. When linings are used for men's work, they are usually cut from a thicker and coarser material. Linings in large

Fig. 12. Fig. 13.

and well furnished establishments are now cut by machinery by the aid of steel knives fashioned to the patterns. In

some of the large establishments they are occasionally cut
by a band saw.

Economical modes of placing patterns for vamp linings
are shown in Figs. 12 and 13.

Fig. 14 represents a counter lining for a Kip Lace,
Hobnail, or Shooting-Boot. The attachment of the back-
strap, as shown, causes the pattern to cut extravagantly;
and, for economy's sake, it is usual to cut the strap
separately and join it to the top of the counter. When
cut short and joined at the side of the heel, a cheaper
material may be employed for side lining. This method
will also insure the lining to lie flat across the side seam.
As the closer, if this advice be followed, will not lay the
side lining over the counter, the seam will, of a necessity,
be a substance thinner at that point, and not so liable to
discomfort the foot of the wearer. The diagrams that

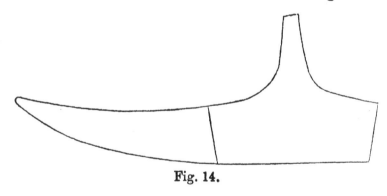

Fig. 14.

we have given and intend to give will be found sufficient
to suggest the principle of interlocking employed to
prevent waste of material.

Fig. 15 illustrates how the stiffeners and side linings
are placed.

Trimming Cutting, &c., including springs, bindings,
beadings, button-pieces, facings, indeed all the small
pieces necessary for their completion. For particulars
regarding webbing, refer to "Choice and Purchase of
Materials." Springs may be cut without waste by placing
the patterns as shown in Fig. 16. Select your webbing of
the required width. If both sides are alike, it matters not

how you place it on the board; if it has one side more
finished or in better order
than the other, it must be so
placed and cut as to show the
best side outwards when the
springs are positioned in the
boots or shoes. For bespoke
work it is usual to cut a
pair at a time; when cut for
wholesale work the folds are
increased. The patterns for

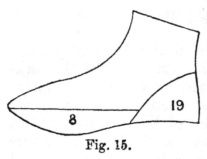

Fig. 15.

the springs of large size boots should have a good quarter
of an inch left on at sides and bottom. Springs are cut
to various shapes; but except
when chosen for ornamental
purposes, over and above their
practical uses, the patterns
given afford an excellent idea
of the economic value of the
methods generally employed.
Be careful to fix the elastic
to the board before proceeding
to place your pattern and to
cut, and see that the cutting
tool used is well sharpened
and straight. In cutting bind-
ings and straight-edged pieces
a gauge, an instrument speci-
ally sold for the purpose, or
straight-edge should be em-
ployed. The leather used for
binding should be of a light
substance, and not liable to
stretch. Men's facings are
cut from calf or kip offal.
Coloured leathers and patent
are also occasionally employed.

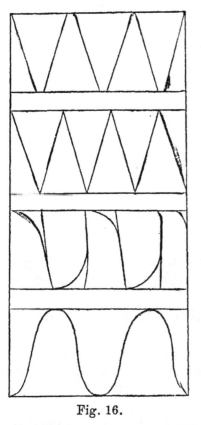

Fig. 16.

For women's and light men's, leathers of very light
substance are used. These so often change, and moreover,

present such an endless variety of shapes, that to attempt to give instructions for placing the patterns would be a mere waste of time. The chief thing to be aimed at in cutting the smaller parts should be to use up pieces that are valueless for larger sections. The leather for button-pieces should be carefully chosen, of good colour and without flaw or blemish. Fold the leather and cut a pair at a time. If cut singly, the pattern must be reversed. The outside quarter and inside and outside button-pieces must not when placed together be too thick, or a great difficulty in buttoning will result. To insure the proper substance, have one or, if necessary, both button-pieces light. The strength of the button-piece should be in its width, as it is on the width, not the length, that the strain falls. It is almost unnecessary to say that the best side of the leather of both inside and outside button-pieces must show outwards, that is, away from the quarter. When cut from leather, the inner edge should have from one-eighth to a quarter left on for seams, and the same allowance must be made at the bottom to permit of its extending under the vamp or toe-cap, or for turning in at seam when vamp and quarter have an inside seam. When both button-pieces are cut from leather, no allowance at the edges is required, inasmuch as they are machined and cut level afterwards. The button-piece should not extend over more than a third of the quarter at the top, and it may be finally noticed that the appearance of the boot is dependent upon the button-piece being neither too large nor too small when in position. When the button-piece is scolloped, a gouge is used by the cutter. Bellows tongues are exceptional, and we have transferred all that need be said of them under the heading "Special Operations," which see. Seat pieces for common work may be cut from almost any scraps of leather; these should be nicked at the curves in order that they shall bed in properly. Tongues, inside and outside back straps, counters, side linings, and stiffeners, need no special instruction. We may mention, however, that it is usual to skive inside and outside back straps at the side and also at the top on

the rough side; that inside counters varying in shape, are cut thick or thin for each separate pair's requirement,

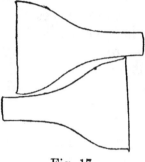

and skived at top and sides on the rough side, the bottom being left stout.

The following (Fig. 17) shows how back straps are cut with little waste. Outside counters (Fig. 18) are cut from the same leather as the upper and skived at sides and tops. When the back part reaches the bottom of the heel and has outside counters, inside counters are

Fig. 17.

dispensed with. For economy sake, the stiffeners of inferior goods are cut from stout paper. In the chapter devoted to closing enough will be found said respecting

Fig. 18

leather linings, placings, skivings, &c. These linings are generally cut from the roundings or offal parts of skins or from skins of little worth, and, like those cut from woven materials, must have sufficient left on for turning in.

Clicking, &c.—Cutting out in bespoke shops is usually performed by one person, the clicker, while in large factories the kind of work referred to under the separate headings of Lining Cutting, Trimming Cutting, &c., is entrusted to distinct workmen. The clicker in large factories has to deal with the outside parts of boots and shoes. Inasmuch as in this department it is far easier to instruct by diagrams than words, we have marked up the following skins, which, with the smaller diagrams, will, we trust, prove ample to effect the object in view. These skins are marked up as though they were entirely

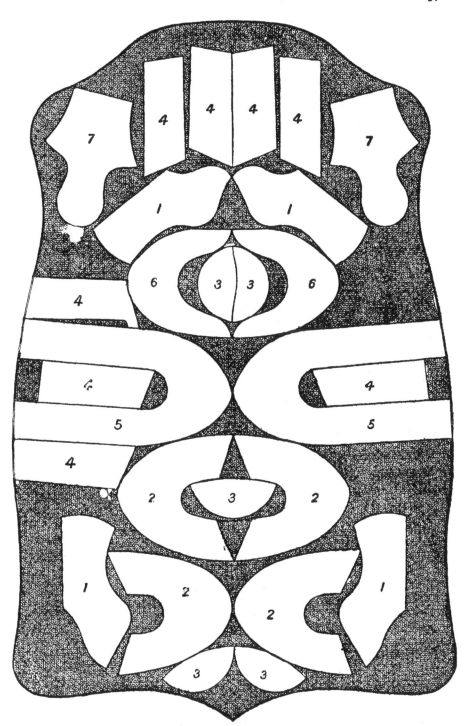

Fig. 19.

free from flaws. It must be admitted that such skins are few and far between; but, as it is seldom that the flaws and damages in skins are found located alike, the advisability of the course pursued will, we trust, be admitted. As may readily be imagined, exception is sure to be taken to one or more of the examples here shown. But to use an old proverb, who is to decide when experts disagree? We admit the existence of other systems, and moreover that much may be said in their favour; but give what we conceive to be the best. Some will declare that, had the plates been less crowded they would have been more readily understood; but this course would have necessitated increasing their number. Fig. 19 is devoted to exhibiting the mode adopted for clicking bespoke work. As will be seen, not a single part of importance, if indeed any, is cut across the centre or pithy part that covered the vertebræ of the animal; the pairing parts are obtained from corresponding positions; the stretch of all the chief parts are identical, and their positioning is regulated by the diversified qualities of the leather of which the skin is composed.

The numbers and names of the separate parts that follow have reference to the whole of the plates. For instance, an Oxford Shoe Quarter is numbered 1 whether it appears in one or more diagrams, and the same with the remaining numbers and parts.

1. Oxford Shoe Quarter.
2. Golosh Pieced Vamp.
3. Toe-cap.
4. Golosh Quarter.
5. Whole Golosh.
6. Oxford Shoe Vamp.
7. Half Bellows Tongue.
8. Side Lining.
9. Single Tongue.
10. Inside Facing.
11. Lace or Button Leg.
12. Button Fly.
13. Elastic Side, Back.
14. Elastic Side, Front.
15. Ladies' Vamp.
16. Ladies' Polish Leg.
17. Ladies' Elastic Side, Back-quarter
18. Ladies' Elastic Side Front.

Fig. 20 is marked up for men's. In this the backbone has been slightly run over ; but, as will be observed, the pithy part where cut into is made to fall in spots that will work no material injury. The patterns fall the long way of the skin. The parts unoccupied may be used for any purpose for which the leather there found is suitable.

Fig 21 represents a calf kid skin marked up for women's or men's. It is commended on economical grounds.

Fig. 22 represents a kid skin marked up for Ladies' elastic side boots.

The importance of placing patterns in accord with the structure of the skin in order to obtain strength in the boot or shoe where it is wanted, has been over and over again enforced in this treatise. Fig. 23 shows at a glance the direction the muscular tissues take, and will prove a useful helpmate to the clicker. It also shows the division of the skin. In the pithy part of the back there is an absence of tissue, and also of strength, and hence the necessity of avoiding cutting into it for vamps, &c. In the breast and belly the muscular texture is less firm, and hence its flabbiness. It is full and thick at the neck, and this produces coarseness. It often occurs that the skin at the neck is thicker than at other parts. Balmoral quarters or backs that are not necessarily much bent when worn can be cut therefrom, or counters, tongues, side linings, if not equal to the former.

It will be seen that it is at the ribs or middle of the skin that the texture is at its best, which accounts for that part being chosen for fronts. The plate, moreover, shows conclusively the disadvantage of cutting pairing parts from positions that have no affinity—in other words, that stretch in different directions. The hip, marked with a circle, is a known weak point and must be missed in cutting. It is only a half skin that is shown, but as the muscles, &c., run in pairs, it answers all purposes for which it is intended.

Fig. 24 shows a method of cutting straight-peaked toe-caps without waste. Patent calf and seal-skins are not always cut alike, but we see no valid reason for

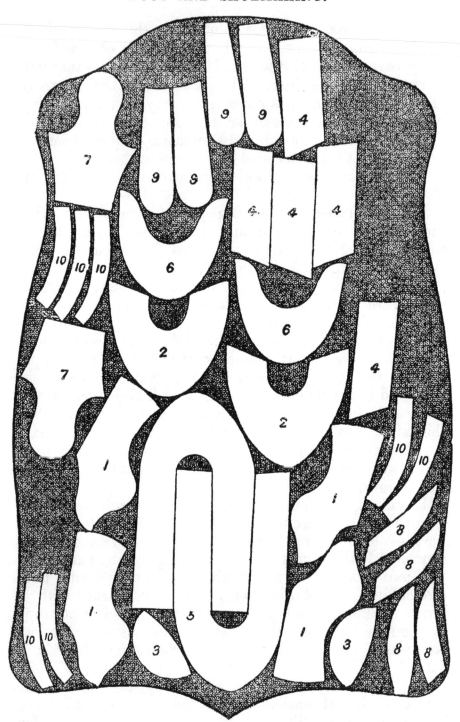

Fig. 20.

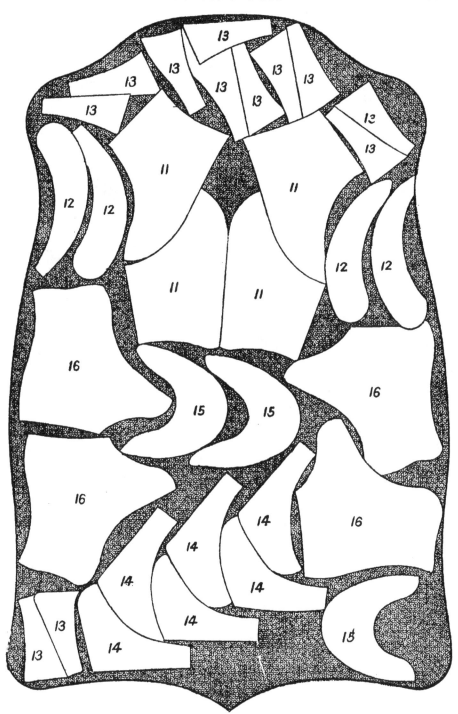

Fig. 21.

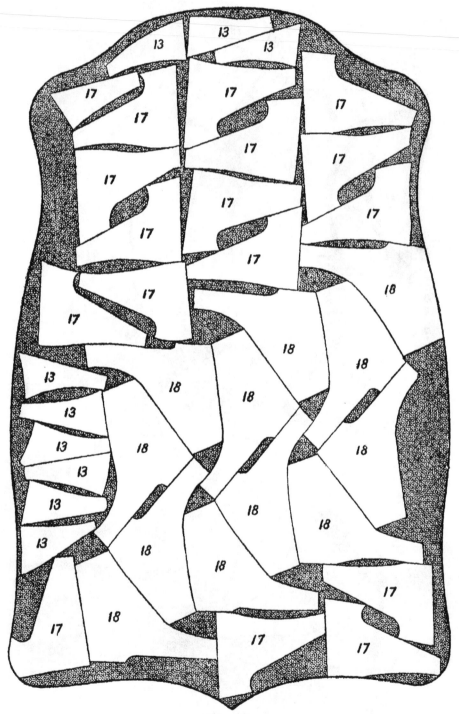

Fig. 22.

the difference. The most economical way is undoubtedly
to run the patterns from the tail to the neck, and that

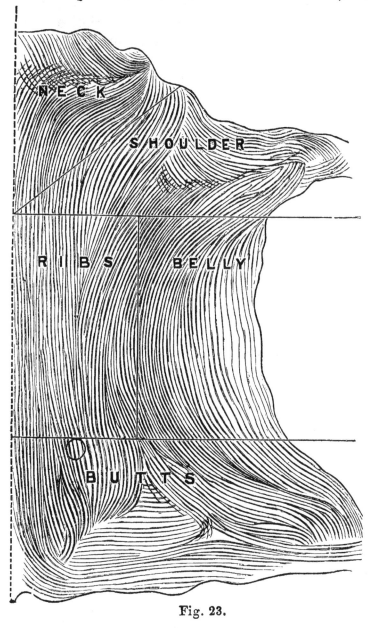

Fig. 23.

plan is generally pursued in wholesale work. For
best work, as already stated, vamps, wing, and toe-cap

patterns are placed on patent seal-skins so that the grain
runs across them. We repeat that in order to cut patent
clean it must be cut from the brown side. We have only
given a few samples of the hundreds of varieties of boots
and shoes, but the parts of others, however much they may
vary, being cut in corresponding positions, those given will
suffice. In conclusion, we may remark that it is customary
with many of the best bespoke shops to deal with the best
portions of skins only ; the remainder being sold to others
who are not so particular with regard to the quality.

Fig. 24.

Allowances.—For hand-sewn work it was formerly the
custom to cut the pattern half an inch larger than the last
in order to allow for the over-lapping of the feather of
the insole and the " take-up " of the seam. At the period
to which we are referring, this allowance was correct ;
but the leather employed for uppers in those days was less
supple and elastic than now. For upper leathers, as now
dressed, three-eighths allowance will be found ample. If
the last-named amount be left on, the stretch should be
fairly pulled out, or it will be found that the boots, how-
ever well they may fit when first worn, will become loose
after they have been worn. To prevent complication,
rivet and machine-sewn uppers may be cut from the same
patterns. Five-eighths larger will be found sufficient if
the leather used be light and flexible ; but if cut from
kip or stubborn leather the upper should be cut fully
three-quarters of an inch larger than the last.

Cutting and fitting up of bottom stuff, &c.—If for be-
spoke work, consult the order book, and if there are any
special instructions to be given, write them and the number
of the uppers out legibly and give them to the maker. See
that the soles, sole-pieces, &c., are of the right substance

and size, and that the condition in which all the parts are handed over to the maker will incur no unnecessary hindrance to his efforts. Remember he is only paid for making, and that he has a right to be furnished with stuff fitted and properly conditioned for the work he has to perform. For instructions in purchasing butts, see "Choice of Material." It is a bad system to delay the cutting of rough stuff to proper sizes till the moment of requirement

Fig. 25.

for use. A store of bottom stuff so cut should be always kept on hand, all of which should be properly numbered and assorted. Under the heading "Machinery, &c.," will be found all that need be said regarding the cutting of bottom stuff by mechanical aid. The mode of fitting, &c., is also treated of under the head of Making. The diagram here given (Fig. 25) will show how soles may be cut for bespoke work without waste.

CHAPTER IX.

FITTING AND CLOSING.

The Light Wellington.—How to Cut and Draft a Wellington.—The Stout Wellington.—The Butcher Boot.—The Top Boot.—Remarks on Long Work.—Short Work.—The Spring Boot.—The Button Boot.—The Balmoral.—The Oxonian or Oxford Shoe.—Toe-cap.

The Light Wellington.—The first thing to be done is to fit the side linings. This is done on the board which is held on the knees of the worker. They are then cut and skived to the proper form, with the necessary thinness at the edges. The front is next taken, and if it be found brittle or harsh in the grain, it must be rubbed and softened in order to render it more workable. With a blunt knife the dirt is scraped off the grain or the vamp side, and the linings pasted on. If the front be lighter than the back, or both front and back be remarkable for their lightness, strips of roan or other light leather will have to be pasted from the joint of the linings along the inside edges of the front and back, if the back be light. The latter must run from just below the counter up to the top lining. The counter can be placed either before or after the slips. In selecting a counter for a Wellington, it is advisable to choose one that will not necessitate the use of a stiffener. If this advice be attended to, it will be found that the maker will produce better joints than would be otherwise possible. If the counter be light, a stiffener will have to be used. This is inserted between the counter and the back. Great care must be taken in fitting this portion of the work, inasmuch as if it be done slovenly, such slovenliness will result in giving considerable trouble to

the maker, and render the proper seating of the heel impossible. The counter is sometimes cut off at the side edges of the back; but the modern and best method, though less speedily accomplished, is to skive thin and let it run over to the front, where it is held by a row or rows of stabbing. This latter method is commended for the support it gives to the boot at this much-tried part. The legs are next to be fitted, when the paste having dried the front is lined. The side linings are whipped or hemmed on with either awl or needle. When this is done no thread marks should be left on the outside. The hemming should not proceed below the joints of the foot, as a single stitch fractured will often cause a break in the vamp. The awl used should have no material thickness behind its point, no keenness at the side, and should be slightly hooked. The counter is now stitched on. When the counter is stabbed across the two back counter rows may be stitched to hold the counter and stiffening. A pricker is used to mark the holes in order to ensure regularity in the stitching. The pricker is used for straight work and the wheel for golosh or fancy work. Before using either pricker or wheel, see that the teeth are smooth, and if not, make them so by the application of a file or glasspaper. Too much care cannot be exercised while using the pricker, as if struck too hard or unevenly it will seriously injure the upper. The side seams are now closed. For this purpose a flax thread is used, the thickness of which must be regulated to the substance of the leather. The back is first placed in the clams, grain-side outwards and top facing the closer. The front is held the same on left side. The small strip of leather that forms the welt is then placed between the front and back, and the whole being placed in the clams, the sides are closed up. The closer's block is then inserted and the seam, slightly wetted, is rubbed smoothly down with the long stick. The top lining is then cut to the size of the leg, and whipped on front and back. In closing the sides, great care must be taken to keep the stitches regularly formed at an equal distance from the

F

edges. In opposition to Devlin, we believe that it is quite possible to put in too many stitches in closing the sides, inasmuch as overcrowding has a tendency to weaken the upper. The leg being now closed, the boot is turned. When this is done, the block is again inserted and the seam made flat. The welt-cutter is now used to take the surplus of the welt away, and the welt-setter applied to set the welt up. Great care must be taken in using the welt-cutter, or the upper may suffer considerable damage, or indeed be utterly ruined. Insert straps after cutting a slit in top lining, put the boot on the tree, and let it remain till dry, when the top and straps must be stabbed, and the leg is finished saving the setting up of the welt, a solution of gum arabic and ink or water being used in this operation.

How to Cut and Draft a Wellington.—As a rule the form and cut of the majority of boots and shoes undergo considerable variations. No such change has characterized the history of the Wellington. As it was cut at the time of its introduction, so it is cut now, or at least with but trifling modification. Cut the back at the bottom of counter as shown in Fig. 26. This cut, as will be seen, slopes upward from the bottom of draft to the bottom of back of counter to the extent of a quarter of an inch. Next place the front and back together in the same position they would occupy if closed, the front overlying the back. Measure the calf, and pierce with awl through front and back while in that position, at the centre of measure as shown by dot. This done, measure the shin (which should be equal to heel measure), as shown by dotted lines marked on figure, and pierce through centre at dot. Then proceed to cut the front of leg, using the straight-edge as a guide, and see that the knife passes through the awl marks (shown by dots), at calf and shin, after which cut the back in like manner. Cut the corner off the front at A as shown in figure at the bottom of side seam, *half the measure of instep.* Place the front and back together, and mark the side half the depth of instep for the top of draft as shown by dot. Overlap and measure at the top of counter, three quarters

of an inch less than heel measure. Pierce at centre of dotted line. Measure from the throat to a quarter of an inch from the bottom of the counter, as shown by dotted line marked for "full heel measure," and pierce at half distance in centre of draft. Take the back and cut from the mark made for top draft in a semi-oval fashion to the bottom of

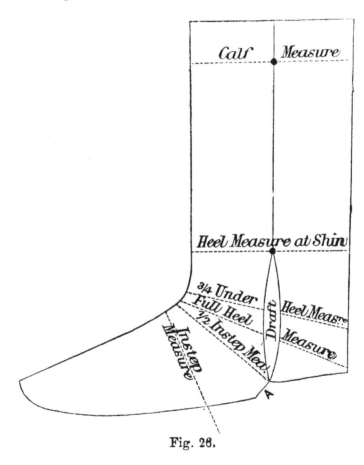

Fig. 26.

counter. Cut the draft in front in a similar manner, using the back as a guide. Place front and back together, and, guided by the last placed on them, cut away the surplus leather round bottom of front, leaving half an inch to be sewn away. Finish by cutting top lining, side lining, and shaping the counter to the back.

The Stout Wellington.—In fitting and closing a stout

Wellington, the edges of the back and front must be grooved. This is done by a tool known as the closer's plough. When this is carefully done, the stitch will be as close as in a leg of a lighter description. In all other respects, the process is the same as already described.

The Butcher Boot.—This boot is usually cut about an inch higher than the Wellington, and square at the top. It has only one seam, and that is at the back. It has a tongue that can be either stabbed on or closed inside. In cutting and fitting the tongue, the first operation is to mark out its contour with the dull knife, and cut it. It is then laid on the leg, scored round, and the piece so scored removed. The tongue is then let in, tacked to keep it in position and closed. In this boot the counter is pasted and stabbed on outside, great care being used to make the corner of the counter and tongue to meet. The side rows are stabbed as in a Wellington, so as to hold the stiffener, which must be cut to reach from seam to seam. The top lining is whipped on the leg, as in a Wellington. The back and front loop used in this boot are extra to the pulling on straps, and are used to affix the boots to the breeches. These are cut narrow, half an inch wide, let into the top lining, and stabbed across, one row being sufficient.

The Top Boot.—With regard to the closing of this boot, it has been very properly observed that a mere knowledge of closing in itself is not sufficient for its proper accomplishment. The fitting must be carefully and skilfully done, and some knowledge of the clicker's art is indispensable to this end. The vamp, counter, and leg must be well kept in position, and the tongue should fall into its place with the greatest nicety. If the clicker has failed to do his work properly, the closer should be in a position to remedy all faults, whether in the cutting, range, position, or back catch of the counter. A closer void of the knowledge requisite to amend the clicker's faults is liable at any moment to spoil the best cutting. Various kinds of holds have been adopted by closers, which we will proceed to describe. First, there is the flat hold, now obsolete, in which the point of the awl

is brought out on the top on the extreme black of the leather on the near or awl side, when the awl point enters again at the same place, on the off or left-hand side, the breadth of the seam being kept in accord with the proper bearing of both portions of the leather. If the awl is not kept at an equal distance from the edge, the seam will be uneven, and the edge-setter will fail to set it properly. 2. Split-closing. In this the awl is struck partially through the leather on both sides, when, on the stitch being pulled in, the seam will be found to rise up full and round. This is used for closing the side seams, that is the two short seams where the vamp and counter join. 3. The general hold, a sort of medium hold between the two former. This is now called edge-closing. In the case of one side being thicker than the other, it should, after the stitches are placed, be pared to match. This forms an excellent seam, being flat and solid. To effect it, the leather is laid on the block, where it is held firm by the pressure of the stirrup. After one side seam is closed paste the quarter to the leg, dropping the edge of it into a slight hollow which has been cut for its reception, while cutting the leg. This cut in light legs must be slight, and in very light ones dispensed with entirely. When the two side seams are closed first, the two back sides of the leg are fitted within the counter and whipped together with a firm end, and then the vamp and counter are drawn over the bottom of the leg and pasted down on both sides into the channel. The further closing is then proceeded with, commencing at the turn of the back strap and going right round, along the range and up the tongue, where, at the top, the one thread will be finished, when a fresh thread will have to be put in to close down the other side. The above is called closing the tongue. When the tongue is finished the counter should be partly turned back and the two side linings put on. These are first joined to the loose under portions of the leg and then whipped on. The turned portion of leg is replaced to its proper form, and the counter-stiffener pasted in. This should extend over both side seams, and be skived at each end as in the Wel-

lington. The substances covering the heel are then care-
fully tightened together, the rows marked for stabbing,
the counter stabbed, and the tongue is then ready for the
maker. On the boot being returned to the closer for com-
pletion, the back strap is skived to the necessary substance
and fitted, care being taken that the edges are pared quite
level. The block must be then put between the loose sides
of the leg, and these held over the block and whipped
together over and over with a split hold. A single fine
wax thread is used for this purpose, and the operation is
called whipping up. Then the back strap is to be pasted
directly along the centre of this seam, after which it must
be moulded and cleared off by the knife. When the
paste is dry, it is closed, the thread entering at the turn
where the closing of the tongue left off, the same kind
of stitch being used. One thread will suffice to close
one side of it. In closing the back strap, some put
the awl point in first on the leg at the top right-hand
side, others at the off side on the back strap, or by
reversing the boot on the knee, place the awl in, on
both sides on the back strap. It matters little which plan
is followed. In closing the tongue, it is advisable to put
the awl first in on the vamp. The celebrated shamrock
tongue, now in our possession, shows that the process here
recommended was adopted. This tongue was closed by
James Dacres Devlin, and took its name from a shamrock
on the counter, in the working of which a hair from his
daughter's head was used as a substitute for a bristle. The
webbing straps are now put on (see former boots) and the
front button loop. These are either whipped on or stabbed
by a single end, so that the stitch appears as a lining stitch
It is best to paste these straps on before the leg is whipped
up behind, the stabbing being thus more easily effected.
The leg and straps are held in the clams between the
knees, the stitching proceeding in and out along the edge
of the webbing. So fixed, the straps have more resisting
power, and look neater than when whipped on. The next
thing to be done is the top. The whole of its sides and
edges must be clean and equally cut, when it must be laid

grain side face to the board, which must be perfectly free from aught that would stain the leather. Mark off the distance or depth of the fold, that is the portion which is to be turned to the inner side of the boot when the leg and top are joined. Pass the top groove along this line, so as to strike out a portion of the flesh side of the leather, so that the bend or fold shall be reduced to the necessary substance. Tops are as a rule closed on the inside with a welt, without turning. The old method of closing them inside on the block and turning, and that of closing them in order to shield them from injury from turning on the outside, are now seldom practised. Skive the edges, so as to prepare for closing with the welt, or by the square cutting groove tool take a bit out, leaving room behind the stitch for the seam to be buried in when rubbed down. The welt that is closed in with the top is cut from a piece of the top leather or from calf leather, if the grain be of sufficiently fair colour, the grain being split off with a keen knife. Double it and paste it together, and, when dry, run the compass round its folded edge at about one-sixteenth of an inch distance, varying to substance of top. When cut through at the mark, the folding part will form the welt. In closing the top without turning, the grain side of the top is held from the closer, and the fold bent backward, grain to grain. The two loose ends are drawn in an angular position inwards, the edges being brought together, grain to grain, and the leather at the fold pressed as tightly as possible. Place the top in the clams, so that they will nip it along the fold, the welt being inserted between the two parts to be stitched, and proceed as in the Wellington. The thread should be tightly made, delicately waxed, and particularly smooth. Let the welt be taken into the stitch with great regularity, or it will look ugly, as it is not usual to use a welt runner. After the top is closed to within half an inch of the turn, cut the thread, damp the seam slightly, press it out by aid of the fingers, and turn the fold up from its bend, when it will be found, if properly and efficiently done, to wear a presentable appearance. Rub down and set the seam, whip together the

opening at the fold part, and paste in the paper employed to stiffen and prevent the oil from the leg penetrating to and soiling the top. The paper alone must be pasted, and this should be smoothly and equally done all over. Paper and leave to dry, fit, skive, fold and cut flash straps and back loops, set the boot with setter slightly heated, a solution of gum arabic or glue paste being used in the setting. The seam setter should be perfectly smooth, and each separate stitch and seam should present a clear and perfect form. The stabbing rows on the counter must be set also with equal care. Whip on the top and stab on the straps. To whip the tops on draw the top over the calf of the leg, and fasten at back and middle. The stitch in whipping is taken over and over, with a single twist or coloured silk end. Turn in the fold, beat slightly round on block with hammer. Paste on back loop, let it dry, and stab. The back loop is stabbed with a clear thread of un-waxed white silk, the stitching proceeding from the corner of the square, catching the back loop up as you proceed, and ending at the opposite corner. This is then skived off to the edge at bottom and fastened there with a slight touch of paste. When pierced through with the stabbing awl, the thread catches it and combines both loops together, one out and the other inside. The side rows stabbing is then proceeded with, the inside row taking no leather strap and the outside the flash strap, which falls over the fold at the centre of the outward half at top. The boot is now ready for shop.

Remarks on Long Work.—Inasmuch as the Military and Napoleon have been superseded by the Butcher boot, and the Hessian and Holderness and Opera boots are now seldom if ever worn, we will here end our remarks on the closing of long work. The same may be said of medium boots, the Prince George and Clarence.

Long work hand-closing held its own for a considerable time after the introduction of the machine; but within the past few years machines especially adapted for long work have been constructed, and all boots of this order made for sale work and a very considerable quantity of that made to

order for even our best bespoke shops, are now machine closed. The fitting for machine closing does not differ materially from that of hand-closing; indeed an old and experienced closer is the person generally sought after to fit for the machine.

Short Work is now almost entirely fitted and closed by machine; still as, when best done, it nearest resembles hand-closing, it is perhaps better to describe the original rather than the copy. A description of the machines used in fitting and closing will be found in another and later section of this treatise.

The Spring Boot.—The lining is first cut and fitted to the last. The opening for the insertion of the spring is then marked off with the dull knife and removed, saving a full quarter of an inch all round for turning in. The back bits and front bits are then placed on the linings about an eighth of an inch from the edge of the lining, back and front, and the springs inserted between lining and outside pieces. When dry stab round the springs, and then turn the front bits back and close the front seam. If the heel seam is to have a back strap, it must be whipped up to within three or four stitches from the top. The back strap must be left over a quarter of an inch at bottom, which will be covered by the golosh. In case of no back strap being intended, the heel seam must be closed before stabbing the spring. Paste in between the linings the front and back straps, and when dry stab up the back strap so as to catch the loop and the inner strengthener, and then stab the front loop across. The leg is then ready to be put on the last for the reception of the golosh. See that the golosh is properly fitted, close the seams, and then proceed to last it; when dry, run the wheel round the golosh close to the edge, but not too close, as it may lead to breakage. Then put the leg in the clams in a proper position for stabbing on the golosh, which operation should commence at the right-hand corner of the vamp. The stiffener is then placed in position, and fixed by a row of stabbing on each side of the seam. The stiffener before being placed must be skived to a feather-edge at its top. The bottom

must remain of the full substance. The upper is then ready for the maker.

The Button Boot.—The lining is placed as in the spring boot, and then the inner back piece is whipped on to the inner side of the back lining. The button-piece or fly is then cut to the shape required, and the button-piece lining, after being pasted round its edges, is fitted to the button-piece. This done, when dry, mark the number of button-holes required at equal distances with the button pricker. Stab them round, and then with the button-hole punch take away the leather inscribed by the pricker. The button-piece thus finished is then closed on. This is a far easier mode than to finish the button-piece on the leg. The front seam is then rubbed down, and the button-piece allowed to fall into its natural position. An awl is then passed through each hole, and the upper marked for the positioning of the buttons. The holes are then made with the button-piercer for the reception of the button-shanks. When the buttons are inserted, pass a stout waxed thread through each shank, this thread being passed between the lining and outside. When the top is reached fasten the thread off. Place the top on last, fit the golosh, and finish as in spring boot.

The Balmoral.—Linings fitted as in previous boots, out quarters are then fitted and pasted on lining. The facings are then cut and pasted in position, and, when dry, the wheel is run round and the facings stabbed on. The remainder of the closing of this boot is proceeded with in the same manner as the spring and button boot.

The Oxonian or Oxford Shoe.—This was formerly closed with a flat seam; since the introduction of the machine, the vamp is stabbed on to the quarter with two rows of stabbing to give it the appearance of an outside seam, and the heel seam is closed inside by the machine. The inside facings are placed on, and two rows of stabbing performed, one on the top and one on the bottom edge of the facing. The holes are then punched and the eyelets inserted. The shoe is then turned and the inside linings fitted and whipped on If inside quarter is used

it must be now stabbed round the quarter from one corner of the facing to the other, and if a stiffener is used it must now be placed and stabbed. In machine-closed boots of this kind there is generally found to be a looseness round the quarter. This is seldom the case when they are hand-closed. This looseness in machine-closed shoes, arises from the peculiar action of the machine.

Toe-cap.—The most convenient method of stabbing on a toe-cap is to perform the operation before the golosh is on the leg. It is pasted on the front and allowed to remain till dry, when it is stabbed across with one or two rows as ordered. The punching, if punching is ordered, is performed before being placed on the vamp. The design for punching is usually outlined by using the point of a fine awl. It is customary with careful workmen to copy smart designs for toe-caps and keep them by them. This punching of a toe-cap is, however, an abominable practice, only equalled in folly by the flowered toe-cap once so common in boots worn by women. It destroys the integrity of the leather, and so renders it incapable of fulfilling its purpose.

CHAPTER X.

BOOT AND SHOEMAKING: MEN'S WORK.

The Welted Boot.—The Waterproof Shooting-Boot.—The Jockey Boot.—The Racing Jockey Boot.—The Real Channel Shoe.—The Running Shoe.—Strong Work.—Riveted Work.—Pegged Work.

The Welted Boot.—The description of one welted boot will be sufficient, inasmuch as no serious departure from the course hereafter described occurs in the endless variety of boots and shoes classed under the word welted. It matters not whether it be intended for men, women, or children, the mode of constructing a welted boot is the same, or so nearly alike, that it would be a sheer waste of space to enter into farther particulars.

Wet the bottom stuff, that is the leather intended to be employed in the bottoming of the boot, by putting it in a vessel of clean water, where it must be allowed to remain till thoroughly soaked. Take it out when sufficiently soaked, and lay it aside till the water has thoroughly penetrated the pores and the leather is found to be evenly mellow, otherwise it will have a stained or blotched appearance when the boot is finished. Skive your insoles and prepare your split lifts. The split lift must be formed from a piece of soft leather, which should be about six inches long and one in width. Divide this equally with your knife, which must cut from within an eighth of an inch to the top on the grain side, right-hand edge, to the same position on the flesh side, or left-hand under edge Bend each to the contour of the heel and hammer it level If hammered too hardly or when too wet, the heel wher formed will be exceedingly liable to give, and present un-

sightly openings. Look to the stiffeners, and if they have not been left in a proper condition by the closer, scrape and skive them. Fit the welts, feather and cast off the heel and stitching threads.

The above operations are usually performed while the bottom stuff is soaking. Some, however, prefer to cast off their threads overnight and let them lay in soak till the morning, when they take them out, twist and rub them dry with a piece of flannel, continuing the operation till they are perfectly level and smooth. See "Thread-making" under "Special Operations." Cut the stiffener so that it meets the binding at its highest point, and round away gradually till it meets the welt about an inch beyond the corners of the heel. Slightly hammer and last the insole, taking out the stretch or leaving a small portion in as you may prefer. The former plan is the better one. Scrape off the grain, and well block the insole to the last by bringing it over its sides by means of the pincers, and fastening it at its extreme edge.

Fig. 27 shows the number of tacks required (those marked with a star) and the position in which they

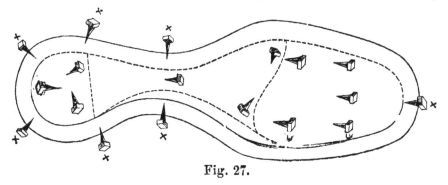

Fig. 27.

should be placed. Tap to the last and leave it so till thoroughly dry. Before the blocking-tacks are with-drawn drive in additional tacks (those without stars) to hold the insole to the last while rounding, lasting, and sewing. In the event of pegs being used instead of tacks for this purpose, cut off their heads when driven with the peg awl. The two tacks nearest the toe-tack are called

straining or draught tacks, the remainder after their positions. Draw the straining tacks and round the insole to the form of the last, that is if you have not been ordered to round it wider or narrower. To ensure the two insoles being alike, take a copy of one for the other with a piece of paper and reverse it. Identicality in the width of the narrowest part of the waist can easily be obtained by measuring with a piece of paper. Pare off the sharp under edge of the insole to prevent it injuring the upper. Mark the length of heel on the insole. For a long flat-seated foot, the heel should range from two and a half to three inches, for an ordinary or under-sized foot it should range from two to two and a half inches. Mark off the guide line from the mark of heel on one side to the other for the feather of forepart with the shoulder stick or compasses, the breadth of the feather being proportioned to the stoutness of the upper, the guide for its breadth being the joint thickness of upper lining and welt. In cutting the feather or rabbet let the inside cut be vertical and about one-third of the sole's substance in depth, the outside horizontal cut meeting it at the bottom. This feather should be cut a trifle wider at the toe. Remove the freed leather. The heel part feather, which must be now cut, does not differ in form, but is cut narrower, the difference being the width of the welt which is confined to the forepart. This feather you must cut a trifle wider at the back to carry the pitch of the heel, except a square heel is intended, in which case the width of the feather continues the same. When the feathers are cut, make a slight upright groove or line a quarter of an inch still farther inwards round both heel and forepart. For a thick firm insole the groove should be employed; but if the insole is formed of thin or inferior leather the line will answer the purpose and leave the integrity of the leather undisturbed. Widen with the opener or any other fitting instrument. In a still more inward position pass the knife round the sole, holding it in a slanting position while doing so, so as to form a ridge between the feather and the insole to facilitate the holing. In doing this you

must pass the awl from the bottom of the channel to that of the feather, when for a boot of ordinary thickness five stitches to the inch in the forepart will be found sufficient, and four or even less for the heel if intended to be of more than ordinary height. In making these holes employ a slightly crooked awl.

The insole is now ready for the upper or lasting, but before proceeding to do this, damp the stiffener to facilitate the bedding, cut and skive side linings carefully, employ paste between lining and stiffener, and also between outside and lining, and shake a little French chalk into the upper. When proceeding to last, first raise the back part of the upper and drive a tack at the centre of the toe (under the toe-cap, if the boot has one). Place the side linings in position without pasting, pull over with the pincers (bull-dog pincers are the best), and drive in the two draught tacks; strain again, and drive in the tacks behind the joints; pull the back of the upper down, and with the pincers applied in a proper direction drive in the waist tacks. Withdraw the joint tacks, pull the upper forward and tack afresh. Other tacks may be used at discretion to complete the lasting, the number being proportioned to the thickness of the upper, taking care that the lining is kept in its proper position. The smaller the pincers used in lasting the toe the better, as it is impossible to take out the pipes properly with a large and clumsy tool. In the case of a toe-cap being used, the leather it will cover can be slightly pared away. The cap is lasted similarly to the toe of the upper, but it must be braced by an end being passed from the insole where it is held fast by a knot, over the draught tack and those of the toe, and fastened to the opposite draught tack. The tacks, then driven through the centre of the bottom of the heel, and others at equal distances, must not be allowed to proceed beyond the lining and stiffener. With the boot held on the knees by means of the stirrup, draw an end from the insole at the beginning of the heel round the back tack and make fast to that at the commencement of the heel opposite, taking care to pull the counter well

under, so that no pipes are left, and begin to sew at the left-hand corner of the heel, the toe of the boot pointing from you. Use an overcast stitch to prevent the upper from being injured. In sewing, the boot is held by the stirrup over the left knee, the stitches being left sufficiently loose to allow the awl to pass freely under them when sewing down the heel. Three stitches to the inch is the quantity usually employed. Skive away a portion of the welt on both sides so as to make it conform to the waist. When the seat is finished begin to sew in the welt. The awl should be carefully selected, be sharp and firm at its point, smooth at its sides, and strong at the shoulder. Over-casting should not be employed, either on the welt or insole side, in sewing in the welt, as one thread is liable to cut the other. A difference of opinion prevails, however, with regard to dispensing with the over-casting, and, having given our opinion, we leave the question with the maker. Commence the operation at the joint of the heel and pull the thread well home, using the hand leather to shield the hand and the awl handle, if necessary, to obtain more force. In sewing keep the thread well waxed and smooth, and care must be taken not to trespass too near the tacks. Insert the left-hand bristle first and let the right follow, and the result will be a firm stitch on the insole and a smaller one on the welt. The smallness of the stitch on the welt will be found of great advantage when stitching on the sole, as you will be able to use the awl without materially interfering with the sewing thread. Beat the seat down, draw the tacks used to keep the insole in position, pare the seam close to stitches, hammer down once more; raise the welt with sleeking bone or other instrument; with the welt beater inserted between the upper and welt, beat the welt up straight, and place a piece of lead or horn between the upper and welt, to prevent cutting the upper and to resist the pressure, trim the latter. After having pasted the insole over, fill up with kid offal if you have any, the use of which will prevent creaking, place the shank piece in position, and after

having driven in a few pegs to the insole to hold it in position, trim it to the required shape, leaving it with the edges rising towards the back proportioned to the height of the heel, applying a little soap to the point of the awl when raising the seat stitches. Cover the shank piece with a bit of felt, kid, or rag, and after skiving and hammering the sole, tack it on without pasting, and rough round it closish to the welt. Drive in one tack at the toe and another at the back part, draw the tacks, displace the sole, and having gauged it to the required substance, trim away to the thickness required from the flesh side, when the double iron in setting will be found to catch it all round. Skive the waist to about one-half the substance of the fore-part, leaving it of its full thickness at the centre. Hammer the sole, replace and fix it with the tacks previously drawn, taking care to block and bed the inside waist so that no great stress shall rest upon the stitches. You must next fasten the sole piece down with pegs and trim it, taking particular care to leave sufficient to hide the stitch. After rounding up, level and pane up the thin part to the stitch, trim up the sole, and remove the heads of the pegs. In trimming, see that the split lift is left sufficiently long to cover up the corner. After having rasped the grain from, pasted and fixed your split lift, follow with your whole lifts, subjecting each to the same preparatory treatment. Each must be rough-rounded and levelled in turn. All being in position but the top lift, cut a groove in it for burying the heel stitch. While pegging on the whole lifts, place the pegs so that they will not interfere with either the sewing or the breast of the heel. With the thin end of the bone, open the seat so as to expose the stitches, mark on the edge of the heel the centre of each, and awl the heel from top lift to sole piece in order to enable you to meet these in sewing, using a thread of con-siderable if not double substance, to that employed in the forepart. Previous to sewing down the heel, hole it and open the loop stitch with the awl's point, which will do away with the possibility of breaking or straining the seat stitch. Use the heel awl for this purpose. Put both

bristles through the first hole in order that it may be filled, and in sewing be sure to pass the thread under the seat stitch. After you have driven pegs into the two corner holes and removed the awl marks from the counter, slightly pane the sole over the seat stitch, hammer down, and square the heel. Scrape away the grain from the top piece, and round it. The two top pieces are formed alike by using one as a pattern for the other. Gouge the breast, beat it under with the joint iron, and mark round a guide for the pin-pointing, using a double-pronged awl for the purpose. The holes thus made will require to be deepened with the straight awl. The pin-points should be driven with a rasp. They are thus driven much straighter and surer than with a hammer. Round the forepart, bevel the waist, mark round with the forepart iron, cut the forepart channel, open it, and before commencing stitching arrange a thin skiving from the welt round the lower part of the upper to protect it. This is particularly requisite if it be cut from patent. When the operation is complete, rub a little paste in the channel, rasp it out, lift the lip up, and pare it away. Run round the forepart iron to mark with its edge the bottom of the sole and remove the edge of the grain of the channel, but not so far as to be without the reach of the forepart iron. Wet the sole, scour with stone, press the outer edge of the forepart channel with the iron as in setting the edge, and sleek the bottom, and apply some tallow or gum to the welt. Break out the stitch with the notched bone, clean the welt with a bit of flannel, pare the forepart, tap round the edge, run the welt off the waist to prepare it for the iron, rasp up the heel, square the corners with the file, level the seat, break in the seat with the breaker, smooth the heel, and level with the buff knife, which when dull is set by the blade of an awl being passed along its sides. You must then scrape the forepart, and after you have used a little tallow or gum to the seat, set it with the seat wheel slightly warmed, and sandpaper the heel.

The seat wheel must be kept clean. Prepare the waist and forepart, running the welt off even to the stitch;

use the stitch-bone to show up the stitches, buff away the rough edge from the welt, sandpaper the forepart, thin the waste to fit the iron, pass the double iron round the forepart to see if it fits, file the waist, and work down the forepart with rasp if required, taking care to pass the rasp in an outward direction in order to force the crease in a position to fill the forepart iron. Paste the channel, scour with a fine stone, clean away the paste, damp round the forepart, rub some gum and tallow round it and welt, after which set the former with a warm iron while the gum is damp, and then the waist with the iron specially adapted for that purpose, using gum and tallow while damp as in the forepart. Take the prick-stitch and divide the stitches, remove the grain from the sole, which should be first damped to soften it, with the buff knife. Scrape and sandpaper the breast of the heel and sole, remove the ragged corners from the heel, gum and tallow the breast, and scour while wet. Damp the waist as far as you propose to black it, mark it off, apply a small portion of paste at the corner of the crease to prevent the colour running into the forepart. Colour the forepart, heel, and waist, using due precaution to keep the ink away from the channel. Wipe the waist, clear off any inky sediment, and sleek it; grease, gum, and wipe off with a piece of rag. After cleaning away the marks on the upper with the pane of the hammer and clearing out the welt, sandpaper and ink the heel, setting the glaze-iron to warm in the meanwhile, and when tallowed and wiped off, glaze the waist and heel with the iron thus prepared. Then, while the glazing iron is being reheated, rub on a little heel-ball, taking care to rub a little behind the seat and waist, and iron it in. To keep the heel clear and level, employ the waist iron. Rub the heel-ball quickly off with a piece of cloth to prevent dull patches being seen on the heel and waist. Having set the forepart with a warm iron, apply heel-ball to fill the pores and rub off, after which buff the bottom, mark across the black of the waist with the dull knife, and pass the waist wheel, or " Jim Crow," as some prefer to call it, along the waist channel.

With a little spittle applied to a piece of rag clean the upper and wipe dry, pull out the tack from the block and remove the last, and scrape away the pegs from the inside. If the boot is to be sprung, after you have beaten the feather down from joint to joint, spring it gradually from heel to toe, and flatten the bottom by the use of the hammer while supported before and behind on your knees. Buff the bottom and top piece, file the sprigs, and sandpaper the top piece ; having first warmed the bottom, sandpaper it, sprinkle it with bottom ball, sandpaper again, and wipe down first with a slightly wet and then with a dry flannel. Rub a little beeswax or finishing ball on the edge of the channel, run the forepart iron round it, wipe off, and clean down the top piece. If the top piece is to be blacked you must colour and finish it at the time when you are blacking the body of the heel. Apply a small portion of beeswax to the edges of the top piece in order to prevent the oxalic acid destroying the colour. Apply the acid, scour it out with sandpaper, gum and tallow and clean off with flannel or cloth. Wipe forepart and waist, and with a soft rag to which heel-ball has been applied, rub round and polish the heel, forepart, edge, and waist. Repeat the process with a rag slightly smeared with white wax, and wipe off, when, the upper being cleansed, the boot will be fit for shop.

The Waterproof Shooting Boot.—Till the lasting is completed, the process is the same as in an ordinary welted boot. The lining in this boot will be found left open all round by the closer, to enable you when the boot is lasted to draw and replace the tacks in the same holes in the linings. Let your relasting be as tight as possible. Having cut a piece of thin india-rubber to the shape of a golosh, coat the lining all round with india-rubber solution, and let it stand till dry. This must be repeated if the coating is not found to be sufficient. Warm and pull the rubber in order to make it lie snug all round and at the heel. The boot must be sewn before the leather is turned down, in order that you may employ a lighter thread and a welt of thinner substance. If the welt is

extra wide take a strip of stout upper leather, after you have sewn in the welt, and sew it round the seat, then pare off the seam and beat and round up the welt and the strip. Regarding toe-cap, if used, see " Welted Boot." Cut to the shape of bottom, so that it will reach the sewing stitch, a piece of sheet india-rubber, and having solutioned the insole, after it has remained to dry, warm and place it, taking care that it covers the seat and welt stitches. Solution and fix the middle sole, and with a whip stitch fasten it to the welt. A middle sole is only used when ordered. If you intend the boot to have a shank or waist piece, it should be cut thin, or the waist will have a clumsy appearance. After giving the india-rubber and the welt another coating of solution, relast the upper to the last, with short tacks that will not reach the water-proofing, and then the upper over the middle sole. Draw your tacks, press the upper into the welt, and using a crooked awl, secure it to the inner sole. Press your upper snug to the welt, and fasten the outside counter to the slip of upper, and with the long stick rub it down. When dry, hobnail the sole. If a brown bottom, buff the grain, sandpaper and gum dragon or paste the sole, using a piece of flannel in the operation. Rub, while finishing, some ball into the sole, rough round and hole it. Drive in your hobs on the flat iron, which will clinch their points, and fix the sole with a tack or so that will not reach the waterproofing. After you have rounded up the boot, stitch the forepart a quarter of an inch from the edge, drawing the tacks as you proceed. A thick thread, with little twist in it, is the best, inasmuch as it will lie flatter. In an extra wide-welted boot a second row of stitching is employed. Follow as directed in the welted boot. If these instructions are followed the boot made will be perfectly water-tight, as the upper, lying over the welt, prevents the water from entering.

The Jockey Boot.—In the Jockey boot the feather of the heel part is cut uniform, is one-third less in width from the absence of welt, the boot having a square low heel. The waist and forepart are kept to the same substance,

and as a rule it has only a single lift between top piece and split lift.

The Racing Jockey Boot.—The leg of this boot is cut for lightness from the skin of an unborn calf, and the bottom is made proportionately lighter to that of the Jockey boot. The heel consists of split lift and a top piece.

The Real Channel Shoe is made without a welt. The Blake Machine shoe is constructed in a similar manner, the chief difference being that tingles are used instead of bracing. The absence of the welt allows the sole to set close to the upper, and gives the shoe a particularly neat appearance. When lasted, the upper is braced round with a single thread with a whip-stitch. The stiffener is thinned at the bottom in order to produce a level surface, and a light shankpiece should be employed. In finishing the edge, employ an iron with an unusually short guard, to prevent the possibility of cutting the upper. The other differences may be left to suggest themselves to the maker.

The Running Shoe.—The Running shoe is made pump fashion. In feathering the forepart, cut it wider than that of the ordinary pump. The forepart is holed as a plain pump, and the waist and heel to the extreme edge. The spike shanks are forced through two holes about an inch from edge and one in centre of toe, and riveted on the flesh side, after which a half-sole is stitched to the pump forepart. In stitching the half-sole along the channel the thread must be made to pass through both soles. The shoe made as described, while light in the back part, has an extremely elastic waist. There are other modes of fashioning shoes for this purpose, that used for sprint running possessing no heel, which in the case of the runner being short in his strides has cork inserted in the forepart. In all instances shoes for running should be formed as light as possible.

Strong Work.—It is not our intention to enter upon a detailed description of the making of strong work, inasmuch as the chief if not only difference lies in the use of heavier materials, thread, &c. The old fashioned strong boot was not an artistic production. Its chief

merit, and a merit not to be despised, consisted in its being put together strongly. As for improvement, or signs of improvement, there was none. Country bootmakers were content to work on the old lines, to employ the same patterns, and having seen nothing better their customers were contented. During the past few years great changes have been introduced, and the heavy boot now worn by labourers is in some cases as well and carefully cut and fitted as the lighter boots worn by gentlemen, of which it is at least a part imitation. This has resulted from whole-sale manufacturers turning their attention to this class of work, masters who can and do afford to pay accomplished clickers to design and cut. Mr. Canham, of Crowland, is largely accredited with having led these improvements, inasmuch as he was the first to point out the faults of the class of boots mentioned, and to suggest the improvements that have followed. We remember noticing some few years back several useful suggestions by way of improvements from Mr. Matthew Thomas, of Stockport, but which, so far as we know, have not been adopted. The suggestions to which we allude he has plainly set forth in a letter from which we extract the following : " I employ a cross-piece on the top of the middle sole at the broad portion of the foot, and use a last at least an eighth of an inch deeper than that generally used, in order to assist locomotion and give comfort. In my second boot, I employ a middle sole extending from shank to toe, a second which is tapered from the tread to the shank and toe, and a cross-piece also tapered front and back. Boots thus made do not wrinkle when knelt upon. I make them spring to the last, whether the heels be high or low, and the top of the heel level with the sole. The uppers should be cut and closed to bear down on the fittings of the last as near as possible across the joints, when they can be lasted down without strain. Each part should be lasted down inde-pendently on its own premises, and then the uppers will not change shape when the last is withdrawn. These kinds of boots or shoes can be made with pegs or rivets, or stitched by machine or hand. If riveted, the insoles

should be thick and close grained, and cut from English oak tanned leather, and a double row of iron rivets should be placed in the shank."

We give a diagram of the last boot described (Fig. 28).

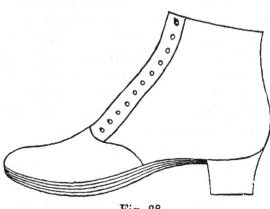

Fig. 28.

The points to be specially attended to in general strong work is the choice of awl, which should be neither too pointed nor too obtuse at its point, nor too narrow nor too broad; the leaving of sufficient from the heel mark to make a solid joint stitch on finishing the welt, and giving increased length to the joint stitches to ensure the welt from being cut through; the selection of fitting leather for the shank piece, of fair substance, and neither too hard nor too horny, the placing of skivers beside the seam in order to level the filling up; the pegging of the second layer firmly up the centre to prevent the breaking down of the waist; the extension of the bottom layer well over the seam and the use of an extra skiver on the bottom where the tacks penetrate; the alternation of split and sole lifts; the careful blocking down of the sole on the shank piece to prevent the heel from cracking round the two bottom joints from want of solidity; the prevention of creaking, the pegging of the hinder part well down to the seat; the lying of the sole flat on the sewing seam; careful channelling, so as not to impair the sole; and the careful abstention from using a round awl in sewing the waist—these are the principal things to be attended to in the making of a sound boot of this order. In justice to the old makers of strong work, it is only fair to state that for solidity of work they have never been surpassed, if indeed equalled. Their chief fault lay in the fixity of

their ideas, and their notion regarding the necessity of sound work was as fixed as their less wise conceptions regarding the alteration of the cut and style of their work.

Riveted Work.—To those possessing a knowledge of the mode in which a hand-sewn boot or shoe is made, the instructions here given will be found ample. Erect a small bench with room for storing bottom stuff and tools, and fix thereto a standing socket. Possess yourself of the necessary number of iron lasts.

When it is not intended to cut the stuff by machinery it will be advisable to cut sets of sole patterns from the lasts. This is best done by fixing on an inner sole and carefully rounding it up to the last. The shape of the outer sole may then be obtained by making an allowance of about a quarter of an inch from joint to joint and about an eighth of an inch in the waist, again allowing a little extra at the heel. The lighter the boot the less allowance will be required to be made from the insole, owing to the thinness of the upper.

Where sole pieces are used, care should be taken that the sole is allowed to come fully three-quarters of an inch under the heel. It is advisable when the sole patterns have been got ready to get them cut in zinc for future use. The use of zinc sole patterns will expedite the process of rounding on future occasions. A good plan to adopt is to get a cutting board about twelve by eight inches. Upon this lay the sole to be rounded, which should previously have been properly wetted and allowed to become mellow. Fasten a zinc pattern on it by driving a tack through to the board, and round up with a stiff knife in an upright position. It is particularly necessary in riveted work to have a solid insole, the integrity of the boot being more dependent upon its insole than upon any other portion of the boot.

The insole need not be hard, or of great stoutness, but it should be close and firm. It must be slightly feathered at the edge, but not too far in. Having skived the stiffener, in the same way as for hand-sewn work, skive well down the bottom also. The top and inner sole being ready

for lasting, draw the upper over the toe of the last with the pincers and tack it down with tingles. Tingles are small tacks from a quarter to three-eighths of an inch long made very thin, so that they may clinch easily upon the insole. Draw over at each side of the toe and then at the joints, taking care, when doing so, that the back part of the upper is left low down on the last, as in hand-sewn. This will have the effect of allowing the upper when drawn up at the heel to fall easily into its place in the waist. Draw in tightly all round with the pincers and tack down. The toe, if a stout upper is used, will need to be cut in in a way familiar to all hand-sewn workers, it being understood that each pleat be tacked down as cut. If a middle sole is to be used, a very small amount of bottom stuff will be necessary. Tack on the middle sole with iron brads or sprigs, then put in the shank, which will not need to be anything like so large as that required for a hand-sewn boot. The sole, previous to rounding up, may now be put on. Prick all round with an awl, about a quarter of an inch from the edges, the holes being a quarter of an inch apart. Brass rivets are accounted the best. These may be obtained of any grindery dealer. Care should be taken that the rivets are of the right length for the boot, otherwise, whether too long or too short, the solidity of the boot suffers. They should be just long enough to go through and touch the last and no more. Five-eighths is a suitable size for boots of an ordinary stout walking substance. Seven-sixteenths will be generally sufficient for the waist. The rivets may be driven with a hammer, but a more convenient instrument will be found in a large half-round file which has had considerable wear. The rivets must be driven absolutely straight. This operation complete, hammer out the bottom. Build the heel in the ordinary fashion, first nailing the split lift with iron brads, and the lifts with iron heel screws, which hold much more firmly. The top piece is then sprigged on and the last withdrawn. Place the boot on a wooden last, pane up, rasp, scrape, and finish.

Pegged Work.—Much that has been said with regard to

riveted work will be found applicable to pegged work. We will therefore be content with adding the following, which we might possibly have been justified in placing under the preceding heading.

The stiffness created by pegs cannot of course be entirely avoided, although two rows are often driven in around a sole when one, if well put in with a proper awl, would answer the purpose of holding the p irts together equally well. We should be very far from recommending any slighting of the work, but simply advocate the use of less of the stiffening material in order to produce a better article. This is done in the best kinds of light pegged boots; and in custom work double soles are treated also in the same way with complete success. If the bottoms, on coarse work, require to be filled up with a mass of stuff to give them the appearance of thick double soles, let it be done with skivings, something that will not add to the foot's labour in bending them at every step.

In order to make a light and solid pegged heel, skive the bottom edge of the stiffeners half an inch upwards, slightly damp the upper and stiffeners, paste in, last and peg.

It may be here appropriately mentioned that Messrs. Harper and Chamberlain, of Nailsworth, have recently introduced to the trade a Patent Waterproof Heel Stiffening. These stiffenings are manufactured from the best

Fig. 29.

American boards, and other kinds of compo, and are readily fixed in position. They are, of course, cheaper than stiffenings cut from leather, and may be used for low priced work advantageously. This stiffening is shown in Fig. 29.

CHAPTER XI.

BOOT AND SHOEMAKING: WOMEN'S WORK.

The Sewround.—The French Sewround.—The Spring-heel Pump.—The Military Heel Pump.—The Spring-heel Welt.—The Bath Clump, or Inside Clump.—The Bevelled Clump.—The Inside Cork.—The North Country Cork.—The French Cork.—The Cork Sole Boot.—The Spring-heel Cork.—The Leather Wurtemburg Pump.—The Leather Wurtemburg Welt.—The Modern Welted Wurtemburg.—The Wurtemburg with Sole Attached.—The Wood Heel.—The Leather Back Military Heel.—The Wurtemburg Heel.

The Sewround.—In the best sewrounds, the sole is reduced to the thickness of the upper, in order that the former shall not strain the latter. The sole is generally cut from a light cow-hide. After the sole has been wetted and hammered, tack it to a board, and reduce it to the required substance and scrape away the grain. Having proceeded thus far, place the piece selected for the sole on a perfectly even board, shape it to pattern, and feather it. The latter is done by bevelling it from the edge inwards to the extent of an eighth of an inch. Cut the channel at a similar distance from the feather or a quarter of an inch from the extreme edge, and hole it on the flesh side with a full-size closing awl, which should be somewhat flat on the underside. Tack the sole to the last at heel and toe. Cut the stiffener from a piece of white lamb's skin, if the upper is formed of white satin or silk. If the stiffener be cut from coloured leather cover it with white paper or linen, as such a stiffener will otherwise give the fabric an objectionable shade. Paste the lining from the binding to the bottom edge, taking care, while so doing, to keep the upper free from paste. Then last,

using small silk tacks, which must not be driven more than half through the sole.

When a side lining is ordered, it should be cut out of white leather, inserted between the lining and upper, and pasted to the former. As a rule, it may be stated, no lining is employed, the substitute being a strip of white leather sewn round the forepart and cut close to the stitch. This is sufficient to prevent the upper falling away from the sole. Some workmen, and good workmen too, prefer to form this strip, as it passes the toe, into a toe-lining. When a blocked toe is ordered, a stiffer piece of leather is used for this purpose. For an approved mode of forming a blocked toe, see " Special Operations." It is placed between the lining and upper, and pasted to the former. The thread employed should be made of about five strands of the finest closing flax. This must be only slightly waxed, as when too much wax is used it has a tendency to destroy the silk or satin of which the upper is composed. Commence the sewing on the left-hand side at the beginning of the quarter lining and follow round the toe, taking care as you proceed to divide the puckers, and terminate at the hole at which the sewing was commenced. Pare the quarter lining close to the stitch, and wax the uncut waste silk or satin to the sole, using prunel wax or stickum for the purpose. Before this is done, carefully pare off the rise of the stitch. Place and paste down the sock lining, and the sock having been allowed to dry, the shoe will be ready for turning. The back lasting is then proceeded with in the usual way, after which beat the sole level and sleek it with the long stick or bone. Dry friction should be avoided from its tendency to burn or harden the sole. Sleek the edge with the pump stick, scrape and sand-paper, colour and glasspaper, and with a flannel to which spittle or gum dragon dissolved in water has been applied, wipe down. When dry, rub with a dry flannel, apply the spring, and the shoe is finished.

The French Sewround.—The sole is channelled all round in the usual way, and fixed by two tacks in the

waist. The quarter is fixed in position by drawing the
tacks and again inserting them through the quarters, the
same holes being used in fixing the sole. The vamp is
then stretched to its proper position, when the aforesaid
tacks are again withdrawn and reinserted through the
vamp, vamp lining, quarter, quarter lining, and sole, same
holes again being used. The sewing is the same as in the
ordinary English sewround ; paring is not needed ; the
edges are sleeked and usually left brown, but if ordered
to be inked, the usual process is resorted to. A sole
leather lining is cut by the same patterns as used for the
sole and inserted.

The Spring-heel Pump.—Hammer and tack the sole to
the last at waist and toe, flesh side out. Pare round fore-
part or to joints of heel, leaving back part untouched.
Draw the tacks, remove the sole from the last, and trim
channel and hole it. Replace it on last, using the same
two tacks. Tack the upper, lining outwards, to the sole,
taking care that the tacks are not driven through it. Sew
with an overcast stitch. If the pump is made of exceedingly
light material, the overcasting should be dispensed with,
as it has a tendency to blister. Cut away the seam if
leather, or wax it down if of silk, satin, jean, or any other
woven fabric. Draw the last, turn the shoe, last the insole
with the sock, lining inside and the flesh side out. In the
best kind of work of this class the insole is lasted without
the sock lining, and cut round the last. Withdraw the
tacks, trim the insole, and paste the lining on the grain side.
Cut the sock lining exact to the insole, round the heel and
forepart, leaving enough to turn in on both sides of the
waist. Should the sock be formed of silk, it must be left
so as to turn in all round. Fit the insole to the last, if it
has not been previously fitted on the board, and feather,
channel and hole the heel portion of the insole. Mark off
the heel, and replace the last with the insole on it. If a
shank piece, or waist strengthener, is ordered, it must now
be inserted. The shank piece is best dispensed with, if the
shoe is intended for dancing purposes. Sew in the seat by
passing the thread from the insole to the upper, commencing

at the left-hand joint or corner of the heel and end at the right, trim the seam to the stitch, neatly block and pare the sole, draw the tack, paste the half-lift under the sole, and retack. The lift should be left fuller than the sole, to allow of its being paned or hammered up to cover up the heel stitch. Cut the back part, channel round the heel portion of the sole, using the forepart iron as a guide, from which the channel must be cut in slanting, bearing from the outer edge. The channel should be deep enough to bury the stitch, and no deeper. When cut, open it with the channel opener, and commence sewing on the right-hand corner, and terminate on the left. In sewing the heel, thrust the awl under the seat stitch, and rise it through the channel. Close the channel, beat the sole, pane up the edge with the hammer, trim a trifle above the seat stitch, pare the edge, file, glasspaper, and after applying a little paste with the rag stretched over the thumb, cold iron previous to putting the edge in colour. This is done with common ink, which will be found to be materially improved if it has had a few iron brads thrown into it. When the ink has dried, apply the welt iron, forepart iron, and seat wheel; heated to the same degree as used for ordinary ironing. When the edge is set, finish with a small quantity of heel-ball, applied by means of an old cotton stocking or piece of cloth, scrape, and colour. When dry, stamp the bottom, withdraw the last, and insert the spring. With regard to pasting, it is as well to mention that in the Spring-heel Pump it is used between lift, soles, and filling.

The Military Heel Pump.—The forepart is made in the same way as the Spring Pump, and the heel the same as that of a military heel welt boot. When the upper is cut from satin, silk, or any other woven material, it is necessary to exercise great caution in lasting, particularly across the vamp. The material should be stretched in a direct line so that the threads are evenly acted upon. When this is done, the shoe will have a much better appearance than if lasted without such precaution having been used. After a silk, stuff, or satin shoe has been sewn, the portions of leather lining, side linings, and quarters that show above the stitch

must be cut away, and the edges of the stuff, silk, or satin pasted down over the seam to prevent it from ravelling, and loosing the sewing stitch. The insole or the half-insole, whichever is used, should be covered with linen before inserted, and a portion thereof doubled over on both sides of the waist, so that the insole, when pasted down to the sole with these doubled-in edges, shall keep the linen in its proper position, and prevent the linen lining from shifting or crumpling.

The Spring-heel Welt is a welted boot with no rise above the sole, the slight rise that it possesses being formed by the placing of an inclined lift under the sole, reaching from the corners of the heel to the back. For household wear, no better form of footgear can be selected. Boots thus made are not so likely to destroy or damage carpets as boots or shoes with heels, and are far better adapted for climbing or descending stairs. As a rule they are greatly in favour with aged persons, and good reasons are not wanting to justify their choice. Wet the insole by placing it in the shop tub for a few seconds, lay it on a board, level it, and pare the loose flesh away; slightly hammer it on a flat iron, and block it to the last by bringing it over its sides, and take out the stretch by means of the pincers. Fasten down by tacks driven into the extreme edge of the insole, and so leave it till thoroughly dry, when it must be tacked at the toe, waist, and heel, the former tacks being then withdrawn. Pare the insole to its proper shape, and mark off the length of heel or inclined part, which should extend from an inch to an inch and a half more forward than ordinary outside heels. Cut the feather of the heel or back part about an eighth of an inch from the edge, and that of the forepart a full quarter. These must be cut straight down, and not too deep, the knife used being held perpendicularly. On opening the channel with the opener, if found too shallow, use the tool to slightly increase the depth, as it is much safer, having a blunt edge, to employ than a knife, which is liable to slip and penetrate too far. Clear out the rabbet or channel. If the boot be a light one, a line must be drawn with the dull knife a quarter of an inch farther in than

the feather, but if middling or heavy this should be converted into a channel, either of which must be taken as the guide for the following operation, namely, the holing of the insole. The awling will be found to be much. easier accomplished if a little soap is placed in the channel. If the stiffener and side linings have not been pasted in by the closer, fix them before lasting, and then sew in the seat, commencing at the left and ending at the right-hand corner. Proceed, without breaking the thread, to sew in the welt, taking care to break the puckers at the toe, and when finished skive off or thin the waist portion to about half its substance. Thrust the welt breaker between the welt and the upper without injuring the stitch, and hammer the welt towards it to make it hard and level. Trim it by aid of the knife and paring horn, the former being so held as to act as a shield when pressed against the welt. Use a piece of soft leather about an inch in width for a split lift. Paste and place it in position to cover the seat stitch after it has been cut to the proper shape, and wax or sew it round the heel. Paste the bottom, level and repaste, and mark off the sole. Apply paste between all lifts, middle soles, and filling. Reduce the waist to half its substance, tack on the sole by a tack at the toe and another at the heel, which must be driven into the last. Mark off the heel to the seat stitch, pare the sole level to the welt and the heel to the split lift, then cut the channel, the cut having an inward bearing, the forepart iron being used as a guide, and open it with the channel opener or seat file. In stitching use a thicker thread for the heel than the forepart. Use a yellow flax thread for the forepart if ordered to be yellow, and brown for the back part. The after processes need not be described, as they are the same as in other boots, which we have or may have occasion to describe.

The Bath Clump or Inside Clump has long fallen into desuetude, but may possibly be revived, as it has merits peculiar to itself. We will therefore in the smallest possible space point out where it differs in the making from others. The process is the same till the bottom has been levelled. The differences mainly consist of the addition of

H

a middle sole and two middle pieces to the heel. This middle sole, extending from the toe to the commencement of the waist, is put on after the bottom has been levelled and rough-rounded, bevelled, and the waist reduced. It is fixed by driving two pegs through the middle sole and about half through the insole. The two heel pieces are next put on and bevelled to the waist. The outer sole, extending from the toe to the back part of the heel, is then tacked on, cramped well down in the waist, and then sewn, the thread passing from the welt to the surface of the sole all round. Then follow as in a Spring Welt.

The Bevelled Clump.—Its construction continues the same as an ordinary boot until the marking off of the heel upon the insole. Mark off much shorter, about two inches. This variation made, the process continues precisely as described in the ordinary welt boot until the bottom is levelled. This done, the middle sole is fitted as in the Bath Clump; but as this middle sole is stitched on without the outer sole, a channel is cut as described in the outer sole of the ordinary welt boot, but a trifle farther inwards to allow for the bradding on of the outer sole without imperilling the edge or stitch. The middle sole being stitched on, the outer is rough-rounded, and laid on. It is now common to put a buckle-strap round the waist to hold the sole down at that part till the paste has become sufficiently dry. This avoids the use of a tack. When dry, the strap is removed, the sole cut closely round to welt and middle sole, the heel part being left rough-rounded, the object of this being that it may be made to cover the stitch. A channel is then cut in the waist portion of the sole, and the stitching of the part being completed, and the channel closed, the forepart is marked off for bradding. This guide line is placed about a quarter of an inch from the outer edge. For ladies' work brass points are used, and for men's iron brads. The brads being filed smooth, the edge is well squared up, scraped, and glasspapered. The double iron you intend using for finishing the welt and middle sole is then passed

round, and, at the line imprinted, a channel is cut to form the guide for bevelling.

The bevelling process consists in slanting the edge back to the nails, by means of the knife, rasp, scraper, and glasspaper. A bevel iron is then used to set the bevel, and the after processes are the same as in the ordinary work.

The old system was to square up the welt and middle sole, &c., before the outer was attached. This plan is still preferred by many; but there is little doubt but that it is inferior to that described.

The Inside Cork.—Except when ordered to meet a special kind of deformity the cork is run from toe to heel. In both fit the cork to the last of the required height and shape, and place it over the sock or covering. Place the insole in position, and pull up the edges of the covering round the sides of the cork and sew in with the upper and welt. Continue as usual.

The North Country Cork.—Fit the insole as in an ordinary clump boot, the difference being that when the boot is sewn, a piece of leather of the stoutness of a sole is cut as a breeches lift, and within this the cork is inserted. Fix this lift with short pegs and the cork with hot wax, and stitch through welt, lift, and sole. This is a cheap mode, and suitable for sale goods.

The French Cork.—Groundwork same as welted boot. Then sew in the two welts singly or both together. The first welt reaches from corner to corner, and the second from one forepart joint to the other. Commence with the first from the heel joint, stopping at the forepart joint, when you must lay the second welt evenly on the under one and continue the sewing. If the welts are sewn in singly, in sewing in the last welt sew between each stitch used for the first or under welt. The lower welt should be double the thickness of the second, and of firmer material. Fit the cork level with seam, wax, and place in position. Prepare shank piece, peg it on, and proceed as usual.

The Cork Sole Boot.—After the insole has been put on,

rounded, and the boot lasted, the cork cover, consisting of a long slip of calf skin, or upper leather, is sewn from corner to corner of the heel. In sewing in the cover, a stiffish piece of insole leather with a tapering edge to receive the stitch must be taken in between feather and insole. This will give firmness to the sides of the cork when covered. After the rand, cork cover, and box have been sewn in, fit the cork and place in on the top of the insole and between the box. In order to soften the cork for cutting, it is commonly roasted, but steaming will be found far better for this purpose. The cork when subjected to this process is not so liable to snap, and can be cut much more readily. In fitting the cork, it should be slightly hollowed out in the under centre, and left much thicker from the joints to the toe than in the waist. Run hot wax over the insole and insert the cork. The cork and top edge of the box being fitted to lie well together, brace over the forepart rand, and the boot will be ready to receive the sole. The heel and sole on, proceed to stitch the cork, making a channel on the sole to receive the stitch on the top. Use a good waxed thread, and let the awl enter a little below the sole on the rand or cork cover, and pierce through the channel, when it will be found that the stitch on one side will fall into the channel, and on the other lie full upon the rand. When the stitching is completed, close channel, pare edge, colour, and set. Polish up the rand or cover, and finish the heel, &c.

The Spring-heel Cork.—Having fitted and rounded the insole as in a Spring-heel Welt, cut the feather. This should be the same for heel and forepart, about a quarter of an inch for a boot of moderate substance. A lesser distance will answer for a thinner sole, and a greater will be required if the sole is to be of unusual thickness. Cut a channel a quarter of an inch further in than the feather, as a guide for holing the sole, and proceed as in the Spring-heel Welt till the filling of the box. When the upper is tacked to the last, shape the rand and welt. Let the rand be cut from ordinary calf blacked on the brown side, and the box of stout insole leather. Shape the heel portion of

the former the same as the box, and the forepart square, which should be nearly an inch wide. In sewing in the rand and box, start at the centre of the left-hand waist, and proceeding round the heel, finish at the centre of right. Then proceed with the forepart. Pare off the spare leather, and fill in the space near the sewing stitch with skivers till level with the inner sole. Wax the inner sole sewing-seam, and box, and while the wax is warm place the cork, which has been previously cut to the required shape, in position. The fitting in will be more satisfactorily performed if the cork is warmed or steamed and rendered pliable before insertion. See that the cork covers the stitches equally all round before fixing it by tacking. When the forepart and heel-part corks are fitted level the waist, and (if used) put on the shank piece. File the edge of the box square all round, glasspaper and well paste, damp the rand, turn it up, and when stretched over the box tack it to the cork. When dry, brace the rand across the bottom, level with a thin layer of skivings, and square the edge with a suitable iron, after which, paste the bottom for the reception of the sole. The sole must be fitted, tacked, braced up in the waist, and pared to the required dimensions, leaving sufficient to cover the stitch, for which an eighth of an inch over the rand will suffice. After the sole is bevelled slightly in the waist, run an iron round the heel and forepart, cut the channel and open it; it will be then ready for stitching. In stitching on the rand, prick each stitch as you proceed. The afterwork needs no special instruction. Friction by the shoulder-stick should be used instead of hammering in finishing, as the latter is liable to disturb the work.

The Leather Wurtemburg Pump.—Up to the back-lasting and stitching in of the seat the making is the same as that of the ordinary pump. Having therefore proceeded thus far, sew down the inclined lifts to the seat stitch, as directed in the leather Wurtemburg welt, and this done, follow as directed in that boot.

The Leather Wurtemburg Welt.—Fit the insole to the last as in the ordinary welt. Channel and hole the insole,

and mark off the heel. Last the upper right side outwards, and sew, commencing at the left-hand corner of the heel, and using an ordinary seat stitch. Attach the welt as usual, and then stitch on three or four inclined lifts, the first of which must extend from the joint to the corner of the heel, while the front edge of the second and third must retreat farther and farther backwards, these together forming the commencement of the breast. Build up the heel by bradding on successive lifts. Tack on the sole, round, &c., and stitch as an ordinary welt. When the joint of the heel is reached, stitch through the inclined lifts to the seat stitch, brad the remainder of the breast, and blind on the top piece. Follow on as usual.

The Modern Welted Wurtemburg.—When the wood heel rand has been fitted, take a piece of light sole leather of the length of the heel, similar to a sewround back part, and tack it in its proper position to the last. Tack the rand round, grain outside, and then bring forward the upper and temporarily fix it at the toe and forepart joints, driving the tacks into the last, there being neither sole nor insole on the forepart. When you have completed the lasting, commence sewing at the left-hand joint or corner of the heel, and finish at the right, as with pump. Trim the seam if the rand is of leather; but if of woven material, wax down as instructed with pump. Take the shoe from the last and turn, fit the insole, channel round forepart and hole. Relast the boot, sew in welt, and pare off seam. Place the wood in rand, level the bottom, and tack on the sole, driving the tacks through the insole into the last. Fit the forepart as an ordinary welt, and the heel in accordance with instructions already given.

The Wurtemburg with Sole attached.—For its reception, the seat should be sewn more inward than is usual. Otherwise it is made precisely in the same manner as an ordinary welted boot. When the shank piece is fitted you take the heel and sole and fit them. You then cut the channel round the back part, pierce it, and attach the heel by means of pegs. The tops of the pegs are then cleared away and the channel closed. The forepart is

then proceeded with in the ordinary manner, and when finished the top piece is bradded on.

The Wood Heel.—The shoe being made, the heel portion is skived away gradually to the upper. In a line with what would in another boot be the starting point of the breast of the heel, the sole is cut half through and a sort of channel made, the back portion of which is perfectly upright, in order that it may act as a stay to the heel when placed in its proper position.

Having placed the heel in position, turn down the leg, and with a bradawl pierce through the sole and heel nearly to the length of the nail. The bradawl used for this purpose should be a trifle thinner than the nail. About five nails will be sufficient. The exercise of ordinary judgment will ensure the proper localities for their position. Care must, however, be taken to place them not too near the edge.

The Leather Back Military Heel.—This heel is sold blacked and finished. The mode of applying it is to brace the upper over the heel portion, and then, by means of a nail driven through the centre of the heel, to fix it in position. This done, a channel is cut round the heel; holes are then pierced for the stitches and the last withdrawn, when the heel is secured by blind stabbing.

The last is then replaced, and the top piece fixed by means of five or six inch rivets.

The Wurtemburg Heel.—With this it is usual to cause the sole to form the breast of the heel. The termination of the breast being hidden by the top piece, gives the entire heel a well-finished appearance.

CHAPTER XII.

LEGGINGS AND GAITERS.

The Changes of Fashion, &c.—Modes of Fastening.—Approved Patterns.
—Blocking.—Fitting and Closing.—How to Strengthen Seams.—
Nomenclature.—General Remarks.

Changes of Fashion, &c.—Some fifty years ago gaiters were in full fashion. Gaiter and breeches making was at one time a special trade. It subsequently became merged into those of the tailor and shoemaker. From causes we need not particularise the use of gaiters declined, so much so, indeed, that to see a person wearing them became a rare occurrence. They appear to have become once more fashionable, and hence the necessity of treating of their manufacture in these pages. They are entitled to be recommended both upon utilitarian and economical grounds. Boots cut to reach high up the leg are of necessity costly, and inasmuch as it is not usual to continue to use the legs when the feet portions of such boots have become dilapidated, the reverse of economical. It may, moreover, be noted, that to wear high boots when low-cut boots or even shoes would give all the necessary protection and yet greater comfort to the wearer, is not only extravagant but absurd, and yet this is frequently done by long boot owners. On the other hand, those who ordinarily wear boots that do not rise above the ankle, and who are provided with gaiters or leggings, can increase their height at any time when such elongation is necessary. A pair of leggings thus occasionally worn, even though they may be purchased at half the price, will outlast a couple or even more pairs of high boots. What may be fairly described as the disjoining

of the leg from the foot of the boot has the additional
merit of contributing to the comfort of the wearer, inas-
much as it is easier to cover over the trousers without
ruck or fold than to force them down into legs that have
no opening saving at the top.

Modes of Fastening.—There has always been a great
want of a ready and secure mode of fastening for this
class of goods, and this want may be said to exist still,
judged by the continuous efforts made to supersede those
now in use. Skewering, lacing, and buckling, and various
combinations of these, have from time to time been called
into requisition. Slides, springs, studs, buttons, running
loops, and all kinds of dodges and inventions have been
tried, but there appears to be a very general belief prevail-
ing that the right method remains to be discovered. Of
those in use some are condemned upon the ground of the
trouble and waste of time in fastening and unfastening,
and the remainder upon the ground that they do not afford
sufficient security, in other words, are unreliable.

The mode of fastening for both long and short work of
this kind is usually determined by the customer. Spring
fastenings are, however, best adapted for the higher-cut
below-knee leggings, inasmuch as they are qualified to
keep them in position by resisting their tendency to fall
into wrinkles. Springs should be placed as near the
centre of outside of leg as possible. For short gaiters,
buttons and buckles are generally preferred. These are
fixed in a more forward position. The styles of fastening
and furnishing employed for leggings are fairly exhibited
in the following figures, as are also those of placing and
using buckles and straps in combination with springs and
buttons. The long thigh leggings are furnished with
straps as shown in figure. These are cut sufficiently long
to reach the waist band from which the leggings obtain
their support. The bottoms of leggings are cut to fit both
tight and loose. To fit them too tight at this point, in the
estimation of good judges, is a mistake.

We remember an attempt being made to dispense with
fastenings, but it ended in failure. Having no side opening,

there was no possibility of getting it on without taking the boot or shoe off. This extra trouble prevented it ever becoming popular.

Approved Patterns.—Herewith we give a few of the most approved patterns for this class of work. Fig. 30 is a trenching or rounding pattern for the main portion of a gaiter leg. Fig. 31 represents the other portion.

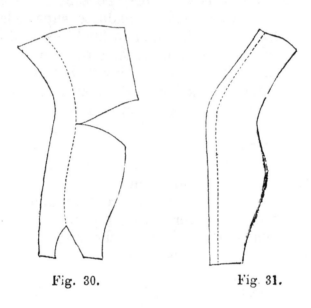

Fig. 30. Fig. 31.

Fig. 32 represents the mode in which the tongue may be cut. That of the stiffener is shown in Fig. 33.

Fig. 32. Fig. 33.

Fig. 34 represents a shorter gaiter, the topmost portion of which extends no farther than the knee. The next (**Fig. 35**) represents how a part of its leg and half of

its tongue are cut. The remaining side of the leg is cut
as Fig. 36.

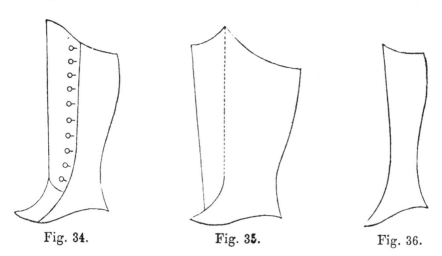

Fig. 34. Fig. 35. Fig. 36.

In this style of legging the one half of tongue is joined
to the portion that, when worn, comes on the
outside of leg. We need not give either
diagram or instructions for the reverse mode
of joining it to inside half. The half tongue
must be cut as in Fig. 37.

Fig. 37.

For a gaiter, cut two portions of leather or cloth of the
following shape (Fig. 38). These,
when fastened up the back and a
button-piece added, will appear like
the top of an ordinary button
boot.

Gaiters for ladies' wear are usually
formed of one piece and lined with
fancy leather. It is far better, how-
ever, for the sake of securing a better fit, to make them
with a back seam.

Fig. 38.

Blocking.—The old system of blocking is now almost
entirely dispensed with, the machines now used for this
purpose being automatically perfect. For a description of
the mode of blocking formerly practised, and even yet
occasionally resorted to in the absence of a blocking-

machine, see "Special Operations." For the new mode, see "Boot and Shoe Machines."

Fitting and Closing.—The various methods of fitting and closing seams, tongues, &c., will be found in Chapter IX. The instruction there given for both long and short work is all more or less applicable to the class of goods under consideration.

How to Strengthen Seams.—When leggings are cut from leather that is liable to break away, it must be supported at the seams by under-lays of thinner leather. It will, moreover, often be found advisable to employ an additional row of stitches. Leggings cut from grained hide are usually closed as heel seams in short boots. Whether one or two seams, or whatever the style of seams, they should be firm and efficient.

Nomenclature.—The names employed to distinguish the various kinds of leggings and gaiters have not been judiciously chosen. Most gaiters are copies of the leg portions of boots. It would have been far better if both leggings and gaiters had been called after their originals, as Wellington leggings, Napoleon leggings, &c.

Fig. 39 (Long Thigh), 40 (Havelock), 41 (Napoleon), 42 (Wellington), 43 (Newmarket), form a fair example of the many styles of this class of goods now being worn, and fairly represent the kind of fastenings usually employed in each.

Leggings that commence or terminate at the bend of the foot are bound to discomfort the weaver. The most comfortable are possibly those blocked to fall over the instep. Where a strap is used, it should be fixed a trifle more forward than the breast of the heel of the boot, in order that it should pull tight at the hollow of the waist. The strap should be stabbed on both sides, and be of good material, in order to resist the great strain it has occasionally to bear.

General Remarks.—Gaiters are made to fasten with buttons, box springs, and buckles, the latter being mostly confined to gaiter fashions formed of leather. In order to keep them in position, foot straps are invariably used.

Rubber straps have given the greatest satisfaction from the lesser trouble they give, and we should not be surprised to learn that their use becomes general. A gaiter should be cut sufficiently large to cover the boot; but not too large. Imitation button pieces are now very com-

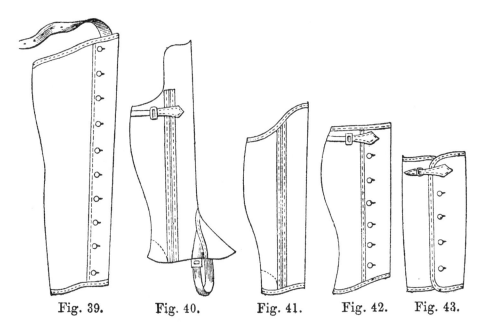

Fig. 39. Fig. 40. Fig. 41. Fig. 42. Fig. 43.

monly used to this class of goods. In cutting gaiters for sale purposes, their different sizes vary to the extent of half an inch. The measurement of an 8 size would be $9\frac{1}{2}$ ankle, $13\frac{1}{2}$ heel, and the next larger size half an inch more at these points, and the size ranging under would be cut half an inch under at the points named.

CHAPTER XIII.

MENDING.

Introductory Remarks.—Formerly the shoemaker and the shoemender were commonly combined in the same person. This combination is now less frequent. Shoemaking and shoemending if not altogether apart, certainly rank as separate and distinct departments of the shoe trade. Small masters still exist, though in sadly diminished numbers, who divide their attention between making and mending, but the cobler's stall, wherein the worker would back himself as a horse is backed into the shafts of a vehicle, is seldom seen nowadays. In the larger bespoke shops, a mender is still commonly employed. With regard to the small bespoke master and the shoemender it may be said their mending operations are conducted pretty much on the old lines. Whether the upper is fractured, the welt damaged, or the sole worn, the awl and the thread are speedily requisitioned. It is not so with the latest class of shoemenders. With them the awl and thread are things of secondary importance, the nail and file having the preference. This class of mending is evidently attracting a considerable share of custom. Cheapness and rapidity are held out to the public as enticements, and, judging

from the heavily rented shops now in the occupation of
those who perform this kind of mending, with no little
success. No one possessing the least knowledge of the
shoemaker's or mender's art who has watched their
operations will say much in favour of the new system.
Its cheapness will be seen to be more apparent than real.
It is in too many instances a mere covering up of old
wounds. It requires real talent to mend shoes as they
were formerly mended, and are still mended in respectable
bespoke establishments, but all that is required of the
newest operator is to be able to cut and skive, drive a nail
or rivet and ink the edges.

Half-Soling and Heeling, Sewn Work.—Wet the new
half-sole and heel-pieces, and take away the loose flesh.
Carefully remove the old sole, taking care not to injure the
welt. This, the removal, is done by forcing the knife
between the welt and sole, and passing it round from joint
to joint. The waist is then bent back and damped, and
the old sole divided, the new acting as a guide if no special
instructions have been given. It is always advisable to
carry the new sole back as far into the waist as possible.
When this is done there is less chance of its breaking
away. The graft should be cut as straight as possible,
for although there may be less strain on a slanting than a
straight graft, there is less hold for the inside stitches.
The waist portion of the graft should be cut so as to
incline slightly towards the heel on the flesh side when in
its proper position. The grafting edge of the half-sole
(having previously been rough-rounded) should be cut
without any incline, or if any incline, a very slight one.
In doing this the grain should face the board. If this
plan is pursued a good joint will be obtained, as the half-
sole will give in the working. The grafting portion of the
half-sole is then channelled, and after the channel has been
widened by passing the channel-opener through it, a small
portion of leather is removed to allow the awl to work freely.
The channel must not be cut too deep, but sufficiently deep
to hide the stitch from the outside. It is then holed. Use
a stout, well-waxed thread, the stoutness of which must be

proportioned to the substance of the sole. The bottom is then relevelled, pasted, and the sole tacked down. Before paring and sewing the sole, the joint should be well rubbed down with the pane of the hammer or the file. The after process is the same as in a new boot. If a black waist is required, the portion to be blacked should include the graft. In heeling the first thing is to remove the top piece and as many lifts as necessary. Supposing the seat to be partially destroyed, you must replace the seat stitches as far as necessary, and leave the seat-lift in a form that will have raised up the outer edge and act as a guide to keep the heel in form. It is temporarily pegged to the insole and attached by means of the seat stitches, the remainder of the lifts are then pasted and fixed by means of pegs. The blinders are driven into the top lift, the top piece hammered on and the whole finished as in a new boot. If it is intended that the yellow stitch shall show on the old welt, instead of passing the knife round between the sole and welt, the face of the stitches showing on the welt must be pared away. This being done, the awl is placed between the old sole and welt, and the two forced asunder. By this method it will be found that the old stitches will come away with the half sole.

Half-Soling and Heeling, pegged, riveted, and nailed work.—In mending either kind of boots mentioned, the same means of attachment should be used. In cutting away the half-sole, it must not be cut entirely through. The direct cut should not penetrate through more than half the substance ; the cut should then slant away towards the toe, and continue for a good half-inch before the complete separation is effected. The new half-sole is cut to meet this and a firm bond is insured. In most instances where an under or middle sole has been employed, it will be found unnecessary to disturb it, but in cases where the boot has been hard worn, and this sole destroyed or impaired, it is necessary to replace or repair it. The nails, pegs, or rivets used to attach the half-sole should be placed a full quarter of an inch from the edge. A single row of nails or rivets will suffice ; but it is usual to employ a

double row of pegs. An iron last or old last sheeted with iron is generally used, or in the absence of either, recourse may be had to the iron foot.

Half-Soling and Heeling, Pump Work.—Remove the old sole by forcing it from the upper by means of the bone or other suitable instrument, and cutting the stitches. Take care in doing this that the upper is not injured. Take the new half-sole out of soak, lay the old on it as a guide, and cut the new across, the cut being straight or nearly so. The waist portion of the graft must be cut so as to incline towards the heel on the flesh side when in its proper position. The grafting edge of the half-sole should be cut without any incline. In doing this the grain should face the board. The old half-sole is then placed on the new, grain to grain, as a guide for cutting. The new half-sole should be cut a trifle larger to allow for paring. This in its turn becomes the guide for cutting its fellow, grain facing grain as before, but with no variation in size. The half-sole is then feathered, channelled, the channel opened and a portion removed as in new work. The grafting portion of the sole is then channelled and holed, and after the channel has been opened a small portion of leather is taken away to provide for the awl's free working. The graft and forepart are then sewn and the shoe turned. In sewing the graft a stoutish waxed thread, proportioned to the substance of the sole, should be used. As in half-soling pumps with heels no last is used, the upper is tacked to the toe of the half-sole, three tacks being sufficient. To hold the boot firm, place the sleeking-stick inside. This will resist the pressure of the strap; sew as in the new work, the old holes, however, being worked into. In case of the upper being strained or weakened, a narrow slip of kid should be sewn round at the same time. The pump is then turned, the insole and shank-piece pasted and replaced, after which the last is inserted. In this position it should be left for a few hours, when the shoe will resume its original shape. The heeling does not differ from that of ordinary work.

Welting.—The old welt must be removed an inch

I

farther back than the graft. In doing this, in order not to injure the upper, incline the edge of the knife towards the welt you are removing. The edge of the new and old welt must be cut aslant, so that the joint is formed without any variation of substance. In the event of the insole being found impoverished, the awl should penetrate from the welt, and the stitch have a double overcast on the insole. Let the old inner sole be well soaped. This will cause the thread to work free, and it will prevent the breaking out of the old sole. The welt is beaten up as in new work, if the yellow stitch is to be shown. Partial welting differs so little that it is only necessary to advise the removal of a trifle more than the affected part.

Underlaying.—When the sole is worn away at one spot only, it is usual to resort to underlaying. When at the outer edge, the ragged portion of the worn part is cut away and a piece of sole leather of the required size and substance is forced between the welt and sole. This should extend a good half-inch under the old leather. In this position the new piece is cut half through to fit the hole in the sole. The piece is then withdrawn and tapered away to its circumference, the outer edge of course being excepted. It is then replaced, when it will be found, if the shoulder is forced tight against the edges of the sole, to give a sufficiently level appearance to the bottom. The old sole is then nailed to the inner edges of the underlay, and afterwards hammered down. Then cut a channel and open at the usual distance from the outer edge, which is then sewn. When the patch is required in the middle portion of the sole, the mending piece must be cut a trifle larger than the damaged part that has been removed. It is tapered off and affixed by either pegs, rivets, or brads. In fine work, it is customary to rip the edge of the sole and force the piece into its proper position beneath the sole.

Patching a Double Sole.—With dull knife, mark the damaged leather it is intended to remove. Cut away as marked, with one clean cut, if possible. Then rip the sewing beyond the dimensions of the patch, without

disturbing the stitching. Cut the patch, using the old piece removed for a guide, leaving a full half-inch over at the bottom. The patch leather should be thicker than the upper. Slightly feather the patch at the closing parts, and mark round, one-eighth of an inch from the edge, with dull knife on grain side. Hole it, using the mark as a guide, the awl passing from the guide line to the edge of the face on the reverse side. Having prepared a thread of four or five strands of fine closing flax, place the edge of the patch against the old upper, grain side outward, and pass the awl from the holing through the upper, overcasting on the right hand. The old leather should be kept moist while these operations are being performed, as otherwise, being brittle and perished, it will break away. On the completion of the closing, the patch must be turned and rubbed down till not a trace of the join is to be seen. Then force the bottom edge of the patch between the upper and the welt, beat the sole tight to the upper, and draw a line a quarter of an inch from the edge on the exterior of the sole, as a guide for cutting a channel of the required length. Open the channel, pierce it with straight awl through to the interior, and then with a small sewing thread complete the blind stabbing. A small quantity of paste should then be rubbed into the channel, which is then closed up, beaten down, and the boot finished in the usual way.

Patching a Single Sole.—This does not differ from the foregoing except with regard to the sole portion. In this instance the boot is turned after the patch is closed in, and the patch sewn to the sole in the usual pump fashion.

Stabbing Patch for Double or Single Soles.—The following is a much cheaper method of inserting a patch than the foregoing. Cut a piece of leather of the size required, skive it on the grain side to a thin edge and cut channel in sole. Place bottom edge of patch between welt and upper, black side facing sole, and sew from the grain side to the sole, after which turn up patch, paste to upper, and when dry, stab. When the material is light

cashmere or prunella, the edges of upper portion must be turned in and the bottom edge left full.

Back Piecing Lady's Boot.—Cut the back piece of the proper size and shape a trifle wider than the old, then force the seat and welt away from the upper, and the bottom of the back piece between the upper and seat with the dull knife, leaving about the eighth of an inch turned up against the upper for receiving the stitches. To keep the patch in position while sewing, drive a tack between upper and welt at each corner. In sewing, the stitches may be full an inch long, the awl passing from the grain to the insole. The sewing complete, paste back piece, turn up and place in position, and when dry, blind stab.

Inserting New Springs.—The old spring is removed by cutting stitches between it and upper, and it and lining, care being taken not to injure the upper. The parts hidden in old spring when placed being pared away, it is laid on the new webbing and scored round, a guide for the placing of the new spring being thus obtained. In cutting, the spring must be kept to the proportions of the old. It is then pasted outside the before-mentioned mark, placed in the position of the old spring, allowed to dry and stitched.

Darning.—Many wearers object to wear boots with patches, however neatly they may be executed. In such cases darning is resorted to. The mode of proceeding is as follows, and inasmuch as the proceeding does not materially vary, no matter where the darning may be required, one description will suffice. Take a light piece of leather, suited to the substance of the upper, either calf or kid. Skive the edges very thin, leaving the substance in the centre. Fix this by means of glue paste exactly under the spot where the break exists, then stab with very light twist across the break on the outside, keeping the stitches parallel. Tap the stitches down with the hammer, and then apply blackball till the stitches are hidden. Rub down and wipe off.

Mending the Side of a Wellington.—Clear away the old welt, and loop-stitch the two edges. This is done by

stabbing each side of the seam close to or through the old holes if sufficiently firm. Make your thread, consisting of six cords of closing flax, wax it well, and take a closing awl. Put the point of awl under each loop-stitch, then insert the thread and overcast each stitch as it is taken, pulling each tight so as to knit the two edges together. Tap it gently down on block, use blackball to cover the stitches, and employ a large welt set to form the imitation welt.*

There are other modes of accomplishing this, by herring-boning, flat-seaming, and stitch-drawing, but the mode here given is in every sense superior, both with regard to strength and appearance.

Gore Closing.—This is often had recourse to when the upper of a boot has been made too small. The length of the gore will of course depend upon the extent of ease-ment required. Slit the boot upper the required length, and then cut the gore to the width required. Point it at each end. Close the first side with an inside seam, using a very fine thread; then rub it down with the pane of the hammer, being careful in doing so that the stitch is neither burnt nor fretted. The other side is then closed with an outside fine seam. This can also be done by blind stabbing a piece on the outside. In this case the under edges of the vamp must be carefully skived. The new piece in this case must be also skived, and should not be too stout. Previous to placing the new piece in position insert a last in boot equal in size to the enlarge-ment. Paste or glue edge of the new piece before insertion, and do not attempt to stab till it is dry. In the case of the gore being required for the side in long work, let the extra width-giving piece be placed under instead of over. The process does not differ. The gore will be found an excellent medium for enlarging a boot that is too small in the heel.

Blind Stabbing.—This is an exceedingly difficult opera-

* Inasmuch as the closing in of new legs and fronts is now seldom if ever resorted to, we will not trouble the reader with any description thereof.

tion, and is not to be acquired without considerable practice. Insert the thread from the outside for first stitch, halve your thread, then work the inner half of thread through, the point of the awl acting as your guide. Holding the point of the bristle between left thumb and finger, let the outer follow, and continue till the patch is completed.

The Patent Patching Needle.—Fig. 44 represents the instrument used to supersede blind-stabbing. It is the

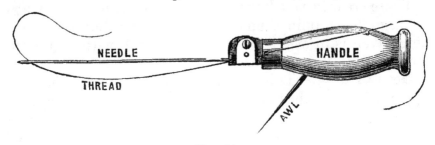

Fig. 44.

joint patent of Messrs. M. H. Pearson and E. Shayler, and if not the only instrument of its kind in the market, it is certainly the best. We have already made reference to the difficulties of accomplishing blind-stabbing, nay, to the impossibility, if the workman has hands abnormally large, or the boot of an unusually small size. There is little doubt about the above instrument receiving a welcome reception from the class of workmen to whom reference has been made. It has been thus described. It consists of a long, grooved, eye-pointed needle, protruding some six to seven inches from a handle; in the same handle is also fixed a short stabbing awl. When it is desired to put in a row of stitches the long needle is threaded either with a waxed thread or a piece of silk twist, the ends being brought through a hole in the handle, at the lower end of which a small cork is fitted that impedes the ready passage of the thread, and thus forms a tension. The stabbing awl is then thrust through the leather in the required direction, is withdrawn, and the needle carrying the thread thrust through as far as it

will go. The thread carried by it can now easily be reached; and as the withdrawal of the needle, to a small extent, causes a slackness of the carried thread, it thus becomes easy to pass between it and the needle a second thread. The needle is now withdrawn, and a lock-stitch is thus formed, which can be repeated as many times as is necessary. By the aid of the same needle a loose welt can also be fastened, thus saving the trouble and unsightliness of the "link-stitch." The following directions will be found exceedingly useful to purchasers. Secure the needle in the clamp by means of the screw, let one of the grooves *face the awl;* pass the thread to be used through the two thread eyes and under the check spring, and through the eye from the side next the awl, and pull about eighteen inches of thread through. Hold the handle in the right hand, with the awl close to the thumb. Commence sewing by first stabbing a hole with the awl, then insert the needle as far as required, draw back one inch, then with the finger of the left hand (inside the boot) pull the loose end of thread *inside.* Now withdraw the needle, make another hole with awl, again insert the needle, draw back one inch and insert the end of thread that is inside the boot through the loop thus formed, taking care to always pass the thread through the loop on the side of the needle *farthest from the awl.* When first learning to use the needles, a bodkin or blunt pointed hand-sewing needle may be tied on the thread inside the boot, to facilitate the passing of the thread through the loop, but practice will soon show that this is unnecessary. The stitch made is exactly the same as made by the Sewing Machine (Lock-Stitch), and practice will determine the length of thread required for each patch.

Last for Mending.—One of the forthcoming trade novelties promised is a last specially adapted for the use of menders. The last is divided vertically, or nearly so, into sections, which are inserted into the boot or shoe in succession, and are removed separately by the aid of a hook. The size of the last can be lengthened or shortened by the insertion or non-insertion of a section at the breast

of the heel. Both last and stand are of metal, and the latter, which consists of two parts, is provided with a pin which penetrates the last and a projecting shoulder. These jointly hold the loose sections of the last together. Those who have had practical experience of the difficulty of inserting and withdrawing the ordinary last in mending, will admit that the invention we have attempted to describe should be welcomed.

CHAPTER XIV.

FURRING.

Where and when commonly worn.—Furred boots and shoes are very commonly worn in Russia and other cold countries. During the last five or six years they have been worn during the winter months somewhat extensively in this country, and, judging from the favourable opinion entertained of them they will doubtlessly continue in favour. Furring with us has been hitherto confined to boots and shoes worn by ladies.

Mode of furring a Lady's Tie-front.—A description of the mode of furring a single boot will suffice. The boot selected is a lady's tie-front. This, if intended for indoor wear, will be made of velvet, cashmere, or cloth ; if for outdoor, of patent kid, cloth, or other suitable material. The fur is given out in the whole, half, or quarter skin, and occasionally in slips. If given out in the skin, half, or quarter, it is the binder's duty to cut it as required for use. The grain of the fur will in all animals be found to incline over the back towards the tail. Noticing this peculiarity, the binder will take hold of the tail or butt end of the skin, place it flesh upward on a level board, and with a straight-edge and pencil line off the slips for binding. The skin must be then taken by its edge from whence these lines commence, and gently scored across, care being taken that the knife penetrates no farther than the skin extends. This done, it will be found that a gentle pull will suffice to

separate the hair, and, as it has not been severed, that an invisible join can be easily effected. The fur vamp and quarter lining are then cut.

How to Place the Patterns.—Where price is no object, the patterns should be placed so that the grain of the skin runs with the foot. Ordinarily this plan would be found too expensive, that followed is therefore selected upon the ground of its being the most economical. When marked off, cut through the skin only as before, and sever the hair by a gentle pull. Calico linings having been cut for the quarters and vamps, the fur quarters and vamps are sewn to them over-edge, that is, the edges of the fur lining, with the calico lining outside, are brought face to face, and the whole sewn at once. Should the boot have a flannel lining, the red flannel must be strengthened in the same way. The inside thus prepared, is carefully placed in its proper position in the leg and whipped over as an ordinary lining. The fur trimming is carried round the centre opening and top, and placed with its fur running downwards before the sewing. The proper place to start from is the right-hand top corner, an over-edge stitch being used. It should be sewn closely, and when done the fur must be turned over and felled upon the exterior. This done, brush down the fur into its proper position and sew on the necessary ribbons for ties.

CHAPTER XV.

BOWS, ROSETTES, &c.

How Mounted, &c.—These ornaments being as a rule mounted on buckram, the binder confines her stitches to this, leaving the bow, rosette, or buckle, if intended for ornament only, as is mostly the case, perfectly free. The mode of fastening is to whip the buckram over edge to the shoe, taking care that the ornament, whatever it may be, shall totally cover the buckram.

By whom Positions are Decided.—The position is usually decided by the size and style of ornament and taste of binder. It often occurs that the effect of the most suitable ornament is destroyed by the slovenly way in which it has been fixed. Ornaments should be placed well upon the instep. When placed they should look as though they had life in them. To flatten them down like a pancake is altogether a mistake. Buckles when intended for use are placed in position by the shopman, clicker, or closer. In the case of any novel ornamentation being used special instructions are, or should be, furnished.

Choice of Bows, &c.—The choice of the style of buckles, bows, &c., and the materials of which they are formed, must be made with judgment. Bows of satin are suitable for shoes cut from patent calf, glacé kid, goat, or black satin; but are in no sense fitted for slippers cut from glove kid. These should be furnished with bows formed of ottoman or corded silk ribbon, or of satin and silk ribbon mixed.

The Vastness of their Variety.—The great feature of bows and rosettes now worn is the introduction of gilt and nickel silver buckles, ornaments, &c. Whether the designs be new or old, their selection evidences the most faultless taste. The richest bows and rosettes are fashioned of silk, satin, and satin Français. Some idea of the immense variety of these ornaments may be formed when we state that Mr. Calder, of Pimlico, has no less than 5,524 different bows, rosettes, and buckles in stock. From these our illustrations have been selected.

Illustrations of Recent Productions.—Those represented by the following figures 45 (Marie Antoinette), 46 (Princess Ida), 47 (Richelieu), 48 (Langtry), 49 (Fenelon), and 50 (Galatea), may be taken as samples of his most recent productions

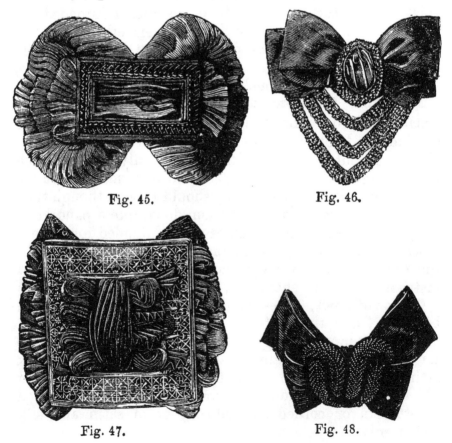

Fig. 45.

Fig. 46.

Fig. 47.

Fig. 48.

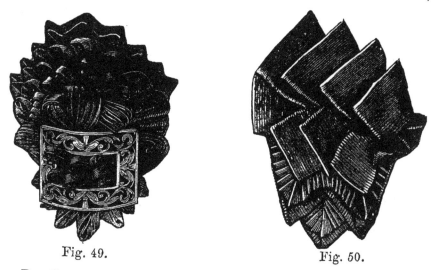

Fig. 49. Fig. 50.

Leather bows for shoes are principally formed of glacé and glove kid. Strap buckles for shoes show signs of

Fig. 51.

revival, and to meet the demand brilliantly coloured metals are being employed in their manufacture.

Fig. 52.

Figures 51 and 52 are intended to show the usual modes of positioning bows, &c.

CHAPTER XVI.

BOUT AND SHOE ARMOUR: TIPS, PLATES, NAILS, &c.

Introductory Observations.—Of all the many attempts to supersede the ordinary tips and plates in common use, few have been even ordinarily successful. It is not our intention to enter on a description of the numerous articles of the kind for which popular favour is now being courted, but we cannot resist the temptation to introduce to the reader's notice the following special production.

Gare's Heel Tips.—Gare's Patent Heel Tips are suited to the wear of both feet—in other words, they are rights and lefts. As will be seen, advantage has been taken of the knowledge that the heaviest wear falls upon the outside of the boot or shoe, and there, as Figs. 53 and 54 illustrate, extra metal has been supplied. By the lightening of the inner range, this great advantage has been obtained without materially increasing their weight. They are made from the best malleable iron, and are easily attached.

The chief points in a plate or a tip, whether made of steel, wrought or cast iron, are found in its metal, its shapeliness, its finish, its evenness, and its groove or counter-sinking. The best method of testing the quality

of its metal is by the application of a file. Plates and tips

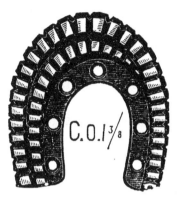

Fig. 53.

Fig. 54.

made of wrought steel are undoubtedly the best. The most common are formed of cast iron.

Whole Tips.—Top pieces are not used when whole tips are employed, their interim spaces being filled in with leather level to the height of the tips.

Half or Quarter Tips.—In making provision for either a half or quarter tip, it is usual to place the one or the other upon the top piece, score it round with the dull knife, and cut away till level.

Heel Plates.—The use of these has chiefly been confined to ladies' boots. It is difficult to imagine why plates rather than tips should be so worn. The latter, while not nearly so dangerous, are equally durable, the central leather acting as a deterrent against slipping. They are formed either of iron, steel, or brass, and being for ladies' wear, should be neat in appearance, and not too heavy. They are mostly fixed with short screws, which are supposed to admit of their easy removal. Experience, however, proves that this is not always the case. In the majority of cases it will be discovered that the cut in the screw's head has been worn away, and there is no hold left for the driver. It need hardly be noticed that whether nails or screws be used, the holes in the plate must be countersunk.

Side Plates.—These are seldom used, and hence it is not usual for grindery warehousemen to keep them in stock. When, however, they are ordered, as they will be occasionally for some special purpose, they can easily be obtained. As with all plates, the screw or nail holes must be countersunk.

Toe-Plates.—Toe-Plates for strong work are fashioned from steel and iron. These are generally affixed by nails. In nailing, if the plates be of steel, they must not be struck too forcibly, or they will fly. In the case of their requiring to be bent, great care must be exercised. The bending is best done by resting their edges on something solid, and tapping them lightly as required.

Nails.—In selecting nails, notice should be taken of their points. If badly pointed, by all means reject them. A well-pointed nail has many advantages over a nail that is faulty in this particular. A smooth pointed nail is driven more easily, it pushes aside rather than destroys the leather as it enters, the passage is smaller and the surrounding leather presses it closer. Nails with rough and badly cut points destroy the integrity of the sole around, and leave apertures through which water will be sure to enter.

Tip Nails.—These should be manufactured from the softest malleable iron. It is easy to understand that toughness, not hardness, is the quality sought after. Tips are subject to sharp raps, and the sudden strains resulting to their attaching nails are often fatal to them when they are of brittle metal. The nails are generally shaped square oblong with similarly shaped heads which fit the grooves in the tips; but there are others having round neads which are used for countersunk tips and plates. In selecting the nails of the latter kind, pliability, suitability of head to groove, and evenness in points are the chief things to be sought after. It is a common practice to shorten these nails and use them instead of hobs in shooting-boots. They are then called "stubbs."

Clinkers or Jacks.—These are used for heavy work, and should be fashioned of good wrought iron. They should

be of uniform shape, more especially in the head and claw. Irregularity in either of these is fatal to the appearance of the boot, no matter how great may be the care taken by the maker.

Round and Square Hobs (cast and wrought) are made of various sizes, the length of shank ranging from a quarter to half an inch. In shooting-boots they are placed about an inch asunder, and five in the heel is usually thought sufficient. The object of their use is to give grip or foothold to the boot-wearer.

Sparables are cast, and are mostly employed in the foreparts of boys' and girls' strong work.

French Nails are made of wrought iron and are used for the outside tread at the heel. Some masters prefer a double or treble row of small hand-cut brads, these being not so liable as the former to eat out the leather.

Brads.—These are used for heels. The most approved shape for their tops is a long square. They should be uniform.

Cutbills.—These are employed in the forepart. As in brads, the heads should be square oblong. Cleanness of cut and uniformity are the chief points to be looked for.

Pin Points are made of brass or gun metal. Those made of the former metal with an alloy of tin, are undoubtedly the best, the mixture being productive of hardness. They are used for fixing top-pieces and clumps.

Steel Points are used at the outside joints, and are driven level with the sole.

Rivets are nails with a slight thread running from the point half way up the shank. They are used as a substitute for stitching and for affixing soles and top-pieces. They are driven best with a rasp or file.

Brass, Copper, and Gun-metal Brads, are used for affixing clumps, and top-pieces, and are of various lengths. They are filed level with the sole.

Brass, and Iron Screws.—These are usually employed in clump work, and are placed where the greatest strain occurs. The grooves in the heads of the screws must range with the edge and not across the sole, and it need scarcely

K

be remarked that too great care cannot be exercised in keeping the range as true as possible. For yachting and light boots worn at sea, copper brads should invariably be used. All other kinds of brads, nails, &c., are more or less damaged by contact with the water.

General Remarks on Nailing, the Selection of Nails, &c. —The awl should in size be as nigh the nail or its point as possible, for if it be too small the nail will bend in driving or go awry. Before starting to nail, a line or lines for straightness should be drawn, and for measuring distances a pronged instrument should be used. For speed the nails should be held in the left hand. It is usual to use a hammer for driving the larger kind of nails, but for pin-points, small brads, &c., a file of sufficient weight is preferable. A single blow should suffice to drive the nail in most instances, indeed in all cases where the nail is not unusually long. Care should be exercised not to drive the nails below the surface of the sole. In nailing to any particular design the design must be first marked on the sole. Care must be taken that the body of the nail selected is not longer than the thickness of the last sole, for under no circumstance must its point penetrate farther than the filling between the soles. It must be kept clear of the seam of the first sole, or its point may cut it, and as this is the very base of the soling, the integrity of the whole would suffer. Where headed nails are used, they should be of a shape that will not allow the dirt to collect or adhere to them, as on damp ground this is particularly objectionable to the wearer.

CHAPTER XVII.

KIT-CUTTING.

Preliminary Remarks.—The art of kit-cutting is difficult to acquire, and necessitates, in those who practise it, a knowledge of the use of the tools to be operated upon. Tools cut by an incompetent person are practically of little or no value, and, per contra, those set by a person who has mastered the art are positive treasures. Who that has ever worked on a shoemaker's bench will fail to confess the heart-burnings and disappointments resulting from ill-set kit? The kit itself may be all that kit need to be, well tempered, shaped, and having its proper bearing; but all these go for little if they are improperly cut. Waste of valuable time, fault-findings, and loss of work are continually resulting from the employment of tools in evil condition.

To be a first-class workman it is necessary that he who aims so high should be able to cut his own kit. Most of the great "dons" have been more or less perfect in the art of kit-cutting, and much of the wonderment conjured up by an inspection of their truly artistic productions would be absent if it was known how far they profited by their labours and ingenuity in this direction. A workman who has studied tool-cutting, on discovering that an iron is not fitted to the work in hand will speedily fit it by a few judiciously applied strokes of the file. A

judicious assortment of files and a small hand-vice that will screw on a bench or table are the chief things necessary for cutting kit.

The Single Forepart Iron.—The edge should be made to take an upward slope from the guard, so that it will clip the edge. If cut the reverse way it is almost certain to slip off the edge of the forepart when applied. The width of the guard is regulated by the substance of the iron, or by the class of work for which it is intended. In cutting the iron, first sink the face and cut it with the desired slope, and, as before stated, the face must be made to rise gradually from the guard and slightly on the round. Keep the guard sufficiently open to run free, but not too wide, or it will fail to clip the sole at the right angle. The crease requires to be cut straight across, and not too deep. The best method of insuring the right depth is to tack a piece of leather on the cutting-board and try an impression, or more if necessary. When satisfied that you have the right depth, round off all the sharpnesses of the iron that traverse the edge, take off the corners of the guard, apply a strip of fine emery cloth evenly to the face till fairly smooth, and then spread a mixture of emery, flour, and grease on the bit of leather whereon the impression has been made, and rub the iron hard upon it as when setting the edge. If due care has been taken to keep the emery powder free from grit and the leather level, the iron will be found in splendid condition. The finishing process here recommended is applicable to the setting of all irons.

The Jigger is the companion tool to the forepart iron, and is used to set the welt and face of the stitch. It requires a deal of care to properly adjust the face and the wire to the necessary position for the performance of this delicate operation. The wire must be cut to suit the kind of boot on which it is intended to operate, that for a shooting-boot requiring to be very stout, the stitch being farther from the edge than in ordinary boots. The jigger crease on all work should take up the entire space from stitch to edge, one side of the wire facing up the stitch and giving it a neat, straight, and solid appearance. If the

wire be too stout it will bruise the stitch and destroy the look of the boot. Jiggers are made of two forms, one with a short handle and forge, a fac-simile of the forepart iron except the wire, and the other with a long handle and slender forge bent so as to lie towards the work. In using the latter, which is most in demand, the workman presses his chin on the handle to increase the pressure. The jigger is cut by a file expressly made for the purpose, this file being light in structure, flat, with bevelled edges, one safe side and edge, and a reverse side and edge cutting. In shaping the iron, let the face rise gradually from the wire and guard, employing the side of the file to cut the wire. See that it is kept at the right angle to clip the edge and allow it to run free and set up the edge and welt, but not cut too close, or it will gall it. Finish as before.

The Double Iron is a combination of the two former, and is mostly used for general work ranging up to a full three-eighth substance. When the work is stouter than this the former two irons should be employed. The Double Iron sets up the edge at once and presses the welt and sole together, which insures a level and solid edge. The forge of this iron must be the same size from the handle to the face. If for the sake of smartness the forge is narrowed away from the face to the handle, when the faces are worn and require recutting, each iron will have to be made lighter in consequence of the narrowness of the shaft. This iron requires three separate files to cut it. 1. The double iron sinking file, which is small and square, with one or more safe sides; and 2 and 3, the jigger and crease file, the latter of which can be obtained with safe sides if required. In sinking the face cut it square across. Take care to throw the jigger wire well on to the welt, so that it will face the stitch, taking care that it is not too thick, or it will produce an ungainly looking crease. The wire on the sole should be neat and round, and the guards well open and square, in order that the impression shall be distinct.

The Bevel Iron has a wider sole guard than the double square iron. The object of its being so open is to make a

heavy sole look like a light one. All that need be said with regard to the cutting of this iron is that the sole guard must be left with an obtuse angle from the face, the lip being cut so that it will set the bevel distinct.

The Dress Bevel Iron will be found the most difficult to cut, in consequence of the lightness of the face that meets the edge. A thin flat file that cuts only on the edge and a light jigger file are best suited to the operation. Take care, in opening the bevel guard, to handle the file lightly, or the crease cut will be large and ungainly. After opening the guard with a flat or jigger file, finish the lip and the clearing out of the crease for the sole wire, which should be a very light one, with a three-cornered file having one safe side.

The Waist Iron must be carefully cut, and if for fine work should have fine wire and crease. In sinking the forge the face must be made to take a very acute angle to the guard, and the wire be cut exactly in the corner made by the sinking. If the wire is required to set a crease more on the welt than on the sole, keep the wire well up to the guard, but for general work the wire requires to be well centred to set right on the edge of the waist. If the crease is to be thrown on to the sole, throw a thin flat wire on the face of the iron in order that it may range with the quarter crease of the seat wheel.

The Round Waist Iron allows more leather to be left on the edge, and so increases its stability, and produces a neat and close waist. It should be cut with a round or oval file, and either with or without a wire. The wire should be cut to range with the wheel.

The Channel Waist Iron is cut similarly, the difference being that the guard must be narrow and blunt, to prevent damaging the upper. It must be cut to run freely.

The Seat Wheel.—Great care is necessary in the selection of this piece of kit, for if the bearings and slide at the back and the screw affixing the slide are not fitted in the most accurate manner, and made of the very best material, it will cause endless trouble and disappointment.

The best workmen, when in possession of a good seat wheel, always take the greatest care of it, and guard it with great jealousy. When making a choice of this article, take it to pieces by unscrewing the back and examine its bearings, and, above all, take care that the roller fits the slot quite close when cold. When heated a wheel so fitted will be found to run quite free, if properly made. One roller is quite sufficient, unless a change from fine to coarse milling be required. In no case should the wheel be thinner than the slot in which it acts, or it will never set distinctly, and can never be depended upon to run true. The wheel itself should be slightly hollowed at its sides. The position or inclination of the face of the wheel to the guard must be adapted for the description of work for which it is intended; for instance, a spring heel is made square; but a Wurtemburg is set quite under, so that in cutting the face of the wheel, these differences must be provided for. The part between the guard and the wheel is called the quarter crease, and should be cut with a dead flat surface, but with a slight rise from the guard to the face. The face must be cut slightly lower than the quarter crease, as otherwise it will give a barrelly shape to the heel. In fixing the wheel, it should be so placed that the bottom of the milling is level with the face, and if thus accurately fixed, it will set up a seat as smoothly as though the quarter crease wheel and face were formed of one solid piece.

The Seat Iron.—This once popular piece of kit has been partially superseded by the seat wheel; but many of the best workmen still employ it to set the seat when putting the boot in colour, in other words before using the seat wheel. When so employed the crease and guard must be cut to correspond exactly to the guard and quarter crease of the seat wheel. The object of thus using the seat iron while the work is in a rough state, is to preserve the seat wheel. The seat iron is still employed on children's and common goods.

CHAPTER XVIII.

SHARPENING KNIVES, AWLS, &c.

Sharpening Knives.—The Bath Stone or Rubber.—Turkish Stone and Hone.

Sharpening Knives.—Many workmen fail to keep their knives and other cutting and piercing instruments in order. This is the result of both ignorance and carelessness. The careless can never have thought of the waste of time and inferiority of the work resulting from the use of blunt instruments. An intelligent workman who feels a pride in his business, and who is moreover desirous of employing his time to the best possible advantage, will provide himself with at least three knives, one for paring, or cutting rough stuff, another for fine paring, and a third, which he will take care to keep always as sharp as it is possible to make it, for finishing, and for finishing only. The employment of three knives, each for the distinctive purpose named, instead of using one for all purposes, is proved to be advantageous both with regard to cost and labour. The clinging to an old stone or worn-out sharpener of any kind, is another act of folly that is often practised by craftsmen, as is also the use of a stone after the sharpening surface has become rough and awkward in shape. By the rubbing of such a stone on another with a level face, a perfectly smooth surface is easily produced, and the time thus spent will be well and profitably employed. The true method of sharpening a knife or awl is best acquired by practice and critical observation. The following instruction will, however, be found useful :—The last stroke on the stone should be given on

the cutting side—that is the side that is from you; the edge ought to be turned a trifle in the opposite direction, or, no matter how keen it may be, it will fail to cut satisfactorily. The finishing strokes should be given after the surface of the stone has been made moist. Neglect of the advice here tendered will prevent the workman from paring or trenching equal to others who adopt it, for the blunt knife will, in a sense, turn rusty, and resist going in the direction desired.

A Bath Stone or Rubber is most generally used for knife sharpening. When purchasing, select a stone that has a moderately rough surface. Many, however, prefer emery cloth, but being so hard it fires the knife. The wisest plan for a maker to pursue is to possess himself of both, employing the former for a rough edge, used for paring the forepart, and finishing with the latter for a smooth one for skiving, &c.

Turkish Stone and Hone are used for sharpening awl points. They need not be large, and oil should be dropped on surface before being used.

CHAPTER XIX.

SPECIAL OPERATIONS

Fixing Gutta Percha Soles to New Work.—Ditto to Old Work.—Prepara-
tion of Threads.—A Stitching Thread for a Yellow Fore-part.—
Bristling.—French Edges.—Stitching and Sewing.—How to form a
Puff or Box Toe.—Waist Springs.—A Boot for a Short Leg.—Block-
ing.—Bracing the Toe.—How to take a Cast of the Foot.—How to
Work in a Spur Box.—Bellows' Tongue.—A Turnover Back-part.—
How to Fix a Button-Hole.—Lace Cutting.—To Prevent Shoes
Creaking.

Fixing Gutta Percha Soles to New Work.—The boot
must be lasted in the usual way, and the seat and welt
sewn in, on a tolerably good insole ; the welt, tapped and
pared, with the insole, is then thoroughly covered with a
solution of gutta percha dissolved in mineral naphtha, after
which process it must be laid aside for a considerable time
to allow of the evaporation of the solvent, *i.e.* to convert
it from a soft, sticky substance, to a hard, dry one. The
solutioned bottom and the gutta percha sole are then
heated, to soften them, and pressed together by the hand,
beginning first at the toe, and going gradually down to a
little below the front of the heel. This pressing and
levelling require some care and judgment, or a re-heating
of the bottom will become necessary to make it level.
Lay it aside to allow the gutta percha sole to set, after
which put on the heel and finish in the ordinary manner.
Pare the sole, and then lightly yet briskly rub with
a soft heelball, which will leave a fairly finished forepart
and waist.

The manufacture of gutta percha-bottomed boots started
at Northampton and finally settled at Glasgow, where an

enterprising firm perfected and carried out a system of moulding the entire bottom of gutta percha, attaching it to an insole and braced upper, while the last was left in for sprigging or nailing.

Gutta percha parings gave rise to a distinct industry. At first they were looked upon in the same light as leather waste, but speculators soon came to the fore, buying the parings at their own price. Some portion was dissolved in mineral naphtha, and re-sold to the manufacturers at half the usual price ; but the greater part was transferred into articles of utility, if not of art, and there were very few houses but what were possessed of specimens of gutta percha ware in the shape of wash-hand basins, water jugs, and various other domestic utensils.

Fixing Gutta Percha Soles to Old Work.—Make the sole of the boot perfectly level, and when dry scratch it with an awl until the bottom surface becomes rough. Warm it before the fire, and spread the solution evenly over it with a hot iron. When the smearing process has been repeated two or three times and the sole of the boot has been well covered, warm the gutta percha sole and also the sole of the boot, till both shall have become soft and sticky, place the gutta percha sole on the boot and press it down. Nothing more remains to be done than to pare the edges with a sharp knife. A solution for this purpose may be purchased, and a receipt for making the same will be found at the end of this volume. An inferior attachment is often made by simply melting down a few strips of gutta percha, and applying it in the same way as solution is applied.

The decline in the use of gutta percha for soling and clumping boots and shoes is in all probability due to its adulteration. At the onset it was sold pure, and gave great satisfaction to the wearer. From its resistance to wear and power to keep out damp it was thought that a powerful rival, if not complete substitute for sole-leather had been found. It may be stated that the pure article then sold was of a very dark brown, with whitish patches of irregular form, differing in a marked degree from the

article now sold, which is of a dull red colour, from its adulteration with from fifty to seventy-five per cent. of veneer sawdust, or some similar ingredient that will readily mix with it. Whether the loss of popular favour arose from the cause stated or not, there cannot be a doubt about the lesser resisting power of modern gutta percha.

Preparation of Threads.—The advantage of using properly prepared threads needs no enforcement. Threads when knotty or uneven, not only delay the progress of the work, but cause it to have an unsightly appearance. Independent of this, they too often cause the worker to lose his temper. The thickness of the thread must ever depend upon the nature of the work for which it is intended. There is a belief prevalent among shoemakers that all threads should have an odd strand, and excellent reasons exist to justify this belief. Rory O'More says there is luck in odd numbers. The odd strand contributes towards the roundness of the thread, and the rounder it is, the more easy it will be found to work. Practice has proved that an even-stranded thread is difficult to work and liable to cotton.

A Stitching Thread for a Yellow Forepart.—Place the ball of flax on the right hand. Hold the strand with the left hand and pass it across the right knee. With a few rubs from the right hand and a gentle snack from the left sunder it at the required length; in doing this a long hold should be taken. This must be continued till the required number of strands have been secured, care being taken that the strands are of various lengths, in order that the thread shall have the necessary taw or taper. Damp the thread by passing it through the mouth, double it over a hook or nail, and twist each half on the knee. Take a piece of old rag, cloth, or flannel, wet it with a solution of gum arabic, and pass it rapidly over the thread. Continue the operation till the thread becomes perfectly smooth and solid. When dry, wax it. Middling hard wax will be found best fitted to this purpose. The thread being thus far complete, give the ends an additional waxing in order to prepare them for the reception of the bristle. For a

sewing thread the gum arabic is dispensed with, and a more pliable wax used.

Bristling.—Select a bristle of a transparent rather than a dead white, and of suitable size. Split about half-way down into three, remove a third. This is done to keep the taper unimpaired. The bristle is then held in the left hand with the two ends divided, when the end of the thread is placed exactly to meet the top of the fork. The thread is thrown two or three times round one split portion of the bristle, the throw being towards the operator; the two ends (one with the bristle attached and one without) are then given an additional twist, after which the two ends are twisted together; the awl is then taken and forced through the tapered portion of the thread, at a distance of about an inch from the extreme end, and the bristle made to follow. The bristle being thus secured, its point is removed by a knife and pumice-stoned till perfectly smooth, when the thread will be fit for use. Some excellent craftsmen object to the removal of a third of the bristle as recommended, averring that it weakens the joint, and, in lieu thereof, advise the removal of a half strand only from below the fork. There is also the rolling process, which is probably the strongest. In this mode, the bristle as well as the thread-point is waxed. The bristle is slightly twisted from the right, so as to attach the thread, and then the twist is reversed, after which it is locked as usual.

French Edges.—French edging is now seldom resorted to. Still, as it is a graceful form of ornamentation, and may possibly be revived, a description of the process may prove valuable. The sole to be operated upon was prepared as a plain sew-round, though, as a rule of lighter substance, and the edge intended to be " Frenched " was left without a feather and slightly inclining inward. Great care was taken to secure a clean-cut edge. The channel was cut or opened deeper than that of an ordinary shoe, in order that the stitch or print should show to greater perfection. The number of stitches generally averaged about eighteen to the inch. A plain stitch was used for the commoner

kind of work, but for the better kind overcasting was invariably resorted to. In the best work the Frenching extended a full quarter of an inch, but inasmuch as the difficulty of Frenching, and the time required for its performance, were greater in proportion to its width, it was, as a rule, much narrower in the lower priced goods. When Frenching was confined to the inside waist, it was usual to leave it till the plain sewing was completed. The thread used consisted of one or two less strands than usually employed, and a lesser quantity of wax was applied to it. The first and last piercing of the awl were through the holes used for commencing and terminating the plain stitching. In awling for this purpose, the awl was kept as near the grain as possible, and perfectly uniform in depth, in order that the course of the stitches might show plain and even from the outside. In sleeking the Frenching, the bone was kept longitudinally over the stitches, and the operation was continued till a dark brown colour was produced. It was then finished by drawing a line round the inner edge of the Frenching.

A readier, easier, and cheaper way, by which the Frenching was made to appear of equal width to that used in the plain sew-round, was found to result from passing a heated wheel over the stitches while the sole was damp.

Stitching and Sewing.—Let the pull in all instances be steady and even, or you may break the work away. The perfection of stitching and sewing will be found in the evenness with which it is done. If the thread should work loose, retwist it; or become too tight, give it a reverse twist. When stitching strong work, run a piece of rag to which soap or beeswax has been applied, round the welt. This will tend to make the thread pass through more easily, or continuously dip the point of the awl into beeswax, handily placed for that purpose. When the work is unusually heavy, an immense additional power over the thread is to be obtained by winding the right-hand end round the handle of the awl, and that of the left round the hand leather.

How to form a Puff or Box Toe.—The introduction of

this style of toe has been a perfect blessing to thousands, more especially to those who have riding or cocked-up toes. They are fashioned in several ways. Prepare two side linings, A and B. Skive their inner edges and where they meet at the toe and paste on the lining, overlapping the edges in order that no unevenness shall arise, then cut and skive the edges of the piece marked c, and paste it on at toe as in diagram. This must be placed in position during the process

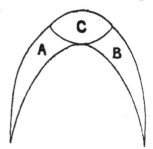

Fig. 55.

of lasting, and fixed by the application of gum or paste to the toe of the upper. The paste must be used so as to stick vamp and lining together. Another mode is to loosen the toe, turn the upper back an inch, after the boot has been lasted, and paste a thin piece of leather, free from grease, between the lining and the upper. Perhaps the easier way, however, and that most commonly resorted to, is to block a piece of crop leather of light substance round the toe of the last, and insert it between the lining.

Waist Springs.—This was the invention of Mr. Cremer, the well-known aristocratic bootmaker of Bond Street, London, from which fact the boot to which it was first applied took the name of "The Cremerian." It has subsequently been called a variety of names. The spring-waisted boot, however, seems to us a far better name than either. The spring is attached to the inner sole, or rather held in position as shown in Fig. 56. Care should be taken in the selection and fixing of the metal shield, which should in all cases be used, in order to secure the foot of the wearer from danger. Instances have occurred in which the spring, through being inadequately shielded, Fig. 56. has pierced through the inner sole to the foot. In one case it is asserted the life of the wearer was thus sacrificed. The object of their introduction was to artificially raise the insteps of those who wore them. How

far they accomplish this purpose, we leave others to decide. These springs can be purchased in the ordinary way.

A Boot for a Short Leg, technically called a Scarp Boot.—The illustration here given (Fig. 57) is taken from

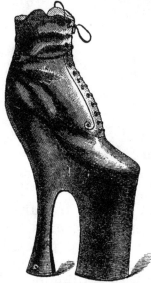

the photograph of a Scarp Boot exhibited by Mr. J. Tyrrell at the Northampton Leather Exhibition in 1873.

The following description of the mode of producing a similar boot has been kindly furnished by its maker. Before taking the measure, correctly ascertain the height of the sole and heel required, which can be readily done by artificially raising the customer's foot, taking care that when finished, the foot shall hold the position shown in boot by the line extending from heel to toe above the cork superstructure. The object of so raising the heel is to

Fig. 57.

assist locomotion. All such boots should be made a full half size longer than boots of an ordinary character. The first process is to fit the bottom stuff. The insoles for boots of this kind must be cut from sound firm leather, as the strain they will have to bear will be unusually heavy. While preparing your threads, scrape, hammer, and block your insoles. The best cover or box to hold the cork is made from the shoulder or first cut from a light butt. This must be soaked, skived, and slightly hammered. The insole is then rounded snugly to the last, and feathered about three-sixteenths of an inch in a sloping position. The seam must then be marked with a straight cut, opened with the channel opener, and the inside removed by the plough. The inside may be holed or not, at the option of the maker. As the boot is pierced from the box, there being no room to use the awl on the insole side, there is no great necessity for holing. The cork may be

of a single piece; but in the event of there being a difficulty of procuring it of sufficient thickness, two or even more pieces must be stuck firmly together by a solution of wax and gutta percha prepared by boiling. Before doing this the separate pieces must be rasped so as to fit them together evenly. When cold and firmly set, cut and rasp the cork to fit the bottom of the last, edges upward. The best instrument to cut the cork with is a keyhole saw. If cut by a knife, the cork should be steamed, the knife being kept well sharpened. Measure the depth of the cork, making allowance for the sole, and mind and keep the heel higher than the forepart. When the boot is fairly placed on the ground, the toe should be raised full an inch from the ground. This will give a rolling motion to the boot from the joint to the toe, and materially assist the wearer in walking. Cut out waist and form the heel, and if the latter is not sufficiently high, raise it by an extra piece of cork. The boot is then lasted in the usual way. When you have placed the box in an upright position, tack slightly at the toe and joints, and put two threads through one hole at the toe, and stitch alternately with the two threads till within an inch of the back seam. Pass the outside threads through and tie off on the insole. In fitting the cork into the box, allow sufficient space for the solution. When placed, press the box well up to the cork and allow it to dry, and then pare the cork so as to form the arch of the waist. The solution for this and other purposes can be melted in an old pot or saucepan, and the smearing and placing cannot be done too rapidly, so long as they are well done. In order to prevent the cork from shifting, bind the box round and let it so remain till all has set firmly. The join up the centre of the heel must be well fitted. It will hold without a seam if the solution is of the right quality. Should, however, the solution be found to be of inferior character, or the workmanship at all inferiorly performed, it will be advisable to stitch it round to the box as in a covered heel, taking care to protect the stitch by sinking it in a channel. This will necessitate the adoption of a square waist, which

must be covered with a piece similar though thinner to that used for the box. The holes at the back of seat must be pierced to the insole and a quarter of an inch asunder. When the last is drawn, stitch the seat with a rather stouter thread than that used to sew in the box. Pare your sole to boot, skive the waist, tap it with hammer, and let the sole go through from toe to heel to insure the heel from breaking away at the waist. Channel the sole, stick it on, take an eighth of an inch hold on the box and stitch through the channel, using a round bent awl to prevent one stitch cutting the other. When the sole is stitched on, close the channel, hammer out, screw the sole, press up edge of channel with forepart iron, rasp and scrape the edge, being careful not to injure the stitch on the box. Nail on the top-piece, sand-paper all over and ink. The channel must be then set with a breaker, paste or gum being used, the glazer passed all over and a little heelball be rubbed on after the box has been ironed all over. The heelball and beeswax should be dissolved with naphtha to a paste. Put a little over the heel, rub it with a piece of cloth, and set the box round with the seat wheel, taking care not to injure the upper.

A boot of this kind is also to be made by fitting an additional insole in box on the top of the cork, sewing a welt round, and stitching the sole thereto, or by pin-pointing the sole to the edge of the box, and finishing off in the manner of a clump boot.

Blocking.—The old style of blocking a Wellington front was by using a piece of wood fashioned to the shape of the front when cut and ready for the closer. It may be noted that it was necessary to have this block a trifle larger than the leg. The back part measured two inches in thickness and tapered off to a thin edge at its front. After the unblocked front had been wetted and rubbed, the bottom part of the leg was placed over the curve of the block, its front made free of every sign of a wrinkle. The heel part corners were then forced with the fingers on both sides as far back as possible, pulled with the pincers and tacked down to the block. The instruments

used by the blocker consisted of pincers, a round wooden rasp, a short round stick made of hard wood and perfectly smooth, and a flounder's hammer. By the assistance of these and the occasional use of the hands, the blocker forced out every ridge and wrinkle on both sides, the action being outward and part circular. When perfectly free of every sign of pucker or unevenness, the front was made fast by tacks on both sides of the leg and vamp. Blucher fronts were blocked in much the same way. Another mode of blocking these was as follows:—One end of a piece of cord or a strong lace was fastened to the board, and the other passed between the vamp, after it had been doubled. The bottom of the vamp was then fastened to the board at both ends, and a slit cut on the side of the tongue at the neck portion of the vamp. Then, while pressing on the vamp with the left hand, the cord or lace held by the right was pulled upwards against the tongue till it was found to have the desired amount of curve, care being taken to remove the wrinkles and make all smooth while turning. The vamp was then blocked and left till dry, when it was cut to the shape required.

Bracing the Toe (Old Style).—Take a strong wax-end and bring it through the inner sole, just behind one of the draft tacks, pass it on the edge of the vamp, round the front of the tacks, draw it tight and fasten to the tack next to the draft tack towards the joint on the reverse side. If not braced sufficiently tight, twist this tack so as to tighten it, and bring the upper leather closer to the feather of the insole, till the pipes totally disappear.

How to take a Cast of the Foot.—In order to do this properly it is necessary to provide yourself with an oblong box and a sufficient quantity of plaster of Paris. This box should be three or four inches high, and an inch or so wider and longer than the foot. Grease the box to prevent the plaster from adhering, and let the foot of which you are about to take a cast be placed in its centre, so as to leave an equal interval all round. In order to raise the foot from the bottom of the box and so allow the

plaster to pass under it, the foot must rest on two or more slips of wood fitted for the purpose. Before the foot is placed in the box, it, like the box, must be oiled. These things done, mix the plaster with water, to the consistency of paste, not too thin, but sufficiently thin to allow of its adapting itself to the form of the foot. During the time this is being done, the foot should be in its proper position in the box, and ready for the plaster, as if not done quickly, failure is sure to result, as the plaster when mixed with water speedily sets. The plaster must not reach higher than the rounding of the outer edges of the foot, from the little toe to the heel. If allowed to flow over the toes, the operation will prove a failure from the difficulty of extracting the foot from the mould. Allow sufficient time for the plaster to set, and when the foot is quietly and carefully withdrawn, it will be found that a perfect counterpart of the lower half of the foot has been left in the plaster. After this has been allowed sufficient time to harden, the usual period being from two to three hours, let the foot be replaced in the mould, and having mixed the plaster as before, or of a rather thicker consistency, pour it over the toes and up the instep, so as to cover them. If any of the plaster should run round the heel while doing this, scrape it away, in order to provide for the foot's withdrawal. Previous to reinstating the foot in the mould, the foot, and edges of the mould should be oiled. When the front part has set, oil the edges near the heel and fill up the uncovered part with plaster. When the back part of the mould is dry, hold the foot up and remove the bottom part, when it will be found that the top pieces can easily be displaced. Due care must be used while handling them. The plaster round the foot should be pretty even, and as nearly as possible an inch in thickness. When sufficiently hard, oil each part on the inside, put them together, taking care to fit them nicely, and bind them, so as to hold them in position. This done, prepare your plaster of the same consistency as in the first instance, and pour it into the mould. In order to prevent the plaster striking cold to the foot, it is usual

to use warm water in the mixing. It would be as well for those who intend attempting cast taking to make their first attempts with ordinary lasts.

How to work in a Spur Box.—In doing this, the first aim of the craftsman must be to realise the proper position of the rowel, so as to avoid placing it in a position in which it is liable to strike the ground in walking. A practical or even a theoretical knowledge of the mode of using and the requirements of the spur will afford material assistance to this end. Some masters, those of the country more particularly, to prevent this, have heels in which spur boxes are to be inserted made much higher than usual. There is no necessity for this if the position for the box is rightly chosen. With stuff fitted and insoles blocked, care being taken that all the stretch has been pulled out of them, round up as usual, taking an occasional careful survey of the pitch of the last, and bearing in mind the height of heel ordered, it being at this point that the foundation for the pitch and range is laid. If the last is found to drop too much behind, round under and fetch it up to range; pursue the same course if the heels are unusually high; and if the last drops too much at the corners of the seat, insert a small wedge-shaped skiving. When rounding for shape avoid the formation of sudden corners at the joints, let the joints and waist gradually blend. Feather as usual so as to meet the requirements of the upper, graduating the width rather broader behind than at the side of the seats. In holing for sewing, let the first hole be in the centre at the back of heel. Place the box in position, to assist you in deciding the length of stitch necessary to allow the heel awl to pass under and catch a fair hold of the lifts on each side of the box in sewing the heel down. Hole otherwise in the usual manner. Keep the heel seam or stabbing rows of the stiffener perfectly straight while lasting, in order to possess a reliable guide for fixing the box upright, and sew as customary, taking great care that the two long stitches catch full hold of the upper behind. Beat up the welt, put in a stiff though not clumsy shank, which must

not reach to the box, and employ a few extra pegs to stiffen it. Hammer and fit the sole to the proper substance, tack on and peg well round the seat, laying the sole well to the boot. Round the sole, at a neat distance from the seat stitches, sufficient to cover them properly when turned over. Level for the lifts, and then take the box and place it on perfectly straight. A glance down the back seam will reveal anything misplaced. Mark off the shape of the box on the sole and cut to the inside of the mark, and then groove the inside clean and square by a small chisel or other fitting instrument. Insert a small closing awl through the groove, causing the point to escape in an exact line with the seat stitch, the hole thus made being taken as a guide for the face of the box, which will prevent the possibility of your positioning it wrongfully. Clear out the groove, place the box level with the awl mark, insert the spur in the box, and take care that it is upright, the edge of the spur wing ranging parallel with the seat. This can be regulated by changing the inclination of the bottom of the groove. Remove the box and proceed with the building of the heel, which must be built up entirely with solid whole lifts. Some, however, use the split lift, but it is a mistake. The strain on the outer edge of the split lift must affect it injuriously, inasmuch as there is nothing solid in the centre of the heel to meet the sides of the box and so hold it firmly in its position. Cut the first lift in halves, then cut quite square and place the edge of the cut to the edge of the groove, or rather over it, and a trifle over the sole at the back. Peg on firmly and rasp level. In the next lift, cut out a piece the shape of groove, peg on and rasp level. A groove is now formed for the box ; but the wings of the same must be provided for, by taking away pieces and so forming grooves in which they can be fitted. Force the box from behind into its proper place and drive a small tack through each of the holes, and if the lifts in position should fail to reach the level of the box, cut another to the desired shape, place it, and tap it with the hammer sufficiently hard to leave the impression of the box on it,

Cut a groove of the shape of the impression to fit the box snugly, and peg the piece on, taking care to drive as many pegs as are necessary immediately round the box. This done, level and proceed to build the heel as usual. Before sewing, however, tack the projecting ends of the lifts together at the face of the box. In sewing down the heel, a smart blow with the hammer at each stitch before pulling in, will assist to settle the heel solidly, and relieve the strain on the thread. Take out the awl marks when the heel is sewn, pane up the seat, round and pare the heel, care being taken not to round too close to the box, after which there will be barely any necessity to touch the face. Break in seat, nail top piece, file off, work up face of heel with file, scrape, and pass a fine file over the face of box. Sand-paper, colour, and finish as usual. A piece of leather greased and dipped in emery powder, rubbed on the box, will give it a finishing polish.

Bellows' Tongue.—In Fig. 58, the tongue is shown doubled outside the throat of the boot at B, so that one

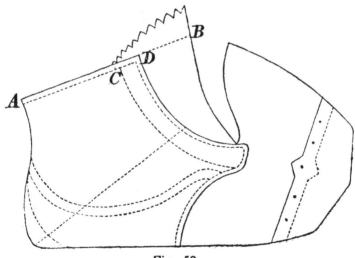

Fig. 58.

half of it is seen. A little consideration will show that three measurements are necessary to settle the size of the principal parts of the tongue. First, the length; second, the width across the top; third, the width across the

bottom, or parts joining on to the vamp. Before these
can be got it is necessary to learn the width it is intended
to have the opening at the bottom, and the length of the
lace part of the leg and the heel measure.

It is evident before the foot can go into a boot, the front
of which is entirely closed, that the opening or throat of
the boot must be at least equal to the heel measure, as
shown by dotted line, across top of leg and tongue, for, as
the heel is the broadest part of the foot it must be as
broad as this before the foot can get in, consequently the
two sides of the top of the leg and the tongue projecting,
as in A B (Fig. 58) must be equal to the heel measure at
least. The bare length will be equal to the opening of
the leg, or lace part of the leg, or from the top of the vamp
to the top of the leg. In this calculation, the part of the
vamp which laps over the tongue must not be reckoned.

In Fig. 59 we have the rule for cutting the tongue of
its bare size. Cut two patterns of the uppers, mark on

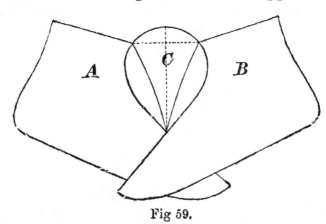

Fig 59.

the front the height you intend to have the vamp, place
the patterns together at this point as shown, A being one
leg, B the other, open them out at the top until between
the two legs you have the difference between the leg
measure and heel measure ; say the heel measure is 15 in.
and the leg measure 9 in., then 9 from 15 equals 6, which
will be the width across the tongue at c; take your measure
and hold it down at the point where the legs meet and

draw the arc at the top of the tongue. When you have drawn the arcs at the side you will have the bare size of the tongue.

To increase this size to the size required for closing, draw the bare size of the tongue as in Fig. 60, in which the method of marking up the tongue is given. The diagram shows the stabbing lines; A and B show the centre crease.

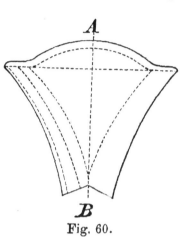

Fig. 60.

But it must here be noticed, that it will be necessary to give about half an inch more play at the top, so that the foot may go in easily, and for loss in closing.

Fig. 61 is a drawing of the boot made up.

It may, perhaps, be necessary to say that a difference in the way of closing the tongue would cause a difference in the size, but not in the shape; sometimes these boots are closed so that the tongue becomes a lining for the lace lap; in this case, it is evident that it will require an extra inch on each side. In the commoner class of work, the legs are made of heavy grain, the tongue only comes to the front of the leg

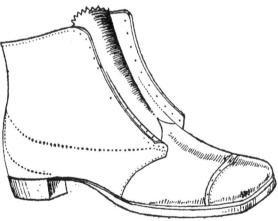

Fig. 61.

about a quarter of an inch behind the eyelets, and, in this case, the tongue will be two inches less in width than the increased size given. The best makers hold that the tongue should be blocked, and we are of the same opinion,

for the curves of the various parts cannot lap over each other clean, unless they are formed like a Wellington front to suit the shape of the front of the leg. If blocked, they should be cut larger than the pattern, and the two edges whipped together, they should then be stretched over the block until they assume the form of the front of the leg.

Before fitting the tongue crease it down the centre. Place the quarter's edge and the edge of the tongue together in the clams and stab the two edges together; then lay the tab of the vamp on the tongue and stab it across, and having made a second fold of the tongue for the line of the second row of stabbing, stab it to the leg.

A Turn-over Back-part is made by taking a piece of morocco and sewing it in round the seat level, and after it has been pared off close to the stitch, placing a lift on and squaring it up close. It should be brought quite thin at the corners of the seat and fully cover the seat stitch. After the rand has been pasted, it must be turned over and strained slightly with the pincers. Tack it over, leaving no foul leather, set smooth with the iron and round the seat. When dry draw the tacks, skive top level, paste and draw the sole over. After being properly moulded rub it obliquely, and leave the top edge full enough to cover the stitch. After it has been channelled, stitch it with stout white silk. The rand, which must be cut full enough to cover the heel, is sewn in as a turn-over. Pare off to stitch, paste, draw the back part of the sole over, and round up the same as a plain seat.

How to Fix a Button-Hole.—The button-hole patented

Fig. 62.

Fig. 63.

by Mr. Lutwyche of the Borough, shows an extraordinary advancement on the over-sewn button-hole. In fixing the

bead to a button-piece, the projecting ends of the cord which is in the bead are tied and tightly knotted. See Figs. 62 and 63.

The flanges are then pasted and the bead pressed gently, on the wrong side of the button-piece, into *a space shaped like a button-hole* which has been previously (as shown in Fig. 64) *cut out cleanly with a small punch* sold for the purpose.

The dotted lines surrounding the three right-hand holes

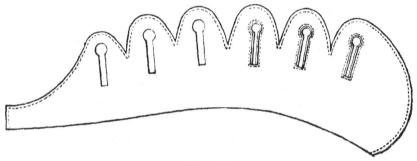

Fig. 64

are merely intended to show the outline of the beads when in position.

The inside button-fly or button-piece lining is then fitted, a mere slit in this, viz., exactly under each button-hole being sufficient, and the whole stitched *closely round the bead* in the same manner as a raw-edged button-hole would be.

Lace Cutting.—Modern shoemakers as a rule purchase their laces, a practice that assuredly does not recommend itself on the ground of economy, inasmuch as a mere youth can be taught the art of cutting them, and the material used may be picked from the waste basket. The old and common way of cutting laces may be discovered in the following instructions : Select from the discarded small pieces a bit of soft calf or mellow kip equal in substance and size to the length of lace required. Through the centre of this drive an awl or tack, and with a sharp knife cut the leather to the form of a circle. This done, cut a nick in its edge of the width of the lace, and

taking the edge of the leather as your guide, cut at an equal distance from the edge, till the released slip is sufficient to furnish a hold. At the bottom of this cut fix the cutting part of a sharp thin-pointed knife, which should be made to slightly penetrate the board in order to the keeping of it firm. Draw the awl or tack, and then holding the knife steady with the left hand and using a finger thereof to regulate the width of the cut, pull the released end till the whole of the piece of leather has been converted into a lace.

To prevent Shoes creaking.—It must be admitted that shoes that creak are a source of annoyance. This fault is easily preventible. It proceeds from one hard substance riding or rather acting on another. The obvious way of preventing this is by separating them by the interposition of a softer substance, for instance, a piece of cloth. The following mode of preventing creaking has also been recommended, but the former is the better mode. Rasp the outer and inner sole on the sides that come in contact and pursue the same course with all other surfaces that have frictional contact with each other. Prevention is undoubtedly better than cure ; but inasmuch as boots are continuously made without due precaution having been exercised to prevent creaking the following remedy is given. When a boot or shoe possesses this annoying quality, drive a few pegs through the sole at the bend. This will stop the friction, and in consequence the noise. It may be also mentioned that a too free use of paste in the waist is a known cause of this unpleasant feature. Many dispense with its use altogether at that portion of the boot.

CHAPTER XX.

BOOT AND SHOE MACHINES.

Preliminary Remarks.—The Sewing Machine.

Preliminary Remarks.—The rapid march of invention is in no trade so forcibly illustrated as in that of the boot and shoemaker. It is considerably less than fifty years since it obtained a footing and, at the time of writing, it may be fairly said to have triumphed in every department of this important industry. Victory has followed victory in such rapid succession, till it would almost appear that inventors had left no laurels to be reaped by their successors. As will be seen by a perusal of the succeeding pages, it has attacked clickers, closers, and makers, in the boot and shoe trade; in fact it would be hard to say whom it has failed to attack, and, what is more remarkable, whom it has not more or less discomforted. Soles and lifts, uppers and parts of uppers, are each cut to the desired shape at a simple stroke; stitches are set with the rapidity of lightning; and pegging, nailing, paring, and finishing are worked by magic or something closely akin to it, if magic answers in any sense to its stereotyped description.

Most of the machines, as will be shown by the descriptions that follow, are so perfect that the operator has little to do save to set them going, stop them at necessary intervals, and, in some instances, only feed them. Indeed, their action is so perfect, and the duty of their attendants so simple, that it would be an unnecessary waste of time

to attempt to teach, as we have already done in the chapters devoted to hand making.

In lieu of this, we have thought it advisable to describe each particular machine, and the work for the performance of which it has been perfected. For these descriptions we confess ourselves largely indebted to the manufacturers of these marvels of mechanical skill, who have, in all instances, most readily supplied us with the desired information.

The world would be interested to learn to whom it is indebted for the series of brilliant mechanical exploits of which we are about to furnish particulars. Unfortunately, the desire, however strong, can only be indifferently satisfied. It may, however, be safely asserted that the names of Thimonnier, Howe, Blake, the brothers Keats, Mills, Goodyear, and Cowburn, will ever take a foremost rank, nor should the name of Waller, the artist, despite of his want of success, be ignored. That many profited by his labour we ourselves could, if necessary, furnish convincing proofs.

The selection made must be taken in no sense as being invidious. Many of the machines described are known to possess more or less formidable rivals. On the separate merits of competing machines we have neither the desire nor the intention of entering. In many instances, the task of deciding, if undertaken, would be found extremely difficult, their separate claims being so evenly balanced. Those described will be found fairly illustrative of the whole and to embrace every variety of importance.

The Sewing Machine.—The introduction of the Sewing Machine was the commencement of a complete revolution in the shoemaking world. It was first employed in the tailoring and dressmaking trades, and for a time those occupied in closing did not even entertain the notion that it might be employed for closing purposes. This sense of security, or rather absence of all thought of danger, did not last long after its introduction, for within a few years of its employment in tailoring and dressmaking, its great success in the sewing of woven

fabrics suggested the possibility of employing it in the
manufacture of boot and shoe uppers. Of its success
there never was the least cause for doubt. Still there
were those who prophesied failure; how false these pro-
phecies turned out to be, may be realised in the fact that
hand closing has almost ceased to exist. The invention of
the sewing machine has been claimed by and for Mr.
Howe, an American, but the justice of this claim is, to say
the least, open to doubt. Howe's first patent was taken
out in 1846. By referring to the lists of patents taken
out in this country in 1790, under the date of July 17,
it will be found that one Thomas Saints, of Greenhill
Rents, in the parish of St. Stephen's, London, applied for
a patent for a machine for fastening soles to uppers.
From the plan of the machine given, it will be seen that
it was provided with a spool for the thread, an awl for
piercing the leather, and a needle with an eye at top for
carrying the thread through. There is even a yet older
patent for a machine for working fine thread and muslin
by a needle with two points, obtained by one Charles
Weisenthal in 1755. The Weisenthal machine worked a
simple tacking or chain stitch. In 1835, Mr. Walter
Hunt, of New York, succeeded in producing a machine
capable of forming a lock-stitch by the use of two con-
tinuous threads; but it failed to satisfy its users from the
absence of a tension regulator. The novelty of using an
eye-pointed needle is claimed for a machine invented by
Messrs. Newton and Archbold in 1841. Their machine
was intended for tambouring the backs of gloves. In the
following year, 1842, a machine was patented in America
by Mr. John Greenough. The advance claimed to have
been made by this invention consisted in its capability
of producing a close imitation of the shoemaker's stitch
with a single thread by the employment of a double
pointed needle. This was neither more nor less than a
resuscitation, the credit of the invention belonging to the
German inventor, Weisenthal. In 1843, a machine was
produced that worked a running stitch by the aid of two
toothed wheels. These wheels, working together, crimped

the material, and forced it against a stationary needle. This machine was the invention of Mr. Bostwich. In 1844, an embroidering machine was invented by Messrs. Fisher and Gibbons, of Nottingham, which by means of a needle and shuttle formed the lock-stitch. This invention was the backbone of the Grover and Baker Sewing Machine. It was a few years after the last date given that Mr. Wickershaw produced the first practical feed motion. This motion was obtained by the use of a rough-edged wheel, the top of which ranged slightly above the plane of the work table. The motion was intermittent, the work being kept stationary by a pressure plate. This was succeeded by the four-motion feed produced by the use of a flat serrated plate, to which was given both a horizontal and vertical motion. The last motion was considered a great improvement on the wheel motion. The wheel-feed needle was confined to one side of the feeding surface; in the four-feed it could operate in its centre. Thimonnier, a Frenchman, was, however, the first to produce a really practical sewing machine, its production dating a few years previous to that of Elias Howe. By some unaccountable delay this was not placed in the Exhibition of 1851 till the prizes were awarded. Still, that Thimonnier's machine was employed for sewing purposes, and that successfully, before the Howe machine, is proved beyond all doubt. Howe's machine was the very essence of crudeness. It had neither feed motion nor eye-pointed needle, and its inefficiency is further sustained by the fact that it was sold for the paltry sum of £50 to Mr. Thomas, into whose service its inventor ultimately entered. It is worthy of mention that Charles Barlow showed a machine for sewing woven fabrics in the Exhibition of 1851, that worked with two distinct stitches, separately fastened, one of which appeared on the front and one on the back of the fabric. In the various Exhibitions that followed, there were numerous exhibits of sewing machines.

The chief stitches produced by sewing machines are shown in Figs. 65, 66, and 67; Fig. 65 represents the

single loop or chain-stitch; the second (Fig. 66) the double chain-stitch; and the third (Fig. 67) the lock-stitch. The first is generally condemned for its untrustworthiness, except for special kinds of work. The second or double chain is mostly used for embroidering. The lock-stitch is that most generally approved for all general purposes, from the fact that the locking renders it more reliable than either of the others. The first is formed like the crochet stitch by means of a hook that passes through the material, catches the thread and pulls it through on its return. The second is worked with two threads, the upper one being carried by an eye-pointed needle

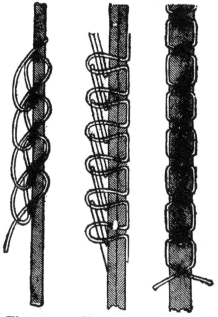

Fig. 65. Fig. 66. Fig. 67.

which passes through the material and through a loop in the under thread. The lock-stitch is produced by the aid of a needle and shuttle. The machines we now posssess owe their perfection to the efforts of rival inventors and a multitude of improvers. Those whose trade the employment of the machine threatened, namely, the closers, laughed at the idea of its succeeding, and busily employed themselves in showing that injury to a single thread ruined the whole; but subsequent improvements (the introduction of the lock-stitch, for instance) speedily convinced many that hand-closing had met with a formidable rival. Despite of all opposition, machine-closing continued to prosper, and ultimately its economic advantages were, as already stated, almost universally admitted. For a considerable number of years after its introduction its employment was confined to short-work; but eventually, by the employment of a long arm. at the

end of which the needle worked, the great difficulty of closing long work, such as Wellingtons, &c., was got over. The following remarks are applicable to the majority if not to the whole of the machines employed for boot and shoe manufacturing purposes, as well as to the sewing machine to which we are now specially drawing attention. In the purchase of a sewing machine it is a mistake to allow lowness of price to influence choice. Since the chief patents have run out, the great aim of makers has been to undersell each other, and the result has been that a large number of machines fashioned from inferior metal are constantly being made and sold. The metal used in many cases is found to be totally incapable of resisting the frictional wear and tear to which such machines are of necessity liable, and, as a natural result, after a few months' use they are worth little, if any more, than they will fetch as old iron. Their working parts become loose, and the strain of the power employed is shifted from its proper bearing, and constant breakdowns are inevitable. This using of iron that can be cut with a knife, like butter, is a huge imposition upon purchasers. The harder the metal, the larger the amount of labour required in the fitting, and the greater the destruction of files, &c., employed for that purpose. It is the extra cost of labour and tools, rather than the saving effected by the use of softer and inferior metal, that prompted the practice of which we complain.

The successful employment of the unwaxed thread sewing machine for the manufacture of boot and shoe uppers prompted inventors to turn their attention to the realisation of a sole-sewing machine, that is, a machine for fastening the soles of boots to the uppers. It was not long before it became evident that hand-labour in this department of the boot and shoe industry was threatened. Workmen were loth to recognise the fact, and, in conformity with precedents innumerable, laughed, or pretended to laugh, at the idea of forcing a waxed thread through sole and welt, or outer sole, inner sole, and intermediate packing. The sole-sewing machine was not the only rival

that threatened hand-sewing at this period. Evidently the invention of the sole-sewing machine set men thinking on the possibility of discarding awl and thread, and this resulted in the introduction of riveted and pegged work. What battles were fought concerning these fresh innovations, it is the duty of the historian rather than ourselves to chronicle. We will, therefore, rest content with recording the fact that the men were beaten, as they ever must be, if they undertake to war against the inevitable. The first sole-sewing machine, like its predecessor, was far from being perfect on its introduction, but, by a variety of subsequent improvements, its sewing capacity, and that of others of which it proved to be the forerunner, is now considered close upon perfection, machines of this class being now equal to the production of either welted or pump work. The success of the sole-sewing machine has been, to say the least, marvellous, and no event that has ever occurred, or is likely to occur, has or can be expected to effect so complete a change in the shoemaking industry. The difficulty of employing a waxed thread was thought by many to be unconquerable; it is now known that a thread so prepared is as easily forced through a piece of leather of ordinary thickness as a common thread is passed through a piece of common calico by an ordinary sewing-machine. The unwaxed thread machines employed in the closing of uppers are those commonly used by tailors, dressmakers, and for household purposes. They are too well known to need describing. Machines of this class, with certain suitable modifications or additions, appear to be capable of performing sewing or embroidering operations; and a specially constructed machine that may claim to belong to this order is now pretty generally employed for sewing button-holes, which has ever been considered a most difficult and delicate operation. We will now proceed to treat of each separate machine employed in the boot and shoe industry.

CHAPTER XXI.

LEATHER CUTTING, SPLITTING, AND ROLLING MACHINES.

Lining Cutting Press.—Leather Splitting Machine.—Upper Leather Splitter.—Leather Rolling Machine.—Range Cutting Machine.— Sole Cutting Press. — Sole Rounding Machine. — Lift Cutting Machine.

THE splendid series of mechanical triumphs we are about to describe are, with few exceptions (those exceptions being distinctly pointed out), the property of the English and American Shoe and General Machinery Company, Limited, and may be seen in operation at their offices, Worship Street, Finsbury, E.C. Our thanks are herewith tendered to the company for the valuable assistance given to us in the completion of this portion of our task, and for their courtesy in having placed the illustrations at the disposal of the author.

We have endeavoured as far as possible to group the different classes of machines employed in the manufacture of boots and shoes. The class of machines ranged under the present heading are placed in a foremost position from the fact that their use precedes that of all others; their special purposes being to prepare the leather and reduce it to proportions and shapes adapted to facilitate and render more perfect the after processes of manufacture. Their employment has resulted in an immense saving of labour, and, from the fact of little skill being required upon the part of the attendants, less costly labour is usually requisitioned.

Lining Cutting Press.—Fig. 68. This is almost an

exact reproduction of the sole cutting press, and its cutting motion is obtained from eccentrics, the cutting block

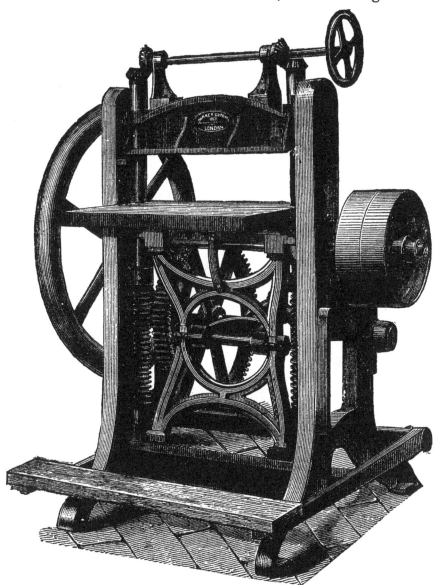

Fig. 68.—Lining Cutting Press.

being carried upon a tray running in and out on wheels. The press has a continuous motion, the block being withdrawn from under the platten in order to the removal

of the cut linings and the readjustment of the knife, and
returned without any stoppage of motion. Purchasers
who prefer a cessation of motion after each cut can be
supplied with a machine with a clutch on the main shaft,
which causes the necessary stoppage. In a machine so
supplied there is no necessity to remove the block from
under the platten, the stoppage giving ample time for
arranging material and removal and replacing of knife.
When the upper is cut in one piece it requires to be
blocked. This is performed by a blocking machine,
in which the upper is doubled and the instep shape is
imparted to it by the pressure supplied by the machine.
By the entire blocking process the flat piece of lining,
previously cut to the requisite shape, is made to assume
the true shape of the upper.

Leather Splitting Machine.—On contrasting this
machine (Fig. 69) with the Upper Leather Splitter, it

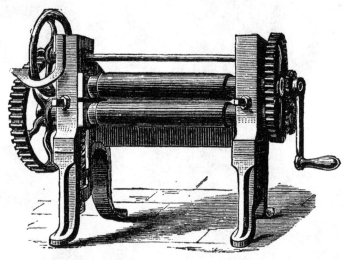

Fig. 69.—LEATHER SPLITTING MACHINE.

will be seen that no special description of the action of the
Leather Splitting machine is required. It is quite true,
as the manufacturers of this machine state, that there is
an immense advantage to be gained from a manufacturer
being supplied with leather of a uniform substance when

it is intended to be used up for a special class of goods. In the olden time the thinning-down process resulted in a great waste of material. This waste is put an end to by the employment of this machine, the split-off portion,

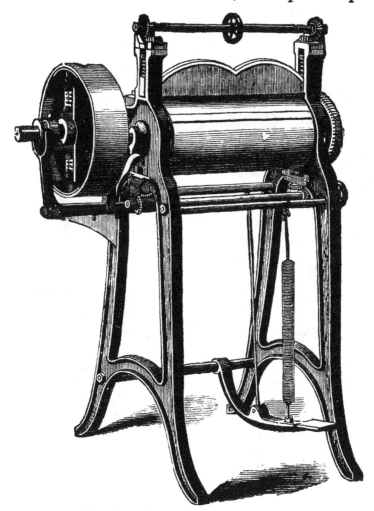

Fig. 70.—UPPER LEATHER SPLITTER.

however thin or thick it may be, retaining from its evenness of substance its proportionate value.

Upper Leather Splitter (Fig. 70) is an exceedingly useful machine employed for splitting purposes. In the event of upper leather, calf, kip, &c., being too thick for a

given purpose, its substance can by its aid be reduced without waste by taking a skiving off or fairly splitting it in half. The skin is seized by its edge and forced round a cylinder, the knife meeting it being adjusted to the substance required.

Leather Rolling Machine.—In boot and shoe factories the rolling process for hardening leather has long since

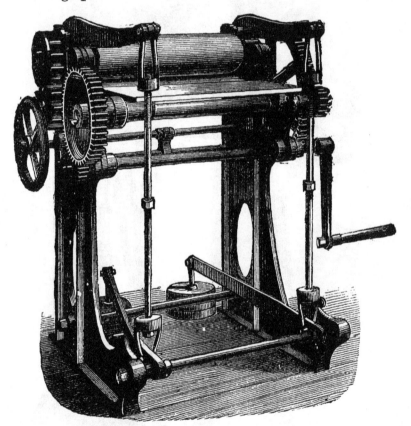

Fig. 71.—LEATHER ROLLING MACHINE.

banished the old method of solidifying by beating. This machine consists of a stout framework and movable weights attached to levers, the lower one being easily raised or depressed by movable wedges, the disposition of which is controlled by a shaft with left and right-hand screw. The pressure applied can be made greater or less at the will of the attendant by means of the hand-wheel

shown in figure. The leather may be subjected to the action of the machine in either a wet or dry state.

Range Cutting Machine.—This machine is driven by steam and the power applied by a multiple of gearing. The cranks on the outer ends of the counter shafts are attached to vertical rods, joined to the sliding head to which the knife is fixed. The machine is provided with a wooden bed and has an adjustable gauge by which the widths of the ranges are regulated.

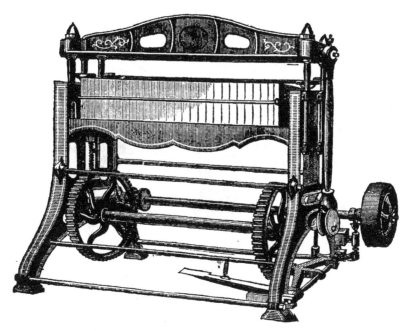

Fig. 72.—RANGE CUTTING MACHINE.

The butts from which soles, &c., are cut are, as a rule, manufactured from the thickest obtainable hides. Fully twelve months were formerly spent in their tanning. By the method now employed, known as "the Vacuum process," this lengthened period has been reduced to two months, and even less. It may be easily understood that this increased speed in the manufacture of leather has conferred great advantages on those engaged in the tanning industry, inasmuch as a much larger out-put can be insured without any increase of capital.

Sole Cutting Press.—This machine is provided with a rising running tray to which is secured the cutting-board. By an arrangement of inclined planes this board can be raised to compensate for the wearing away of its surface. The cutting motion is obtained by eccentrics. The table is carried on four rollers that work on runners, to facilitate the adjustment of the knife on the range of leather. When so fixed the tray is pushed under the sliding head, which, descending, gives the pressure by which the cut is effected. This machine will also cut uppers and linings.

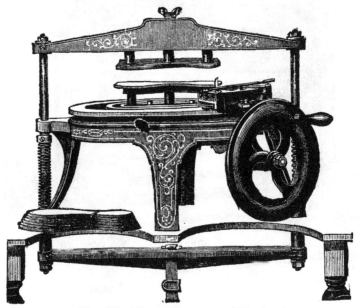

Fig. 73.—SOLE ROUNDING MACHINE.

For the latter, in consequence of the great length of the material from which they are cut, a supplementary tray is provided. The lining material, as described elsewhere, is acted upon in folds and several pairs cut at a single operation. In some machines of this class, the action of the head is continuous, in others intermittent. The knives used are formed to the shape desired. When not kept in stock to the shape wanted they can readily be obtained by giving a special order. The price varies with the different makers.

Sole Rounding Machine.—This machine (Fig. 73) is used, as its name implies, for sole rounding purposes. The leather intended for soles having previously been cut into ranges, is placed within easy reach of the operator. The sole stuff thus prepared is passed between the pair of templets situated above the bed plate, the lower being a

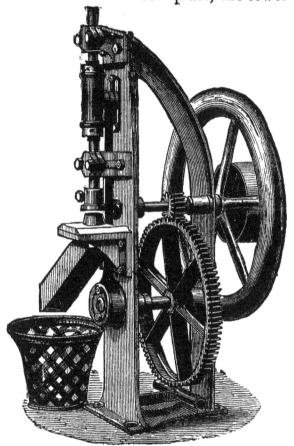

Fig. 74.—Lift Cutting Machine.

fixture. The upper templet is fixed to the cross-head, at either end of which is a side bar with a coiled spring.

On the operator pressing the lever with his foot, the upper templet, descending, presses and holds the sole in position till cut and rounded to pattern. The mode by which this is accomplished will be readily understood when we state that a carriage with a knife travels, on the

bed-plate of the machine, round the templets thus closed. The knife is provided with play enough to admit of its cutting the waist or narrowest portion of the sole, or to cut a bevelled or straight edge. The power by which the knife-carrying carriage is driven is communicated by suitable wheel gearing hidden beneath the bed-plate. This is set in motion by the operator turning the wheel shown on the right of the figure. This machine is capable of rounding one hundred soles per hour to any pattern, and dispenses with the use of steel dies and presses.

Lift Cutting Machine.—This machine (Fig. 74) is specially adapted for cutting lifts, small pieces of leather, mill board, linen, or other material. Lifts, top-pieces, washers, &c., are cut much more readily by this machine than by the ordinary eccentric press. Its knife is a fixture, while that of the press is loose, and requires to be shifted after each cut. The Lift Cutting Machine is made in two ways, either with the knife stationary and fixed edge upwards on a bed, or edge downwards on what may be called the pressure rod, the upward and downward movement of which it of course follows. In the first, the lifts, top-pieces, &c., fall as cut through the knife into a basket beneath, while in the latter, the lifts pass upwards through the knife and are carried by means of a shoot to a similar destination. It can be worked by steam power or treadle.

CHAPTER XXII.

MACHINES EMPLOYED FOR PREPARATORY PRO-CESSES—UPPER SPLITTING, SKIVING, &c.

Douglas's Patent Upper Skiving Machine.—The Tripp Rand Splitter.—Rand Turning Machine.—Strip Cutting Machine.—Channel Cutting Machine.—Sole Moulding Machine.—Patent Magnetic Lasting Machine.—Mackay Tacking on Machine.—New Utilisers.

Douglas's Patent Upper Skiving Machine.—Upper skiving machines, at the time of their first introduction, met with a hearty welcome. The old process of skiving by hand was a delicate operation, and not always certain of being successfully performed. In many instances, indeed, it was very badly performed, and the integrity of the work was thus not unfrequently endangered. This machine (Fig. 75) possesses the advantage of a simplified action, and for that reason, if at all carefully used, is not likely to get out of order. Another recommendation will be found in the limited space it occupies. By the aid of this useful mechanical helpmeet much time and labour may be saved. By a simple operation this machine is easily adjusted to skive uppers to any substance. The changes are regulated by the wheel. If turned towards the operator the substance of the skiving will be found to be lessened, and thickened if the turn be made in the opposite direction. The pressure on the roller requisite for carrying the work through is regulated by a screw. It may be remarked that in skiving corners or small curves no more pressure than is necessary should be employed. The knife is kept as close as possible to the top roller and the

stud, but not so close as to touch the roller. In skiving the corners and sharp turns of the upper, the stud acts as

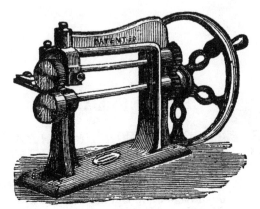

Fig. 75.—UPPER SKIVING MACHINE.

a guide. It is almost unnecessary to remark that the knife should be kept well sharpened. This machine is manufactured by Messrs. Buchanan, Brothers, Bristol.

The Tripp Rand Splitter.—In setting this machine for cutting welts and rands the knives are adjusted by means

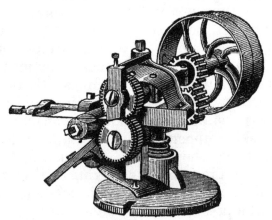

Fig. 76.—THE TRIPP RAND SPLITTER.

of screws. The distance between the feed rolls is similarly adjusted, and so also the tension of the spring. When

the rands are cut they are passed through another machine called a "Chase Skiver," by means of which all inequalities are removed. An adequate amount of pressure can be applied by this machine (the amount of pressure being at the option of the operator.) There is yet another machine employed to level and groove the edges.

Rand Turning Machine.—This clever invention (Fig. 77) is capable not only of turning but crimpling split lifts. This machine is furnished with a driving spindle, on the end of which is fixed a steel rose head with radiating angular grooves, against which the rand, previously bevelled, is firmly pressed by a spring lever,

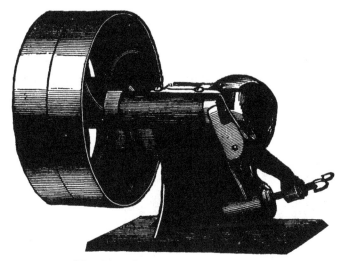

Fig. 77.—RAND TURNING MACHINE.

and as a spindle is driven the rand is seized by these angular grooves in the rose head, and discharged from the machine ready for use. When turned the split lift appears as though turned by hand. The object of the split lift is to give the necessary concavity to the inside of the back part of the boot in order that it may allow the heel to bed in properly.

Strip Cutting Machine.—This machine (Fig. 78) consists principally of a frame and a series of circular

knives and a roller. The two latter are arranged to work

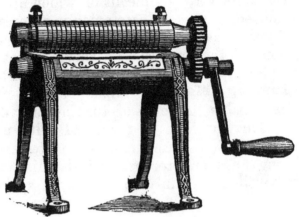

Fig. 78.—STRIP CUTTING MACHINE.

in unison. It is equal to cutting several thicknesses of calf at a time, and of any breadth.

Channel Cutting Machine.—This machine (Fig. 79) is employed for cutting the groove in which the stitches are

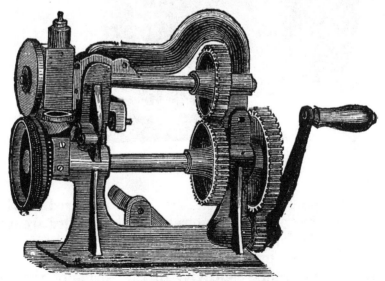

Fig. 79.—CHANNEL CUTTING MACHINE.

ultimately buried. The soles being uniformly cut, the edge of the sole acts as a guide and insures the whole length of the channel being cut a uniform distance from

its outer edge, the distance being changeable at the will of the operator to suit any kind of work. This machine is usually attached to a suitable bench. In the upper part, proper gear being furnished, it is readily worked by hand. The upper portion has two horizontal spindles, to the topmost of which is fixed a feed wheel, the circumference of which is notched. The lower has a brass drum with a perfectly smooth surface, which acts as a guide wheel. The drum is separated by the action of a lever from the feed wheel, so as to allow of the sole being inserted. The knife for cutting the channel is fixed in a vertical position to the frame over the drum, and that for feathering the sole's edge in a lateral position at the side.

On the treadle being liberated, the sole which has been placed between the feed wheel and drum is then held firmly in position, and being set close against the knives by the attendant, the feather and channelling are completed.

The Sole Moulding Machine.— By this machine soles, middle soles, and shank-pieces can be readily moulded to the required shape. It is extensively employed in America in connection with the magnetic laster and the tacking-on machine. It consists, as will be seen by reference to Fig. 80, of an upright frame with an adjustable head to which one half the sole pattern is attached. The bed beneath holds the corresponding half and has an up-and-down motion produced by a powerful toggle movement which communi-cates the necessary pressure to the sole, middle or shank piece, which is placed in the lower half pattern.

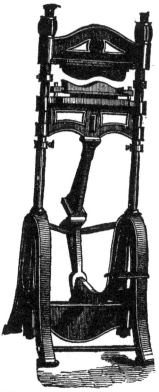

Fig. 80.—Sole Moulding Machine.

Patent Magnetic Lasting Machine.—No machine yet invented has been found equal to the complete lasting of a boot or shoe. That shown in Fig. 81 and described as in

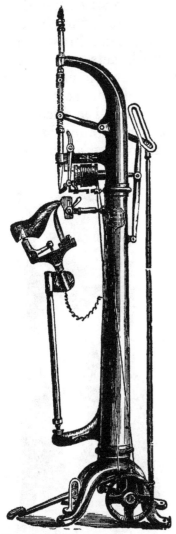

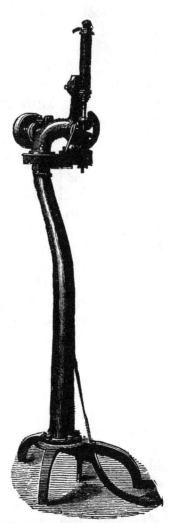

Fig. 81.—Patent Magnetic
Lasting Machine.

Fig. 82.—Mackay Tacking-
on Machine.

heading, has, however, all but accomplished this exceedingly difficult undertaking. The insole is laid on the last and the upper drawn over and tacked at the toe. The

last, so furnished, is fitted on to a movable jack. At a properly regulated distance over the last, a hammer having a magnetised face is stationed. As the operator draws or arranges the upper he touches the treadle with his toe, when the hammer, picking up a tack, automatically delivered from the tack reservoir, drives it and so secures the upper. The drawing of the upper is beyond this, and we believe all other similar inventions.

The Mackay Tacking-on Machine.—This machine (Fig. 82) consists chiefly of a hammer, guides, gauges, suitable feed motion, and cutting arrangement for severing the tacks from the prepared slip. It is used for driving the necessary tacks into the channels to secure the outer sole to the inner, preparatory to the boot being machine sewn or riveted.

New Utilisers.—The object of this machine is to use up the small waste pieces that result from sole cutting, and all such small pieces that are otherwise useless, and to produce good lifts, any size or thickness, and of a quality far superior to ordinary lifts, cut from offal. No skilled labour whatever is necessary for the working of this machine, and a girl of fifteen can produce from one hundred to one hundred and fifty of these lifts per hour, after ten minutes' instruction. Messrs. Pearson & Co. are the makers.

CHAPTER XXIII.

UPPER CLOSING AND SOLE ATTACHING MACHINES.

The Improved National Closing Machine.—Blake Sole Sewing Machine. The Improved High Speed Sole Sewing Machine.—Welt or Forepart Stitching Machine.—Keats' Fair-Stitching Machine.—The New Welt Sewing and Sew-round Machine.—Standard Screw Machine.—Pegging Machine.

The Improved National Closing Machine (Fig. 83) is

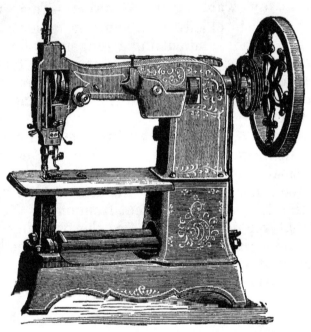

Fig. 83.—NATIONAL CLOSING MACHINE.

specially adapted for closing uppers. It produces a chain or single loop-stitch.

The awl and the accompanying parts are fitted to work in the most perfect unison. The following is an abstract of the instructions issued by the makers. The awl, which passes through a slot in the throat plate, must be fixed firmly to the bar by a fixed screw, the hook must be fastened in the bar with the set screw, the barb towards the operator, but slightly inclined to the right. When the awl and hook come nearest to each other, the space between them should measure an eighth of an inch. The machine can be easily adapted for the heaviest description of work by the mere loosening of a nut, and changing the position of the connecting link. The cast-off is set by means of a screw. The thread guide must be set to lay the thread under the barb, just as the hook is about to descend. The pressure foot is lifted by means of a lever, the extent of lift being easily regulated by a screw. The feeding must be arranged to take place when the pressure foot is free from the material, and can be regulated by loosening the set screw in the driving wheel and turning the wheel on the shaft. The length of stitch is dependent upon the position of the stud in the slotted arm, which can be shifted at the will of the operator after he has loosened the wing nut. The operator must see that the cast-off does not rub against the body of the hook, that the hook in its descent follows the line of the awl, that there is sufficient friction on the cast-off bar, that the point of the cast-off is kept smooth, the screws fast, and that the point of the awl does not come in contact with the needle. Though occupying but little space, this is a powerful machine, and is equal to the closing of the thickest uppers.

Blake Sole Sewing Machine.—Inasmuch as the special machine we are about to describe was the forerunner of all other machines of this class, a slight sketch of its history may be safely ventured upon. The merit of conceiving and working out the idea of forming a sole sewing machine undoubtedly belongs to Lyman R. Blake, of Abingdon, Mass., America. After being duly protected by royal letters patent, this invention was introduced to the English trade in 1859. From the specification we gather that the

purpose of the invention was to attach soles to uppers by a process that differed materially from that practised by the hand-sewer. The mechanism is described as consisting of an apparatus operating with a hook or crotchet-needle, which pierces the outer sole, inner sole, and upper, from without the boot or shoe (the last being removed), and uniting the solid parts by a seam formed by interlacing loops of the same thread, without drawing the end or ends and the unused length of the thread through the parts every time a stitch is formed, as is the case with hand-sewing. The sole may be channelled on the outside, so that in sewing the chain or interlocking of the loops is drawn into the groove, which covers it from sight, while the plain side of the seam comes within the shoe against the foot, the sewing being of the description which is generally known as the chain or tambour stitch.

An important alteration was made in this machine in 1864, whereby the horn instead of remaining stationary was made to revolve. This improvement has been followed by others, all of which have largely contributed to the perfecting of this wonderful piece of mechanism.

This machine may be taken as being the best all-round machine. It is equal to both light and stout work, and can be used for a light dress boot or a stout navvy's. In preparing the work for the machine it is necessary to put half-a-dozen blinders round the forepart in order to fix the sole. The channel must be well opened before attaching the boot to the machine. By this machine the outer sole is stitched through to the inner, which should be of a good substance.

The Improved High Speed Sole Sewing Machine (Fig. 84) is supplied with a new description of gear, and the thread is wound on a cone-shaped cylinder.

Welt or Forepart Stitching Machine.—This machine (Fig. 85) will stitch the forepart of a welted boot or shoe precisely the same as it would be stitched by hand labour. The boot is fixed on the table and can be stitched either with or without a last. The machine is furnished with a *curved needle* and an awl. The holes are first pierced by

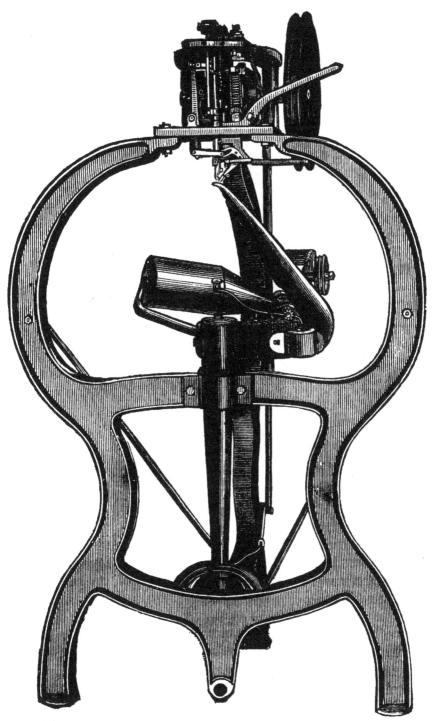

Fig. 84.—HIGH SPEED SOLE SEWING MACHINE.

the awl, and the thread-carrying needle forms the stitch, which is a single loop. The awl and needle work in unison.

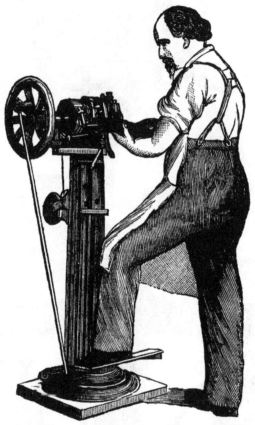

Fig. 85.—WELT OR FOREPART STITCHING MACHINE.

The awl should be positioned slightly to the right, as the machine has a right-hand feed motion.

The Keats' Fair-Stitching Machine.—The introduction of this machine (Fig. 86) may be said to have commenced a new era in the history of attaching soles to uppers, inasmuch as it stitches the sole on the welt middle sole with a lock-stitch equal to the best hand work. After the boot or shoe has been lasted, you can sew on a middle sole reaching to the heel or to the joints. The better mode is to put on a half middle sole and stitch it to the inner with the Blake Sole Sewing Machine. The outer sole being channelled, fix

it with blinders and stitch from joint to joint or from heel to heel with the machine now under consideration, using the half middle as a welt. Blake the waist if the middle

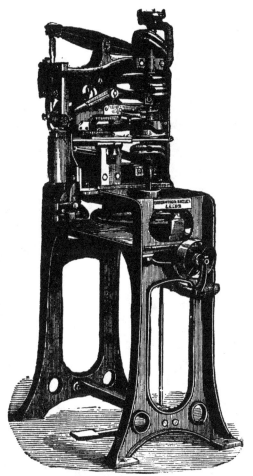

Fig. 86.—KEATS' FAIR-STITCHING MACHINE.

sole does not extend beyond the joints; but if it extends to the heel this machine will complete the stitching.

The New Welt Sewing and Sew-round Machine.— This machine (Fig. 87) is specially for making boots precisely similar to the hand-sewn welted boot. The merit of its invention belongs to Mr. Goodyear, of America. Its chief working instruments consist of an awl and needle.

The holes are first pierced by the awl, and the thread-carrying needle completes the stitching. In this machine the awl and needle require to be set so as to work in perfect unison. The inner sole is rounded and channelled as

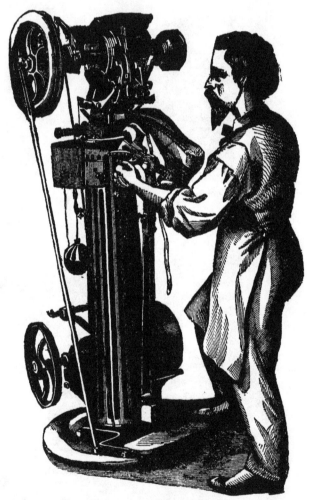

Fig. 87.—New Welt Sewing and Sew-round Machine

described elsewhere. If the boot is lasted on a wooden last, it is sewn without the use of a jack; but if on an iron last, a jack must be employed. It can be used for sew-rounds without any change, and run at the extraordinary speed of 400 stitches a minute. Boots and shoes manu-

factured by the aid of this machine possess all the advan-
tages of hand-sewn work, having no lasting tacks or pegs,
wax or thread inside to hurt the feet or soil and wear out
the stockings.

Standard Screw Machine.—The present machine
(Fig. 88) is the outcome of years of labour upon the part
of its inventor ; the boot, instead of being nailed or riveted,
is by this machine *really screwed* together, a method of
fastening long used and popular in France.

A riveted boot is only kept together by the head out-
side and the clinching of the rivet point on the inside,
assisted by the binding of the rivet in the leather ; and
after the boot has been worn a short time, it is within
every one's knowledge that the rivet is liable to *work loose*
in the leather and fall out, or to *work in* and wound the
foot, in either case leaving the boot practically unfastened.
With a screwed boot, on the other hand, the fastening
actually *holds for its entire length* in the leather, and it is
out of all question for it either to *work in* or to *work out ;*
and so firmly do the fastenings bind the shoe together,
that unless by tearing the material itself asunder, the
parts of a screwed boot cannot be separated. A boot put
together on this machine is quite smooth inside, and there
is no clinched point to turn up in course of wear, as often
happens with the old-fashioned rivet. Besides, the screw
is automatically cut off to the exact length demanded by
the substance of the work. The wire, whether of iron or
brass, is supplied in rolls with the screw thread cut.

The Pegging Machine.—The invention of the first
machine for pegging purposes is ascribed to Amos
Whittemore, a young mechanic who, as far back as 1833,
exhibited to a number of persons a machine which was
capable of punching the holes, making pegs, and driving
them with great rapidity. Various impediments to the
successful working of the machine were, however,
encountered, and eventually the young inventor put aside
his machine in disgust, and without patenting it. For
fifteen years no further step was made, and then another
machine was made by a Methodist preacher named

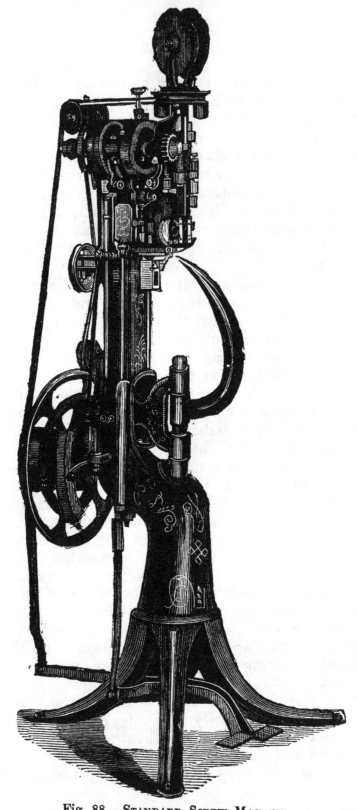

Fig. 88.—STANDARD SCREW MACHINE.

Alpheus C. Gallahue, who obtained a patent for it in 1851. Several later patents were taken out by him, and numerous patents were also granted to other persons, whence followed endless quarrels and litigations, by which several persons were ruined, and all the earnings of the machines swallowed up. Finally Sturtevant, the inventor of the peg-wood strip, compromised all the law-suits, and freed users from fear of claims from rival patentees.

This machine is self-feeding, the pegs being cut as required from a coil of wood properly gauged and pointed. Little instruction in its use is needed. The boot is prepared in the same manner as though it was to be pegged by hand; and is pegged on the last.

CHAPTER XXIV.

MACHINES FOR BUILDING, MOULDING, ATTACH-ING, BREASTING, AND FINISHING HEELS.

Heel Compressing or Moulding Machine.—Mackay Heeling Machine.—
 Inside Nailing Machine.—Latham Heel Parer.—Heel Breaster.
 Heel Building Machine.—Heel Attaching Machine.—The Cowburn
 Heeling Machine.—Sand-papering Machine.—Tapley Patent Burnish-
 ing Machine.

THE application of machinery to upper and sole sewing having proved successful, inventors turned their attention to the production of machines for heeling purposes. It speedily became evident to those who voluntarily undertook this task, that it would be easier to produce a machine or machines capable of building up and fixing prepared heels, than to copy the old-fashioned way of building them up, lift by lift, on the extreme back portion of the sole. Their labours have resulted in the machines we are about to describe. The latest machine, as will be seen, is constructed on the old lines.

The method of preparing the lifts, &c., will be found described in the chapter devoted to cutting presses, &c.

Heel Compressing or Moulding Machine.—The working parts of this machine as will be seen by referring to Fig. 89, are exceedingly simple. The lifts that are intended to compose the heel are placed in a mould or die of the required shape and subjected to a heavy pressure. A machine very similar to this was invented by Mr. Waller, a well-known artist, some twenty-five years since. The employment of this machine is confined to heels attached from the inside.

The Mackay Heeling Machine.—The mode of fixing the heels adopted by its inventor is by means of nails driven

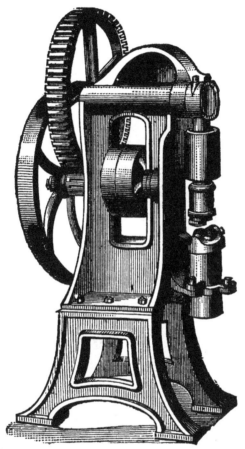

Fig. 89.—Heel Compressing or Moulding Machine.

from the top piece inwards till clinched by the inside iron last. It consists, as will be seen by reference to Fig. 90, of a tall frame fitted with a leg which carries the last on which the boot is placed. The heel, already punched and loaded with nails by a separate machine, is positioned on a plate furnished with holes and drivers that correspond to the nails in the heel. The leg is slid to a gauge. The boot is thus stationed precisely over the heel, when the machine, started by the foot of the operator, drives the nails simultaneously and forcibly home to the last which

clinches them, the boot being at the same time pressed on
to the heel. By touching another treadle, a knife is set
in motion, which, as it passes round the heel, pares it to

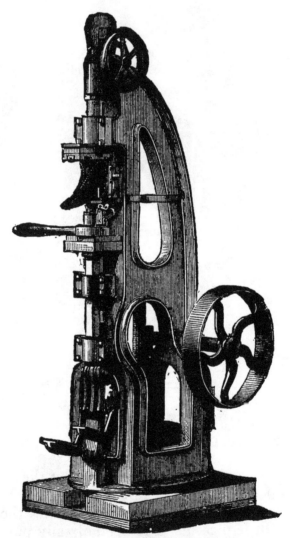

Fig. 90.—MACKAY HEELING MACHINE.

the shape required, leaving it, after application to the
sand-paper wheel, ready for the inker and Tapley bur-
nisher. By a peculiar and ingenious arrangement of the
pricking awl, the nails, although driven as stated from

the top-piece, are made to spread in their passage, and so nail the heel firmly round the seat.

The Inside Nailing Machine (Fig. 91) is another machine for attaching heels. It has also a strong frame and has an upright stump formed like the seat of a last, the top part of the stump being perforated with holes through

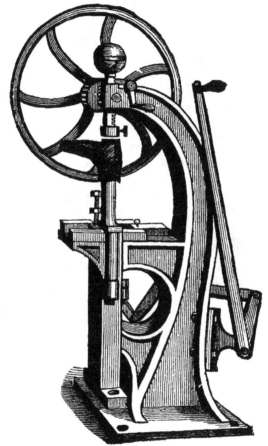

Fig. 91.—INSIDE NAILING MACHINE.

which the nails are driven by punches. When the stump has been charged with nails the boot is placed on it, the heel placed in position, and a powerful lever acted upon by the treadle, brings down the pressure plate on the top-piece which presses the heel firmly to the seat. The action of another lever, while the heel is thus fixed,

completes the nailing. The nails are made to converge as they are driven, and by a special arrangement are prevented from piercing through the sides of the heel.

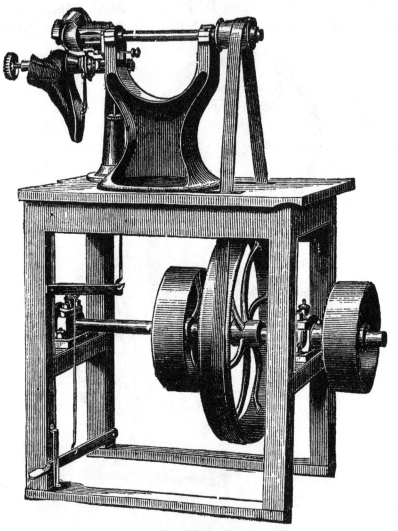

Fig. 92.—Latham Heel Parer.

The Latham Heel Parer.—This machine possesses the advantage of being exceedingly simple in its construction; hence there is small chance of its getting out of order, a fault too common with machines of a more

complex character. Most boots intended to be heeled without requisitioning the Mackay heeling machine have their heels pared before burnishing. The Latham heel parer is used for this process. The boot is affixed to a "Jack" attached to a universal joint. The boot thus held is presented to the machine so that the guide roller enters the feather while another presses against a template of the form of the top-piece when pared. By applying pressure to the treadle the boot is caused to move round slowly, when a revolving cutter, guided by these rollers, pares the heel. This cutter has four separate and distinct knives.

Heel Breaster.—This useful invention is used, as its name implies, for shaping the breast of the heel. The machine is provided with a movable stand or last, upon which the boot is fixed. This stand or last with the boot in its proper position is then slid in to a gauge immediately under the cutting instrument. The knife is shaped to the exact form of the breast and hollowed on the edge to fit the contour of the waist. The action of the knife is dependent upon the foot of the operator

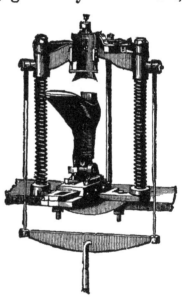

Fig. 93.—Heel Breaster.

pressing upon a treadle attached to the under crossbar of the machine. The knife is prevented from proceeding too far by the guard that precedes it coming in contact with the shank and arresting its progress, and preventing the cutting of the sole. By an. exceedingly simple arrangement by which the knife can be changed slightly to the right or left, the breast of either a right or left heel is shaped with unvarying accuracy.

Heel Building Machine.—This machine is made expressly to suit the requirements of manufacturers not having *power*, and those whose space is limited. The

method of working these machines is very simple, boys in most cases doing the entire process. The lifts are first placed in a mould, and a sprig driven through to hold them together. The sprigging block being filled with brass rivets, the mould is placed under the machine and pressed, and the top piece sprigged at one operation. The heel after being knocked out of the mould is then ready for attaching. Any size and shape of heel can be made by having different moulds and spriggers, and every heel is uniformly pressed, even if the lifts vary in substance. This, and the heel attaching machine following, are the property of Messrs. Pearson & Co., and may be seen at 141, Shoreditch.

Heel Attaching Machine.—This machine is made to attach the heels previously built by the before-mentioned machine, and is worked by hand power, and consequently has the same advantages. The horn or stand is first filled with suitable pins (length being regulated to height of heel), the boot is then put on the horn, and the heel placed in position, the pressure being applied by wheel at the top, and the pins are driven home from the inside, the heads being well buried in the insole.

The Cowburn Heeling Machine is named after its inventor, a son of the "gentle craft." This is, we believe, the latest production of its class. It is beyond all doubt a "marvel of mechanism." It differs materially from the preceding machines, inasmuch as it builds up the heel on the boot, and when the top piece is on pares it and takes out the front of the heel. The boot to be heeled is fixed on an arm or ram, the lifts necessary for the formation of the heel are delivered as required from a cup automatically, and the heel pins and brass rivets are supplied in their turn through a series of tubes. These and other complicated actions are regulated by different levers. The pins are driven by punches through insole, sole, and lifts by the ram, as are also the rivets. A perforated steel block is employed for regulating the positions of both pins and rivets. A full description of this remarkable machine would trespass too much on our space, and it is somewhat

more than doubtful whether it is possible to fully describe by words the combined and multifarious actions of a machine of so complicated a character. The machine is equal to French or imitation Wurtemburg heels in addition to those of the ordinary character. The time taken for heeling a boot by this machine averages about thirty seconds.

Sand-papering Machine.—This machine (Fig. 94) should supersede the employment of buff knife, &c., and

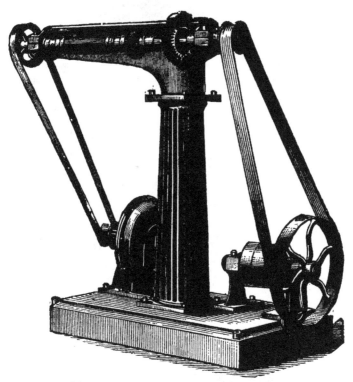

Fig. 94.—SAND-PAPERING MACHINE.

consists of a spindle which is caused to revolve with great rapidity, and upon which is mounted a plain cylindrical roller covered with paper for sand-papering or buffing off the bottom, a file to smooth the heads of the rivets, a round face roller mounted with sand-paper for smoothing off the heels, and a brush. All these run in the mouth of what is technically known as "a hood," with which is connected an exhausting fan for collecting the dust and waste

particles and removing them by means of a pipe. The

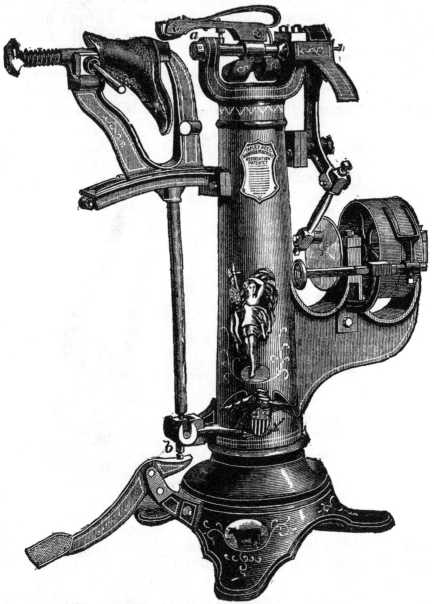

Fig. 95.—Tapley Patent Burnishing Machine.

rollers can be readily removed when recovering with sand-
paper becomes necessary.

The Tapley Patent Burnishing Machine.—This

machine is extensively employed for finishing purposes. It consists of a column supporting a shaft in continual reciprocating movement, making three quarters of a turn with each partial revolution. To the column is attached a burnishing iron, its pressure being regulated by a strong spring. This iron is fashioned of the right shape to meet the heel and is kept warm by a jet of gas that moves with it. The position of the boot when inked on the jack is shown in Fig. 95. The jack is pressed by the operator towards the column and slightly raised by means of the treadle, which brings the heel into contact with the heated iron, which, passing over its entire surface, by a few strokes imparts to the whole of its rounded surface the required glossiness.

CHAPTER XXV.

MACHINES USED FOR LEVELLING SEAMS OF UPPERS, EDGE SETTING, LEVELLING AND BUFFING BOTTOMS, &c.

Seam Rubber.—Patent Edge Paring Machine.—Blake Edge Setter.— Gilmore Leveller.—Edge Levelling Machine.—Blake Buffing Machine.—Edge Plane.—Welt Trimmer or Plough.—Heel Shave.— Self-feeding Punch.—Self-feeding Eyeletter.—General Remarks.

MOST of the machines, if not the whole, referred to in the present chapter are of American origin. Though individually of lesser importance than many of those already described, it is almost impossible to over estimate their worth to the boot and shoe manufacturer.

Seam Rubber (Fig. 96) represents an instrument for pressing seams in order that they may be made to lie

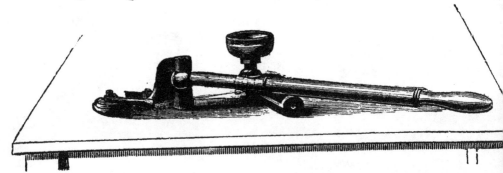

Fig. 96.—SEAM RUBBER.

flat. Weight and leverage power are regulated at the will of the operator.

Patent Edge Paring Machine.—This machine (Fig. 97) is constructed to pare the forepart edge preparatory

to its being inked and burnished. Before the operation commences the boot is fitted on an expanding last carried by a jack susceptible of easy and varied move-

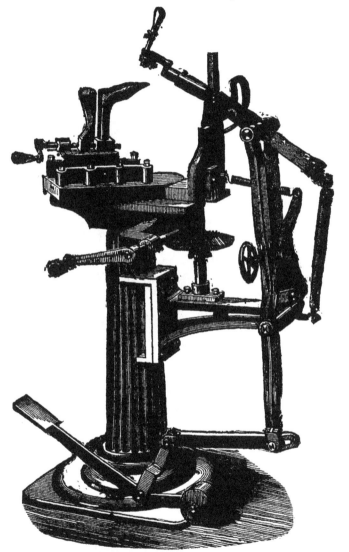

Fig. 97.— PATENT EDGE PARING MACHINE.

ments arranged to meet the varying sizes and shapes of soles and bring them within the action of the paring tool. The jack which carries the plate receives a mixed rectilinear and circular motion adapted to bring every

part of the forepart in contact with the cutting instrument. The paring instrument is modelled somewhat like a plane and is borne by a swinging arm with a universal motion. The gauge in the plane enters the feather and protects the upper. When the boot is on the last, the arm, controlled by the spring, is allowed to approach the boot. When the plane rests on its edge the jack is made

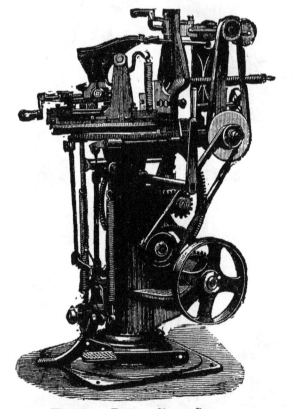

Fig. 98.—BLAKE EDGE SETTER.

to revolve rapidly, and a clean shaving is taken off the edge and also off top edge of the welt, leaving it clean and clear, either straight or hollow, and ready for inking and burnishing. Each machine is furnished with a set of nickel-plated lasts for either men's, women's, or children's work, and two paring tools.

Blake Edge Setter.—This machine is used for setting

the edges of the forepart of soles, and is used in conjunction with the Tapley heel burnisher. The two machines jointly finish the setting, saving the waist portion, which is performed by hand labour. The Blake edge setter is mainly composed of a pillar, table, jack, swing frame, and arm almost identical to those of edge parer. The action is a close imitation of that of the edge parer, a burnisher

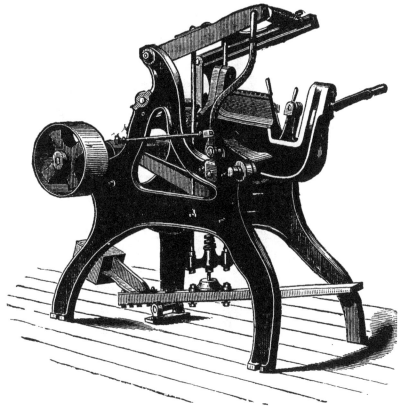

Fig. 99.—GILMORE LEVELLER.

taking the place of the cutting instrument. The machine is self-acting when started, and the operator is set at liberty to prepare for another machine alternately as each is set going.

The Gilmore Leveller.—The work of this machine is to close the channel after the boot has been sewn, and level the bottom. The boot on the last is fixed to a jack,

upon which it moves slowly backwards and forwards, the distance of the forward and backward motion being easily controlled by the operator. When this motion has been given to the jack a treadle is acted upon which brings a roller into contact with the boot. The spindle to which this roller is loosely affixed passes rapidly backward and forward, the distance being limited to a short range. In

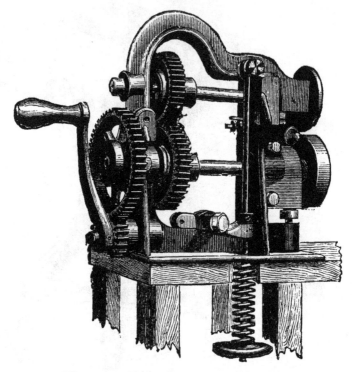

Fig. 100.—Edge Levelling Machine.

order that the rolling pressure may act upon every part of the bottom, the jack is provided with a handle by which the position of the boot may be readily changed to meet the roller.

Edge Levelling Machine.—The object of this apparatus is to reduce the edge of a sole to a uniform substance, or to skive round an insole or other piece of leather requiring a reduced edge.

Blake Buffing Machine.—This machine, of which Fig. 101 is a representation, consists of an upright column with a head which holds the chief working parts, the driving apparatus being stationed at the foot of the column. On the boot being brought in contact with the

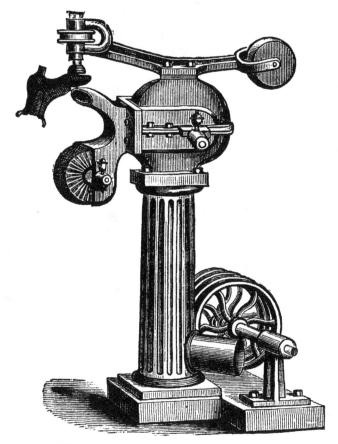

Fig. 101.—Blake Buffing Machine.

buffing surface, the rapid motion and pressure of the latter give the sole a finished velvety surface. The process is exceedingly rapid, and the result satisfactory.

The Edge Plane, Welt Trimmer or Plough, and Heel Shave are American inventions. They are so fully represented in Figs. 102, 103, 104, that no special descrip-

tion is needed. It requires some little practice to use them freely, but when used by a trained hand there is little doubt of their superiority over the knife, rasp, &c.

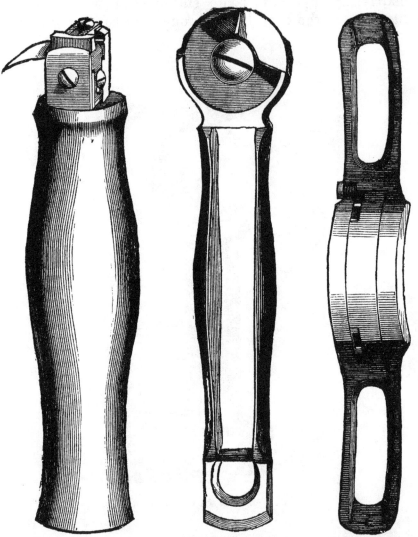

Fig. 102.—Edge Plane.　　Fig. 103.—Welt Trimmer or Plough.　　Fig. 104.—Heel Shave.

Self-feeding Punch and Self-feeding Eyeletter.—Fig. 105 portrays the Self-feeding Punch, and Fig. 106 the Self-feeding Eyeletter. The English and American Shoe and

General Machinery Company, Limited, in addition to these, possess a Self-feeding Punching Machine. This machine, after punching the hole, feeds the material and retains it at the required distances, that is, the spots where the succeeding holes are to be made. It is furnished with a gauge that regulates the distance of the holes from the edge. The change of distance is readily made by shifting the gauge, and no matter what the distance decided upon,

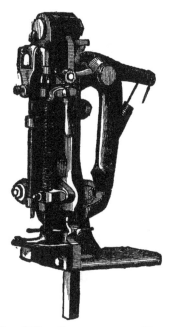

Fig. 105.—SELF-FEEDING PUNCH.

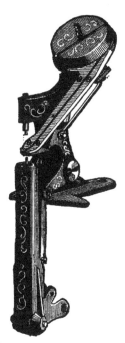

Fig. 106.—SELF-FEEDING EYELETTER.

machined Balmorals and other uppers intended to be laced are punched by this machine with unfailing regularity.

General Remarks.—In addition to the machines already named and briefly described, there are many others used, more or less useful, by the modern boot and shoe manufacturer. Indeed, their name is legion.

The divisions of labour in a modern boot-making establishment are enough to drive the great art critic, John Ruskin, mad. There is undoubtedly a deal of truth

in what he has written with regard to the evil effects of keeping a man continually engaged on one simple operation, but manufacturers will not listen, nor can they be expected to listen, to his arguments in favour of returning to old methods, nor to his lamentations over the decadence of art workmen. The team system in America and the minute division of labour in England are known to have been effectively employed in cheapening the labour cost of production, and all the condemnation that can possibly be hurled at these changes will not induce those whom they profit to discard them.

Never has so wonderful a change as that effected in the trade of which we are treating resulted in so little suffering to the workmen dependent upon the cunning of their hands. Fortunately for the seat-men, the great cost of, and necessarily high charges made for, the machines first invented, rendered masters diffident about employing them. Several years elapsed before they could be said to have obtained a fair footing. It, however, became evident that the machines would ultimately succeed, and the rank and file of the trade, acting under the advice repeatedly tendered through the pages of *St. Crispin*, set sternly to work to reduce their numbers. The result of this wise resolve on the part of the men was that the reduced number who remained engaged in the older form of manufacture, profited by the introduction of the machines, the influence of which they had so much reason to distrust, and it is a fact beyond dispute that their wages now range higher than at any former period.

Hand-made work is known to possess certain advantages over machine-made, and therefore it is not surprising to find that it still finds favour. With those who can afford to pay for it, these advantages will continue to count. It is in the ready-made or sale department of the trade that machine-sewn boots have so completely triumphed, triumphed indeed to such an extent that to attempt to compete with them seems equal to the folly of the old lady who endeavoured to repel the advances of the sea with a besom.

Perfect as modern boot and shoemaking machinery is now acknowledged to be, other improvements will undoubtedly follow. The rivalry known to exist among the various firms engaged in the production of the machines now in use, combined with the vastly improved patent laws now existing, will not only insure the retention of old inventors, but enlist the sympathy and aid of others endowed with inventive genius.

The one great advantage of machine-made boots and shoes over those made by hand will be found as stated in the great saving effected in labour, and the consequent lesser cost of production. This is charged with having led to the use of inferior leather, and the practice of splitting it into substances unequal to the wear and tear that await it when manufactured into boots and shoes. This charge is indisputably well founded, but purchasers and wearers must rest comforted with the assurance that drawbacks attend the greatest blessings.

On comparing hand-made to riveted and pegged boots and shoes, the superiority of the former is yet more marked.

The hand-closers and makers claim for their work superiority on the following grounds. First, the hand-closer has a better opportunity of regulating the tension of the thread than the machine. They declare if the shuttle-thread of the machine is over tight, it will necessarily have a tendency to lie straight rather than sink into the material. In hand-sewing they declare the threads used are prepared with greater care, and are in every sense better calculated to fulfill their office, the twist in them being better regulated, and the waxing more reliable. They say, moreover, that boots made on the knee have generally more care bestowed upon them than machine-made boots.

CHAPTER XXVI.

USEFUL RECEIPTS FOR SHOEMAKERS, &c.

Varnish for Shoes.—Jet for Boots or Harness.—Castor Oil as a Dressing for Leather.—Composition for Leather.—Waterproofing.—To Render Cloth Waterproof.—To Preserve Boots from being Penetrated by Wet and Snow Damp.—Waterproof Compositions for Leather.—Chinese Waterproofing Composition for Leather.—Polishing up Soiled Boots.—To Restore the Blackness to Old Leather.—To Clean Top Boots.—To Polish Enamelled Leather.—Softening Boot Uppers.—Cleaning Buckskin Gloves and White Belts.—To take Stains out of Black Cloth.—Liquid for Cleaning Cloth.—How to Remove Ink Stains.—Kid or Memel Colour Renovator.—French Polish for Boots.—Fluid for Renovating the Surface of Japanned Leather.—To Separate Patent Leather.—To Preserve Leather from Mould.—Balls for taking out Grease.—Mode of Using Cements.—Cementing Glue.—Fastening Leather to Iron.—Cement for Leather Belting.—Cement for Leather and Cloth.—Gutta-percha Solution.—Durable Glue.—A Black Ink.—Shoemaker's Wax.—Solution Wax.—Spankum or Bosh.—Sieburger's Paste.—Superior Paste.—A Durable Paste.—Rice Flour Cement.—Best Stiffening Boot Paste.—Blacking Receipt.—Warren's —Imitation Leather.—Margate Boots : a Warning.—Pannus Corium.—Cleaning of Sewing Machines.

Varnish for Shoes.—Put half a pound of gum shellac broken up into small pieces in a quart bottle or jug, cover it with alcohol, cork it tight, and put it on a shelf in a warm place ; shake it well several times a day, then add a piece of camphor as large as a hen's egg ; shake it again and add one ounce of lamp-black. If the alcohol is good it will be all dissolved in three days ; then shake and use. If it gets too thick, add alcohol ; pour out two or three tea-spoonfuls in a saucer, and apply it with a small paint-brush. If the materials are all good, it will dry in about five minutes, and will be removed only by wearing it off, giving a gloss almost equal to patent leather. The

advantage of this preparation over others is, it does not strike into the leather and make it hard, but remains on the surface, and yet excludes the water almost perfectly. This same preparation is admirable for harness, and does not soil when touched as lamp-black preparations do.

Jet for Boots or Harness.—Three sticks of the best black sealing-wax, dissolved in half a pint of spirits of wine, to be kept in a glass bottle, and well shaken previous to use. Apply it with a soft sponge.

Castor-oil as a Dressing for Leather.—Castor-oil, besides being an excellent dressing for leather, renders it vermin proof. It should be mixed, say half and half, with tallow and other oil. Neither rats, roaches, nor other vermin will attack leather so prepared.

Composition for Leather.—Take one hundred parts of finely pulverised lamp-black, and thirty parts of East India copal, previously dissolved in rectified turpentine. Mix the two together until the whole forms a homogeneous paste. To this is to be added fifteen parts of wax and one part of india-rubber, which has been first dissolved in some ethereal oil. When the whole is properly mixed, a current of oxygen is passed for half an hour through the mass, and after cooling, the whole is to be thoroughly worked up. It may then be packed in tin boxes, and kept ready for use.

Waterproofing.—Half a pound of shoemaker's dubbin, half a pint of linseed oil, and half a pint of solution of india-rubber. Dissolve with a gentle heat and apply. Note these ingredients are inflammable, and great caution must be used in making the preparation.

To Render Cloth Waterproof.—The following is said to be the method used in China. To one ounce of white wax melted, add one quart of spirits of turpentine, and when thoroughly mixed and cold, dip the cloth into the liquid, and hang it up to drain and dry. Muslins, as well as strong cloths, are by this means rendered impenetrable to rain, without losing their colour or beauty.

To preserve Boots from being penetrated by Wet and Snow Damp.—Boots and shoes may be preserved from wet

by rubbing them over with linseed oil, which has stood some months in a leaden vessel till thick. As a security-against snow water, melt equal quantities of beeswax and mutton suet in a pipkin over a slow fire. Lay the mixture, while hot, on the boots and shoes, and rub dry with a woollen cloth.

Waterproofing Compositions for Leather.—Melt over a slow fire one quart of boiled linseed oil, a pound of mutton suet, three quarters of a pound of yellow beeswax, and half a pound of common resin. With this mixture rub over the boots or shoes, soles, legs, and upper leathers, when a little warmed, till the whole are completely saturated. Another way is, to melt one quart of drying oil, a quarter of a pound of drying beeswax, the same quantity of spirits of turpentine, and an ounce of Burgundy pitch. Rub this composition, near a fire, all over the leather, till it is thoroughly saturated.

Chinese Waterproofing Composition for Leather.—Three parts of blood deprived of its fibrine, four of lime, and a little alum.

Polishing up Old and Soiled Boots.—If required to tell in the fewest words how to dispose of old goods, we should say, make them as much like new as possible. We would then go further, and advise never to let them get old. This may be thought rather difficult, but still it can be put in practice so far as to make it a piece of first-rate counsel. Some may think it a good plan to put the lowest possible price on them, and keep them in sight as a temptation to buyers, without taking any other trouble. But if this is a very easy effort, we think ours is far more profitable to the seller, and therefore worthy of being explained somewhat minutely. Among the things that ought to be in every shoe shop, besides the necessary tools, are blacking, gum tragacanth, gum arabic, varnish, neatsfoot oil, and perhaps some prepared dressing for uppers. With these, or such of them as may be necessary, an old upper, however rusty looking, if properly treated, can be made to shine. Ladies' shoes, if of black morocco or kid, and have become dry, stiff, and dull, try a little oil

on them—not a great deal—which will make them more soft and flexible, and will not injure the lustre materially. Then try a delicate coating of prepared varnish, designed for the purpose, over the oil. When this has dried the shoes will doubtless be improved. If a calf kid begins to look reddish and rusty, give it a slight application of oil, which will probably restore the colour; but, if not, put on blacking. When the blacking is dry, brush it off, and go over it again very lightly with the oil, when it will be as good as new. Patent leather will not only be made softer, but the lustre will also be improved, by oiling. For pebbled calf, or any kind of grain leather that has become brown, the treatment should be the same; when only a little red, an application of oil, or even tallow, will often restore the colour. When it is very brown, black it thoroughly, and oil it afterwards, giving it a nice dressing of dissolved gum tragacanth to finish. This is the grand recipe for improving uppers; the labour of applying it is very little, and the effect very decided and gratifying. For men's boots that have been much handled, often tried on, or have become rough, or dry, stiff and lifeless, from lying in shop a long time, or all these things together, another treeing is the best thing in the world, and precisely what they need. It should be done thoroughly. After putting them on the trees, a supply of oil must not be forgotten. Then a dressing of gum tragacanth, and, when it is partially dry, a rubbing with a long-stick to give a polish, after which a second and slight application of gum, to be rubbed off with the bare hand before fully dry. It is almost surprising how much a boot is renewed by this treatment, and, though it may require half an hour's time to each pair from some man who understands it, the cost is well expended and many times returned. A good supply of trees, of different sizes, should be always at hand, and not be allowed to get dusty for want of use. But when, for any reason, it is inexpedient or difficult to apply a thorough process with old boots, they can still be oiled and gummed without using the trees, and though with less good effect, yet still enough to prove very useful.

If any mould has shown, or the grease used in stuffing has drawn out of the leather, a little rubbing off with benzine would be necessary at first to clean them. After this an application of cod oil and tallow might be useful to make the leather soft and pliable; to be preceded, if the colour is a little off, by an application of a prepared black of some kind, of which there are several in the market. The soles would probably be improved by cleaning and a vigorous use of the rub-stick; they might also be rebuffed, if the stock would stand it, and a slight application of size would help to give them a polish. To do all this well requires some skill, and the expenditure of considerable labour.

To Restore the Blackness of Old Leather.—For every two yolks of new-laid eggs, retain the white of one; let these be well beaten, and then shaken in a glass vessel till as thick as oil. Dissolve in about a table-spoonful of Holland gin, a piece of lump sugar, thicken it with ivory black, and mix the eggs for use. Lay this on in the same manner as blacking for shoes, and after polishing with a soft brush, let it remain to harden and dry. This process answers well for ladies' and gentlemen's leather shoes, but should have the following addition to protect the stockings from being soiled: Shake the white or glaire of eggs in a phial till it is like oil, and lay some of it on twice with a small brush over the inner edges of the shoes.

To Clean Boot Tops.—Dissolve an ounce of oxalic acid into a pint of soft water, and keep it in a bottle well corked; dip a sponge in this to clean the tops with, and if any obstinate stains remain rub them with some bath brick dust, and sponge them with clean water. If your tops are brown, take a pint of skimmed milk, half an ounce of spirits of salts, as much of spirits of lavender, one ounce of gum arabic, and the juice of two lemons. Put the mixture into a bottle closely corked; rub the tops with a sponge, and when dry, polish them with a brush and flannel.

To Polish Enamelled Leather.—Two pints of the best cream, one pint of linseed oil; make them each lukewarm,

and then mix them well together. Having previously cleaned the shoe, &c., from dirt, rub it over with a sponge dipped in the mixture; then rub it with a soft dry cloth until a brilliant polish is produced.

Softening Boot Uppers.—Wash them quite clean from dirt and old blacking, using lukewarm water in the operation. As soon as clean and the water has soaked in, give them a good coating of currier's dubbin, and hang them up to dry; the dubbin will amalgamate with the leather, causing it to remain soft and resist moisture. No greater error could possibly be committed than to hold boots to the fire after the application of, or when applying oil or grease. All artificial heat is injurious. Moreover, it forces the fatty substance through and produces hardness, instead of allowing it to remain and amalgamate with the leather. Note this opinion about heat, and act as experience dictates. We think, if the heat be not too great, no harm will result.

Cleaning Buckskin Gloves and White Belts.—Should these be stained, a solution of oxalic acid must be applied; should they be greasy, they must be rubbed with benzine very freely. After these processes are complete some fine pipeclay is to be softened in warm water to the consistency of cream; if a good quantity of starch be added to this it will prevent this white clay from rubbing off, but the whiteness will not then be so bright. If a small quantity be used the belts will look very bright. This mixture is to be applied with some folds of flannel as evenly as possible, and put to dry in the sun or in a warm room. When dry, the gloves can be put on and clapped together; this will throw off a good deal of superfluous pipeclay. The belts are to be treated in a similar way.

To take Stains out of Black Cloth, &c.—Boil a quantity of fig-leaves in two quarts of water, till reduced to a pint. Squeeze the leaves, and bottle the liquor for use. The articles, whether cloth, silk, or crape, need only be rubbed over with a sponge dipped in the liquor.

Liquid for Cleaning Cloth.—Dissolve in a pint of spring water one ounce of pearlash, and add thereto a

lemon cut in slices. Let the mixture stand two days, and then strain the clear liquor into bottles. A little of this dropped on spots of grease will soon remove them, but the cloth must be washed immediately after with cold water.— Or, put a quart of soft water, with about four ounces of burnt lees of wine, two scruples of camphor, and an ox's gall, into a pipkin, and let it simmer till reduced to one half, then strain, and use it while lukewarm. Wet the cloth on both sides where the spots are, and then wash them with cold water.

How to Remove Ink Stains.—Owing to the black colour of writing ink depending upon the iron it contains, the usual method is to supply some diluted acid in which the iron is soluble, and this, dissolving the iron, takes away the colour of the stain. Almost any acid will answer for this purpose, but it is, of course, necessary to employ those only that are not likely to injure the articles to which they are applied. A solution of oxalic acid may be used for this purpose, and answers very well. It has, however, the great disadvantage of being very poisonous, which necessitates great caution in its use. Citric acid and tartaric acid, which are quite harmless, are therefore to be preferred, especially as they may be used on the most delicate fabrics without any danger of injuring them. They may also be employed to remove marks of ink from books, as they do not injure printing ink, into the composition of which iron does not enter. Lemon juice, which contains citric acid, may also be used for the same purpose, but it does not succeed so well as the pure acid.

Kid or Memel Colour Renovator. — Take a few cuttings of loose kid, pour over sufficient water to just cover them, and simmer them for an hour. When cool they will be of the proper consistency. Apply with the fingers or a piece of rag or cloth.

French Polish for Boots.—Mix together two pints of best vinegar, one pint of soft water, and stir into it a quarter pound of glue broken up, half a pound of logwood chips, a quarter of an ounce of best soft soap, and a quarter of an ounce of isinglass. Put the mixture over the fire and

let it boil for ten minutes or more, then strain the liquid and bottle and cork it. When cold it is fit for use. It should be applied with a clean sponge.

Fluid for Renovating the Surface of Japanned Leather. —This liquid, for which Mr. William Hoey obtained provisional protection in 1863, was described as being applicable for boots, shoes, and harness. It was composed of about 2 ounces of paraffin or rock oil, or a mixture of both in any proportion, $\frac{1}{4}$ drachm of oil of lavender, $\frac{1}{4}$ drachm of citrionel essence, and $\frac{1}{2}$ an ounce of spirit of ammonia; sometimes ivory or lamp-black was added to colour the mixture. When the ingredients were thoroughly mixed together, the fluid was applied lightly on the surface of the leather or cloth.

To Separate Patent Leather.—Patent leather is an article with which there is always more or less liability to trouble in handling and working. It is sensitive to very warm weather, and great care is needed during the cold season.

If it should stick, and cold be the cause of the sticking, lay out the skin on a wide board, and with a hot flat-iron give it a rather slow but thorough ironing around the edges, where most of the trouble exists. A couple of thicknesses of cotton cloth are necessary to keep the iron from touching the leather. When both parts are well warmed through there will probably be no difficulty about their separation.

When the difficulty is owing to hot weather, the skins should be put away in the cellar, or the coolest place within reach and left till cooled through, when unless the stick is a very strong one, they will offer little resistance to being pulled apart.

If the stick be a slight one, open it gently and breathe on it as you pull.

To Preserve Leather from Mould.—Pyroligneous acid may be used with success in preserving leather from the attacks of mould, and is serviceable in recovering it after it has received that species of damage, by passing it over the surface of the hide or skin, first taking due care to

remove the mouldy spots by the application of a dry cloth.

Balls for Taking out Grease.—Dry fuller's earth till it crumbles to powder, moisten it with lemon juice, add some pulverised pearlash, and make the whole into a paste, then roll it into small balls, and dry them in the sun. In using them, moisten with water the spots on the cloth, rub the ball over them, and leave the article to dry in the sun. On washing the spots with common water, and brushing the part, the stains will disappear.

Mode of Using Cements.—The best cement that was ever compounded would prove entirely worthless if improperly applied. In the first instance it is necessary to bring the cement into intimate contact with the surfaces to be united. This is best done by heating the pieces to be joined. In those cases where the cement is melted by heat, as in using resin, shellac, marine glue, &c., as little cement as possible should be allowed to remain between the united surfaces. To secure this the cement should be as liquid as possible (thoroughly melted if used with heat), and the surface should be pressed closely into contact (by screws, weights, wedges, or cords), until the cement has hardened. Plenty of time should be allowed for the cement to dry or harden. Where the article is to be used immediately, the only safe cements are those which are dissolved by heat, and become hard when cold.

Cementing Glue.—Fine shreds of india-rubber dissolved in warm copal varnish make a waterproof cement for wood and leather.

Fastening Leather to Iron.—Reduce nut-galls to powder, dissolve in eight parts of distilled water, and, after they have soaked six hours, filter through a cloth; and the decoction thus produced is applied to the leather. Take the same quantity of water as that used for the nut-galls, and place it in one part (by weight) of glue, which is to be held in solution for twenty-four hours and then applied to the metal, which should first be roughened and heated. The leather is then laid upon the metal and dried under pressure.

Cement for Leather Belting.—Common glue and isinglass, equal parts, soaked for ten hours in just enough water to cover them. Bring gradually to a boiling heat and add pure tannin until the whole becomes ropy or appears like the white of eggs. Buff off the surfaces to be joined, apply this cement warm, and clamp firmly.

Cement for Leather and Cloth.—An adhesive cement for uniting the parts of boots and shoes, and for the seams of articles of clothing may be made thus:—Take one pound of gutta-percha, four ounces of india-rubber, two ounces of pitch, one ounce of shellac, two ounces of oil. The ingredients are to be melted together, and used hot.

Gutta-Percha Solution.—See "Fixing Gutta-percha Soles to New and Old Work," under "Special Operations."

Durable Glue.—A very permanent and durable glue, which may be called chrome glue, is made by adding to a moderately concentrated solution five parts of gelatine, this sort of chrome being thought better adapted to the purpose than bichromate of potash, which is usually used. The glue thus prepared, after being exposed to the light, becomes insoluble in water, in consequence of the partial reduction of the chromic acid. This preparation can be used in cementing glass objects liable to be exposed to boiling water, the treatment being the ordinary one of applying the glue to both surfaces of the fractured object, and then binding them together until dry, and exposing them for a sufficient length of time to the light, after which boiling water will have no action upon them. Two or three applications of the glue, either by immersion of the object in or by the use of a brush, will answer the purpose.

A Black Ink.—An absolutely permanent black ink is thus prepared:—Boil one pound of logwood chips in one gallon of water at boiling point ten minutes, then stir in the eighth of an ounce of bichromate of potash, and boil this ten minutes longer; then add, when cold, one half-pound common gum, previously dissolved, and stir well in. The cost of the above ink is sixpence per gallon.

Shoemakers' Wax, when made for handwork, is com-

posed generally of equal quantities of pitch and resin, with 10 per cent. of tallow; after boiling (if good wax), it is pulled until the wax assumes the colour of pale resin. The pulling takes out, or more properly bleaches, the ingredient pitch, and thereby takes out the colouring all pitch contains. Wax used for machines has all of it too much pitch and tar for clean work; the colouring matter in pitch and tar comes up through the grain; once in it cannot be got out—and wax boiled or heated again, unless in a perfectly clean vessel, and even then, partly recovers the colouring bleached out by hand pulling. Wax that will work up the pure bronze colour so much liked by shoemakers may be made of 4 lbs. resin, 1 lb. pitch, 4 ounces beeswax, 3 ounces tallow—the tallow to be refined, otherwise 3 ounces best sperm oil. The beeswax seems to destroy the colouring matter of the pitch, when in that proportion. A good resin wax is superior to any other composition for wear, because it decomposes on exposure and wears into a stony substance in appearance, and looks not unlike pegs of amber when put under the microscope. Wax, with tar at all in, or much pitch, when heated continuously, becomes only a dirty discolouring matter, as the oil evaporates, carrying with it all the valuable adhesive or glutinous properties of the pitch, and such wax will most readily soil or discolour the flange of the channel that is laid over it. Wax can also be made of the following simple ingredients. Flake white, ground fine, virgin wax and resin. Melt the resin and virgin wax together, and then put in the flake white. Stir it, and let it cool. The proportions should be equal, or nearly so. If wanted hard, let the resin slightly preponderate; if soft, the wax.

Solution Wax.—1 lb. pitch, 1½ oz. of beeswax, 1½ oz. resin, 2 heelballs, and 1 pint of boiled oil—all simmered together slowly. *In winter a greater portion of oil should be used.*

Spankum or Bosh.—Take three heelballs and an equal quantity of beeswax and dissolve them in naphtha or spirits of wine.

Sieburger's Paste.—Soak four parts, by weight, of glue,

in 15 parts of water, and warm slowly until a perfect solution is formed : then dilute with 65 parts boiling water, stirring thoroughly. Take 30 parts of starch, stirred in 200 parts of cold water, and free from lumps, and into this pour the glue solution, heating and stirring, If the paste is to be kept, add ten drops of carbolic acid.

Superior Paste.—To make paste of a superior quality, that will not spoil when kept in a cool place for several months, it is necessary to add dissolved alum as a preservative. When a few quarts are required dissolve a dessert-spoonful in two quarts of tepid water. Put the water in a tin pail that will hold six or eight quarts, as the flour of which the paste is made will greatly expand while it is boiling. As soon as the tepid water is cooled stir in good rye or wheat flour until the liquid has the consistency of cream. See that every lump of flour is crushed before placing the vessel over the fire. To prevent scorching the paste, place it over a dish-kettle or wash boiler partly filled with water, and set the tin pail containing the material for the paste in the water, permitting the bottom to rest on a few large nails or pebbles, to prevent excessive heat. Now add a teaspoonful of powdered resin, and let it cook until the paste has become as thick as stiff gruel, when it will be ready for use. Keep it in a tight jar, and it will last for a long time. If too thick add cold water, and stir it thoroughly. Such paste will hold almost as well as glue.

A Durable Paste.—Four parts by weight of glue are allowed to soften in 15 gallons of cold water for some hours, and then moderately heated till the solution becomes quite clear. Sixty-five pints of boiling water are now added while stirring. In another vessel thirty parts of starch paste are stirred up with twenty parts of cold water, so that a thin milky fluid is obtained without lumps. Into this the boiling glue solution is poured, with constant stirring, and the whole is kept at the boiling temperature. After cooling, ten drops of carbolic acid are added to the paste. This paste is of extraordinary adhesive power, and may be used for leather, paper, or cardboard,

with great success. It must be preserved in closed bottles to prevent the evaporation of the water, and will in this way keep good for years.

Rice Flour Cement.—An excellent cement may be made from rice flour, which is at present used for that purpose in China and Japan. It is only necessary to mix the rice flour intimately with cold water, and gently simmer it over the fire, when it readily forms a delicate and durable cement, answering all the purposes of common paste.

Best Stiffening Boot Paste.—Mix best dextrine (procurable at any druggist for about 6d. per lb.) with cold water into a paste of the desired thickness.

Blacking Receipt.—The following is said to have been the source of a fortune to the patentee, Mr. Bayley, of Cockspur Street. This blacking is made, according to the specifications of the patent, with one part of the juice which issues from the shrub called "goats' thorn," during the months of June, July, and August, four parts of river water, two parts of neat's foot, or some other softening or lubricating oil, two parts of a deep blue colour prepared from iron and copper, and four parts of brown sugar candy. The water is then evaporated till the composition becomes of proper consistence, when it is formed into cakes of such a size as to produce, when dissolved, a pint of liquid blacking.

Another: 3 ozs. of burnt ivory, 1 oz. of candied sugar, 1 oz. of oil of vitriol, 1 oz. of spirits of salt, 1 lemon, 1 tablespoonful of sweet oil and 12 ozs. vinegar. The ivory is first of all mixed with the sweet oil, then the lemon, sugar, a little vinegar, and the spirit, which has been previously mixed with the vitriol, added with the rest of the vinegar.

Warren's.—Ivory black, 4 ozs.; linseed oil, 1 oz.; sulphuric acid, 1 oz.; treacle, 4 oz.; gum arabic, 1 oz.; copperas, 1 drm.; spirits of wine, 1 oz.; vinegar (brown) 1½ pint.

Imitation Leather.—To make imitation leather, a mixture is prepared of 16 parts by weight of glue, 16 of water,

4 of colza oil, 8 of glycerine, and 18 of boiled linseed oil. Atmospheric air is driven through the mass, to oxidise the linseed oil, and drive out the water. The mixture is laid with a brush on paper or linen cloth, cooled and dried in the open air, and finally dipped into a solution of tannic acid. Any pattern desired is pressed into the composition before it dries.

Margate Boots : a Warning.—This kind of boot is often spoiled by using paste that has been kept in a tin can. Paste that has been so held, from a chemical action that need not be described, will turn black, and destroy the colour of the uppers.

Pannus Corium was the invention of a Mr. Hall, draper of Plymouth, the father, we believe, of Mr. Hall, the well-known London bootmaker. It was patented, but the patent has long run out. The invention is said to have been suggested by the blackened and shiny appearance of a mechanic's fustian trousers. In order to produce a similar effect he applied hellball and beeswax to the fabric mentioned. It is said, however, that a steeping process is now used, after which it is blacked in the ordinary way. It is more porous than leather, and being free from oil, does not draw the foot to the same extent. Its strength is not equal to leather, but tender-footed persons who have tried it, ourselves among the number, speak of it favourably.

Cleaning of Sewing Machines.—If the machine is not very rusty, pour rather a large quantity of neat's-foot oil on those parts of the machine which are generally greased, and put it into a quick motion, by which means the oil mixed with black dust, will be driven out again at the shaft. Wipe this mixture off, and repeat the same process until the oil comes out quite clean, which is a sign that the machine is perfectly clean. If the machine is very rusty, the aid of a machinist is required, who generally uses files and emery paper, which are very disadvantageous to the gearing, but if the rust has not penetrated too far, it can be cleaned without any mechanical aid, in the following manner :—Grease the machine with

a brush for several days at those parts where friction is produced, and principally at the deepest parts. As soon as the rust has become dissolved, put the machine carefully in motion, and repeat afterwards the first-described process. If the machine has not been used for some time, a thick dust has accumulated, which consists of dust and oil. This substance can be best removed by greasing the machine with neat's-foot oil. After this continue to clean the machine with spirit of turpentine in the above-described manner; but we do not recommend too much use of this spirit. Another adviser on this important matter says: "Paraffin should be employed to soften grease that has become dry or clogged. After the clogged grease has become softened, wipe it and the paraffin away. The best machine-oil should be employed. The dust should, of course, as far as possible, be prevented from getting to the working parts of the machine."

CHAPTER XXVII.

CONCLUSION.

THE changes that have taken place in boot and shoe manufacture have, we trust, been fully revealed in the preceding pages.

It is easy to conceive that these altered conditions in the trade have necessitated the possession of different qualifications to those formerly sufficient to command success. The successful maker's qualifications when bespoke shops were in the ascendency consisted chiefly of a winning address, ability to satisfy individual customers, and a thorough knowledge of each separate phase of bootmaking. Clearly these do not include the whole of the qualifications now requisite, although it must be admitted that they still retain their importance.

Boot and shoe manufacture, as now carried on by the aid of machinery, necessitates among other qualities great powers of distribution as well as production. Boots and shoes can be produced in any quantities. That is a mere question of plant, capital, and efficiently organized labour. Orders for military work that took twelve months and more to complete could, if necessary, be, and often are, satisfactorily performed in as many days. Thus it will be seen that the commercial element in the shoemaking trade has risen in importance, the greatest difficulty being found not in production but in disposal. To secure this, great powers of organizing an efficient staff of travellers are imperative. The men required for this purpose need not have an intimate knowledge of the details of the trade, although it must be admitted that the possession of such

qualities would occasionally prove of great value. What is most needed in men whose duty it is to solicit custom is a knowledge where such custom is to be found, power to judge of the soundness of the transactions entered into, ability to force business, and strict honesty. Without a staff so formed, to start manufacturing boots and shoes on an extensive scale is a mistake. Nor is success dependent upon travellers only. Practical men must be found for each department; accounts must be efficiently kept, wastefulness reduced to a minimum, and punctuality secured at any cost.

Where possible, the ready money principle should be consistently followed. It is the only mode of making success easy. Credit must be paid for, ready money invariably commands the cheapest market, and successive discounts will go far towards making each transaction profitable.

In starting a shoe factory care should be taken to select a spot of easy access, and where efficient labour can be readily acquired. The absence of railway accommodation is sure to prove fatal to success, and inability to recruit labour readily leads to serious failures in the completion of orders.

England's foreign trade in boots and shoes has not marched with the times. This may partly have resulted from conditions over which Englishmen have little or no control; but the chief cause has undoubtedly been a want of knowledge and a want of enterprise upon the part of modern manufacturers or factors. The representatives of America in foreign nations are known to be chiefly recruited from men of considerable trading experience, and a short time back they were ordered by the American Government to collect every kind of information relative to markets for the disposal of goods, purchase of raw materials of manufacture, cost of production, and wages tariffs. On reading over their reports, which were in most instances of an exhaustive character, we were struck with their value to the manufacturing and trading classes for whose benefit they were intended, and we were forced to the conclusion that the sooner we imitated the example set the better. The comparative depression which has so

long ruled in our foreign trade in boots and shoes has been attributed to many causes, but there is one asserted cause that should be, in the way indicated or otherwise, remedied. We, for want of knowledge, have failed in many instances to gauge the wants of the boot-wearers of other nations. The boots supplied may have been better than those that find a readier and more permanent market; but the prejudices and wants of both head and feet must be suited. Peculiar ideas respecting boots and shoes to be worn, and the qualities and substances of the materials of which they are made, are known to exist among different peoples; while the feet of all peoples do not conform in shape. Egregious blunders are known to have been committed in consequence by English and possibly other manufacturers. If we are to succeed in enlarging our foreign trade in regard to this important industry, steps should at once be taken to acquire the missing knowledge; and if it be not possible to imitate the mode adopted by America, then it is time that the example set us by German manufacturers should be followed, which consists in important firms subscribing a sufficient sum to start and support men specially selected for their technical and business knowledge, to gather up and report the desired information.

With regard to the education of our artisans, little need be said. Its importance has already been recognised, and schools are known to be in process of formation (a few already existing), that will furnish scientific and technical information that cannot fail to place our artisans on an equal footing with their most favoured foreign brethren. The result of this new departure cannot but prove beneficial, and we trust to see the day when the profitable result of the exertions now being made will be patent to all men. We have said elsewhere that the outcry regarding the want of taste of English bootmakers has not been warranted by the facts—that modern boots and shoes of English manufacture are equal in this respect to those of any other nation; but what is desired is that England shall be without a rival, and this can only be secured by

following the course indicated, namely, by giving an art training to the most willing and ambitious of our workmen.

At the commencement of the present work an attempt was made to sketch the rise and progress of boot and shoemaking as an art. This sketch was brought down to a period within the knowledge of living men. The after contents, while devoted to matters entirely of a practical character, have bridged the intervening chasm, and our concluding remarks, slight as they may appear to be, have been made with the desire to indicate how the future of this great industry, an industry in which England has always stood pre-eminent, shall be made to prosper in the future.

INDEX.

THE END.

PRINTED BY WILLIAM CLOWES AND SONS, LIMITED, LONDON AND BECCLES.

CPSIA information can be obtained
at www.ICGtesting.com
Printed in the USA
BVHW081038180620
581558BV00002B/113

9 781578 989720